HANDS-ON GUIDE SERIES®

Hands-On Guide to

Creating Flash Advertising

The Focal Press Hands-On Guide Series

The Hands-On Guide Series serves as the ultimate resource in streaming and digital media-based subjects for industry professionals. The books cover solutions for enterprise, media and entertainment, and educational institutions. A compendium of everything you need to know for streaming and digital media subjects, the series is known in the industry as a must-have tool of the trade.

Books in the series cover streaming media-based technologies, applications and solutions as well as how they are applied to specific industry verticals. Because these books are not part of a vendor-based press they offer objective insight into the technology weaknesses and strengths, as well as solutions to problems you face in the real-world.

Competitive books in this category have sometimes been criticized for being either technically overwhelming or too general an overview to actually impart information. The Hands-On Guide Series combats these problems by ensuring both ease-of-use and specific focus on streaming and digital media-based topics broken into separate books.

Developed in collaboration with the series editor, Dan Rayburn, these books are written by authorities in their field, those who have actually been in the trenches and done the work firsthand.

All Hands-On Guide books share the following qualities:

- Easy to follow practical application information
- Step-by-Step instructions that readers can use in real-world situations
- Unique author tips from "in the trenches" experience
- Compact at 225–300 pages in length

The Hands-On Guide Series is the essential reference for Streaming and Digital Media professionals!

Series Editor: Dan Rayburn (*www.danrayburn.com*)

Executive Vice President for StreamingMedia.com, a diversified news media company with a mission to serve and educate the streaming media industry and corporations adopting internet based audio and video technology. Recognized as the "voice" for the streaming media industry and as one of the internet industry's foremost authorities, speakers, teachers, and writers on Streaming and Digital Media Technologies.

Titles in the Series:

- *Hands-On Guide to Webcasting*
- *Hands-On Guide to Windows Media*
- *Hands-On Guide to Video Blogging & Podcasting*
- *Hands-On Guide to Streaming Media*
- *Hands-On Guide to Flash Video*
- *Hands-On Guide to Creating Flash Advertising*

HANDS-ON GUIDE SERIES®

Hands-On Guide to

Creating Flash Advertising: From Concept to Tracking—Microsites, Video Ads, and More

JASON FINCANON

ELSEVIER

AMSTERDAM • BOSTON • HEIDELBERG • LONDON
NEW YORK • OXFORD • PARIS • SAN DIEGO
SAN FRANCISCO • SINGAPORE • SYDNEY • TOKYO
Focal Press is an imprint of Elsevier

Acquisitions Editor: Paul Temme
Publishing Services Manager: George Morrison
Project Manager: Mónica González de Mendoza
Assistant Editor: Dennis McGonagle
Marketing Manager: Rebecca Pease
Cover Design: Eric Decicco
Book Production: Borrego Publishing (www.borregopublishing.com)

Focal Press is an imprint of Elsevier
30 Corporate Drive, Suite 400, Burlington, MA 01803, USA
Linacre House, Jordan Hill, Oxford OX2 8DP, UK

 Recognizing the importance of preserving what has been written, Elsevier prints its books on acid-free paper whenever possible.

Library of Congress Cataloging-in-Publication Data
Fincanon, Jason.
 Creating Flash advertising : from concept to tracking microsites, video ads and more / Jason Fincanon.
 p. cm.
 ISBN-13: 978-0-240-80949-6 (pbk. : alk. paper) 1. Computer animation. 2. Flash (Computer file)
3. Internet advertising. I. Title.
 TR897.7.F48 2007
 006.6'93--dc22
 2007023375

British Library Cataloguing-in-Publication Data
A catalogue record for this book is available from the British Library.

ISBN: 978-0-240-80949-6

For information on all Focal Press publications
visit our website at www.books.elsevier.com

08 09 10 11 12 13 10 9 8 7 6 5 4 3 2 1

Printed in the United States of America

This book is dedicated to my entire family whose love and support is the most valuable thing I could ever have.

To my wife, Sarah: Thank you for all of your understanding and support of the days and nights spent working on this book either at home in front of the computer or at the library. I couldn't have fallen in love with (and married) a better woman or found a better friend. I love you bunches and munches!

To my son, Riley: As I am writing this, you are not yet two years old. I never could have imagined what it would be like to have you in my life, and now I can't imagine what it must have been like before you were here. Be nice, be respectful, be caring, be strong, and never forget that I will always love you and be here for you no matter what. Oh, by the way, you're going to be a big brother soon!

To my parents: Thank you for everything you've ever done for me (including putting up with those crazy teenage years). I wouldn't be where I am today without your love, help, and support. If I can do even half as good of a job at raising my children as I feel you've done with me, I'll know that I've done well. I love you guys!

In memory of my father

Bill Fincanon

May 2, 1950–November 29, 2004

I love you and I miss you dad.

Table of Contents

Chapter 1: Flash Advertising Quick Start

Chapter 2: Constants and Considerations

Chapter 3: Designing Banner Ads

Chapter 4: Preparing and Building Ads

Chapter 5: Forms and Data in Ads

Chapter 6: File Optimization

Chapter 7: Third-party Rich-media Technologies

Chapter 8: Trafficking and Tracking Your Ads

Chapter 9: Designing Microsites

Chapter 10: Preparing and Building Microsites

Chapter 11: Driving Traffic to Your Microsite

Chapter 12: Advertising Examples

Chapter 13: Snippets and Classes

Foreword

Not all that many years ago online advertising was limited to pop-up ads and annoying banners filled with animated gifs that were anything but "interactive." Flash and other rich media were in wide use but mainly relegated to the arena of websites. It wasn't really considered a viable option for advertising online because of bandwidth limitations and the high costs associated with the production of such ad units. Well, as is always the case, the tools and technologies evolved and adapted to overcome those limitations. In today's technical arsenal, Flash sits atop the coveted throne of rich media. The technology has become refined and optimized so as to allow developers to focus on the core of its capabilities rather than concern themselves with all the mundane details that formerly consumed the lion's share of their energy.

Today, the World Wide Web is flooded with rich media in every conceivable shape and form. From banners and microsites to heavily branded online games as well as immersive and heavily experiential websites. It seems as though everyone is producing Flash-based ads in one form or another. But how effective are these executions? How much thought has gone into layout, optimization and design? From a creative as well as a technical perspective? Has any consideration been given to search engine compatibility? How did the programmer go about addressing the vast (and growing) array of diverse platforms and web browsers? Or worse, will the produced units even be supported by the sites they're destined to run on?

If you've ever found yourself stumped or just curious about what goes into the production of a successful Flash-based media execution, this book is one you'll want to add to your library. And if you're considering a career in the field of multimedia advertising, this book may be the one to form the cornerstone of that library.

Jason Fincanon has carved out a niche for himself in the world of Flash advertising and has taken the medium itself to a whole new level in the process. He can just as often be found hovering over a colleague's desk answering questions as hunkered down over his own code as he looks for ways to squeeze just one more ounce of optimization out of the end product. However, Jason really isn't what you'd expect from someone with his depth of knowledge and professional experience. He takes his work very seriously, but he's definitely not above pulling off the occasional practical joke (or bearing the brunt of one himself for that matter). Jason has earned the respect and admiration from both his colleagues in the field of multimedia development as well as that of those from the other side of the creative tracks, the art directors (or "creatives" as we like to refer to them).

In writing this book, Jason has managed to incorporate both his sense of humor and his unquestionable expertise in the subject matter in a way that really takes the edge off of a very challenging topic. If you're already an experienced Flash developer this book will show you how you can take your craft to the next level without overwhelming your senses and forcing you to read and re-read each section to grasp the methods discussed. You'll find yourself thinking about the production process in ways that you've never considered before. And even if you're new to the technical disciplines you'll likely find value in Jason's methodical approach and attention to detail as he takes you through the production process.

From working within the constraints of antiquated site specs, to navigating the stringent quality control process while keeping your wits about you. From optimizing your code for re-usability to taking full advantage of version control, Jason has covered it all. He's been there and done that. And now he's taken the time to share what he's learned so perhaps you won't be forced to learn those same hard lessons at the cost of countless hours of lost sleep and anxiety.

Randy Bradshaw, Principal, Click Here, Inc.

Acknowledgments

My thank you list could go on for pages in this book, but I'll trim it down a bit. First off, thanks to Glenn Thomas for introducing me to Paul Temme at Focal Press. Thanks to Paul Temme, my acquisitions editor, and Dan Rayburn, the Hands-on Guide Series editor, for all of the hard work they put in to making sure everything stayed on track and got done right. Thanks to Geoff Stearns and Bobby van der Sluis whose work I've referenced in this book. Thanks to everyone at Click Here and specifically to (in no particular order) Randy Bradshaw, Dick Mitchell, Chris Long, Shawn Scarsdale, Scott Filloon, Eric Patrick, Brian Linder, Jamie Squires, Mackenzie Squires (with The Richards Group), Harley Jebens, John Keehler, Paul Herring, Kyle Sawai, Katie Holmes, Cheryl Huckabay, Roddy McGinnis, James Henningson, Brad Vinall, and James Wilson. Finally, thanks to the wonderful people at National Pork Board and The Patrón Spirits Company for allowing me to show works created for them.

About the Author

After graduating with a major in computer animation from The Art Institute of Dallas in 1998, Jason started working at a publishing company creating artwork for school yearbooks. Since he was working the "graveyard shift," he kept his eyes open for any new opportunities that might happen to come along. Within six months, he found a new job where he was first introduced to Flash.

At the beginning of his Flash career, Jason was only making small animations and programming very simple interactivity such as buttons that linked out to other websites. During that first year of working with Flash, he started to see the strengths and power of ActionScript. He decided he wanted to move in that direction, and since then has put nearly all of his focus on ActionScript.

Once Jason moved on from that first Flash job, he found himself going back and forth between freelancing and being employed by companies that fell along with so many other startups that no longer exist today. Fortunately, just as he was getting tired of chasing after paying gigs and thinking of changing careers, Jason was put in touch with Click Here in Dallas, Texas (http://www.clickhere.com), one of the nation's largest interactive advertising agencies. Upon talking with them in 2003, Jason was hired as a contractor and subsequently moved over to a full-time employee. He has since become a Macromedia Certified Flash Developer, moved into a senior position, and works on projects for some of America's biggest and best brands.

Outside of work, Jason enjoys creating experiments with Flash, playing his guitars and video games (when there's time), and most of all, spending time with his family. In addition, he also maintains two Flash-related blogs. One of them, titled "The FlashCanon," is about various Flash topics and can be found at http://flash.fincanon.com. The other blog, "The FlashCanon Lab," is a collection of his Flash experiments and can be found at http://lab.fincanon.com.

Introduction

Advertising online has come to have a not-so-favorable reputation with Internet users. Combine that reputation with the often uninformed opinion that Flash is for creating exceptionally annoying banners or website intros that are bloated in file size and you've got a recipe for disaster. On the other hand, when done correctly, Flash can be (and is) used to create some of the most eye-catching, awe-inspiring, mind-blowing, award-winning work on the Web.

A major contributor to the unfortunate misconception of this combination is the fact that there *is* work out there that fits directly within its own reputation. However, with a little forethought and planning, those same ads could be very quickly redesigned with the outcome of much better user reception and interaction. If the work that is causing the bad reputation for Flash advertising can be made better, then so can the reputation itself. This book was written in hopes of doing just that. It was written to help educate and inform individuals, teams, departments, and even companies on the ins and outs of creating advertising with Flash. Let's take a quick look at the chapters inside.

Chapter 1: Flash Advertising Quick Start

As I mention in this opening chapter, you should always choose the correct technology for the job at hand. With that in mind, I talk a little about when and why you would want to use Flash to create your online advertising in the form of either banners or microsites. This chapter then moves on to give a bit of an overview on the different banner formats that will be covered later in the book and a little information on interactive standards, and touches on Flash advertising templates. Lastly in this chapter, I show a quick, high-level rundown of the general life of any given project from design to launch.

Chapter 2: Constants and Considerations

In every project you work on, there will always be some aspects that will remain the same. Likewise, there will be certain considerations to keep in mind as you work on those projects. In this chapter, I cover several of those constants and considerations, such as ad specs, deadlines, quality control, and version control. Sometimes just paying attention to the steps you are taking in a project can help you better prepare for, and save time on, future projects.

Chapter 3: Designing Banner Ads

Designing banner ads may seem very simple on the surface, but there are things to know before jumping right into Photoshop. For example, do you know the goal of the campaign? How well do you know your client on a business level? A personal level? How well do you know the audience and what they are interested in? Now figure file size constraints and animation time limits into the mix and there's a bit more of a challenge. In this chapter, I share some insight I've received from some of the best art directors in the industry and show how to handle these questions and potential production speed bumps while you design.

Chapter 4: Preparing and Building Ads

The next natural step after designing banner ads is to prepare and build them. As with most of the chapters, the title of this one says it all. I start off talking about planning your ad by thinking ahead to issues like how interactions will work and if your animations will be tweened, scripted, or use a combination of both. Moving on from planning, I cover setting up and naming a typical advertising Flash file. Next

in this chapter is a section on cutting images to be used in your banner followed by sections on linking out from your work, using ActionScript to save development time, and building to internal standards within your team and company. You'll also find some information on Flash's bandwidth profiler and how you can (and should) use it on every banner ad you create. After your Flash file is built and you've published your swf, you'll need some sort of wrapper to contain it, so I cover that as well as a couple of potential issues in the sections titled "HTML/JavaScript" and "Default Images." Finally, the chapter ends just as the banner project itself would—with quality control.

Chapter 5: Forms and Data in Ads

Some projects will require you to include a form in your ads. That form may be for finding and booking a flight and hotel, it may be for configuring the color and trim level of a car, or it may be for any number of other tasks you would like the user to complete. Regardless of the specific function of an individual form, there are things to know and keep in mind when building them into your ads. Some of those items, such as variable names and possible values or where the form will actually submit its information, are very obvious when you think of forms in general. Other items, however, such as the amount of file size consumed by a Flash comboBox component, are less apparent on the surface but just as important. In this chapter, I not only talk about the common form functions, but I also give some ideas on keeping the Flash components from bloating your file size.

Chapter 6: File Optimization

One of the challenges I often come across while working on an advertising campaign is file size restriction on banner ads. While I talk about tips to cut file size on forms in the last chapter, this chapter will cover more areas where file optimization is possible (and recommended). Since your banners will almost always need to be under a given file size (usually 25–30k), it's good to know where you can trim the virtual fat. However, file optimization doesn't only lend itself to banner ads. It's also a good idea to keep the size of your microsite files as low as possible. The tips, tricks, and things to keep in mind that are in this chapter will help lower the final size of your swf files.

Chapter 7: Third-party Rich-media Technologies

There are companies out there that specialize in finding and providing ways for advertisers to push way beyond standard 30k banners. The technologies they have in place allow developers to create ads that are far more inviting, engaging, and generally have a much higher "wow" factor to them. From taking over an entire page (with users' permission of course) to playing a video in a banner to creating the equivalent of what I like to call a "micro-microsite," these technologies are where to turn when you just can't say what you need to say in a 30k Flash banner.

Chapter 8: Trafficking and Tracking Your Ads

Even though you might be finished building a round of banners, that doesn't mean the project is complete. After your ads are built, checked for quality control, and approved by everyone who needs to approve them, they need to be trafficked out to the Internet. This chapter covers the general steps involved in making that happen as well as what's involved with tracking their performance. If you're new to online advertising, I also introduce some terms in this chapter such as impressions, interactions, clicks, and conversions, and what the differences are between them. Additionally, you'll learn about determining the different costs associated with your ads and how to optimize the entire campaign.

Chapter 9: Designing Microsites

When people think of online advertising, they generally only think of pop-up ads and banners they've seen on the top or side of a website they've visited. While banner ads do encompass the general meaning of advertising, there's another form of advertising online that gets by under a different name: microsites. In this chapter, I talk about concepts/designs for microsites and some things to consider while you're in this step of a project.

Chapter 10: Preparing and Building Microsites

This chapter shares a few similarities with Chapter 4, "Preparing and Building Ads." For example, you still need to have a good plan in place before building and you still need to have as many assets in place as possible before you actually need them. However, there are also plenty of differences when it comes to building a microsite as opposed to building a round of banners. For one thing, you'll need to

have a different backup plan in case your viewer either has an older version of Flash Player or doesn't have it installed at all. Another big difference is the amount of user information you can collect (if users are willing to share it), and how you'll collect and subsequently store that information.

Chapter 11: Driving Traffic to Your Microsite

You've just finished building and launching a microsite for your client and you need to somehow let people know it's out there. In this chapter, I discuss some of the important steps to take in not only letting people know about your microsite, but getting them there as well. From the banners that may accompany the microsite to purchasing predefined keywords in search engines to kicking off a viral marketing campaign by getting the buzz started, there are many ways to inform potential visitors of the new site and to get them talking about it as well.

Chapter 12: Advertising Examples

In this chapter, I show examples of actual client work in which I've been involved. For each example, there are screenshots of the work, and I explain just what the banner or microsite in question does. These examples should not be confused with case studies, but looking over them should give you some idea of the possibilities (but definitely not the limits) of using Flash to create your online advertising.

Chapter 13: Snippets and Classes

Just as the title of this chapter suggests, this is where you can find reusable code in the form of snippets and classes. For each piece I explain what happens from a user's perspective, then I show the code, and then I explain what is happening in the code. All of the code in this chapter has been used in actual projects and can be found on the book's accompanying website located at http://www.flashadbook.com.

CHAPTER 1

Flash Advertising Quick Start

With the lines between the computer desktop, the Internet, and the television blurring more and more every day, it has become increasingly important to give users better, more intriguing experiences in everything they do online, including viewing advertising. Whether it's a small ad with some fun animation, a larger rich-media ad with interactive video, or a full microsite for a product or service, people want to be wowed and your clients want you to wow them.

Flash has matured and grown into a powerful tool over the years, but there are still a lot of ads and sites out there giving some people a bad impression and it's up to us to change their minds. So how do we change the minds of these people and wow them at the same time? We can start by following a few simple design rules, anticipating interaction and animation issues, targeting the correct audience, and steering away from the things we find annoying or wouldn't want to see ourselves.

As Flash has grown, so has online advertising. There was a time when you had to choose between a static jpg or an animated gif file for your banners. Not anymore. The option to use Flash has enabled interactive advertising agencies, as well as individual developers, to create much more engaging and entertaining ads. It has also opened up a channel for more interactivity and the ability to gather user information from within an ad itself (see Chapter 5).

In this first chapter I'm going to talk about why you should use Flash for advertising and several of the choices you have in doing so. The sections contained within this chapter are:

- Why Use Flash for Advertising?
- Ad Formats
- Interactive Standards and the IAB
- Flash's Built-in Advertising Templates
- Microsites
- Mobile Devices
- Place, Design, Build, and Launch

One more thing before we get started. Let's make sure you have the software you'll need to move on (**Figure 1.1**). If you don't have Flash installed, you can get a trial version at http://www.adobe.com/products/flash/. The other main tool I'll be using in this book is Photoshop, which you can get a trial version of at http://www.adobe.com/products/photoshop/.

Okay, now that you've got your tools, let's continue.

Figure 1.1
Your tools for this book—Flash and Photoshop.

Why Use Flash for Advertising?

I'll be completely honest here and say that Flash isn't going to be the best option to achieve your goals 100% of the time. As with any technology, you should avoid using Flash just for the sake of using Flash. Instead, you should assess the project at hand

to decide if Flash is the best option to go with. That said, this is a book about creating Flash advertising, so we'll go ahead and make the assumption your work calls for it.

Banners

So why use Flash for advertising? Why use it to create banner ads for your client's service or product? The short answer: Brand interaction via features not available with other options. With a static jpg or even an animated gif banner, you might have a good enough picture to get a user to click and go to the intended destination, but that's pretty much all you have—a picture. With Flash, you have the ability to engage your audience with your client's brand. You can use smooth animation and interaction to tell a story. You can build an ad with tabs for different "pages" within your banner. You can build a banner that gives users even more interactive elements once they interact with it the first time. You can even show an actual television commercial or other video inside your ad.

Inside the Industry

 "The true purpose of any online ad unit is to communicate the biggest message in the smallest amount of real estate."

—Randy Bradshaw, Principal, Click Here, Inc.

Let's look at an automobile manufacturer as an example. Your client, XYZ Motors, wants you to build a round of online advertisements that will allow the end user to begin choosing options on their newest model car. They want people to see the ad, make choices from dropdown menus about what color and trim package they would like on the car, submit the form, and be taken to the "build your own" section of the manufacturer's website where the selections made in the banner will carry over. By allowing users to fill out the form in the banner, you've allowed them to complete a portion of the task before they even get to the site.

So why wouldn't you just build the banner out with HTML? That would be a great option if we were only talking about a form and two, maybe three, frames of images and text. However, your client wants more than that. They want to see several different images of the car smoothly cross-fade from one to the next on user interaction. They also want to offer users an option to watch their new TV spot directly inside the banners. Now, if you can pull all of that off without the use of Flash, I'd be interested in meeting you and hearing how you did it.

Microsites

So what about microsites? In addition to the banners, XYZ Motors wants to launch a site specifically for the new car. They would like to see an interactive 360-degree view of the car, an image gallery page, a video page, maybe a driving game featuring the new car, and several other features. This is of course in addition to the information you would expect to find on a car site like a specs page or the manufacturer's suggested retail price (MSRP) of the car. They would also like to see a nice, fresh, creative approach to page transitions. Now you could probably accomplish some of those tasks with anything like Ruby, PHP, .NET, or several others, but in order to give them the full experience they seem to be looking for, I'd suggest designing and building them a Flash microsite. I'll talk a little more about microsites later on, but for now let's get back to the banner ads.

While covering the banner example for XYZ Motors I mentioned forms, videos, animation, and a few other things that need to be considered. What I haven't talked about yet is the different ad formats that are available for you to choose from. Let's get to that now.

Ad Formats

When it comes to creating online banner ads, you have options for the format in which you will build them and the top-level, bird's eye view of those options are standard Flash and rich media.

Standard Flash

I'm going to stick with XYZ Motors for now and we're going to tone down their ads to simple animations with nothing more than a couple of images and some text. Since we aren't going to include any high-profile extras like video, this is a good time to use what's called a standard Flash ad. Standard ads are the most basic of all the Flash ads you'll build. They're simple, straightforward, and get the message across. Your standard Flash ads will usually consist of a small animation, a couple of lines of copy with a call to action such as "click here to visit our site," and one or more clickable areas. These ads are usually constrained to a file size limitation of 20–30k and are served by either an ad serving company or directly by the site on which the ad is running (see more on ad serving companies and site serving ads in Chapter 8). Keep in mind that while some sites allow you to utilize more file size, standard banners are not the place to try to squeeze in anything like audio or video.

Rich Media

If you're looking to have audio or video in your ads, or if you feel you'll need more than the 20–30k file size allowed by standard Flash ads, you'll need to move them over to a third-party rich-media company (I talk about several of them in Chapter 7). These companies have technologies in place that allow you to have much more file size, interactivity, video, audio, etc. They allow you to build a much richer experience. In addition to the features I've just mentioned, you'll need the rich-media companies to serve your banners if you plan on creating anything like expandable or floating ad units. Again, I'll talk more about those later in the book but as a quick explanation, both of those banners do exactly what you'd think: Expandable ads expand to a larger size when a user rolls over or clicks on them and floating ads "float" over the main content of the page.

Cost Can Be an Issue

ALERT When you are planning and working on a banner campaign, always remember that choosing rich-media banners over standard Flash ads can cost more. However, also remember that the added benefits of rich-media banners may very well be worth the extra expense.

So why wouldn't I design my ads to run with a rich-media company every single time? I mean, if I'm going to be constrained to a file size, I'd rather be constrained to 100k than 30k. How about the ability to have additional loads in the form of Flash files, images, XML, or several other options? Why give that up? What about the video I want to stream into my ads? The answer is cost, my friend, cost. When you upsize that meal at the drive-thru or when you buy the car with the larger engine, you expect to pay more because you get more, right? The same concept applies here. The difference is that you aren't spending your own money now; you're spending your client's money. Another concept that fits perfectly is the concept of not using a technology just for the sake of using that technology. Pitch your ideas to your client and let them know which ones will require them to "upsize their order." They will let you know which one they are happy with as well as which one they feel comfortable spending their money on.

Interactive Standards and the Interactive Advertising Bureau

Since we just got finished talking about ad formats and since I mentioned a usual file size limit of 20–30k, let's spend a minute on online advertising standards. The Interactive Advertising Bureau (IAB) is an association whose goals are not only to campaign for interactive marketing and advertising, but also to prove its effectiveness. In addition, they also lead the charge to get the industry organized with a voluntary set of standards and guidelines for interactive marketing.

The voluntary guidelines you'll find from the IAB are those that most sites and agencies currently follow. They include, but are not limited to, ad units, emails, pop-ups, and rich media. By familiarizing yourself with their voluntary guidelines and standards, you'll know valuable information pertaining to important topics dealing with your work. Topics like ad formats (width and height), recommended file sizes, animation lengths, and audio/video controls.

Figure 1.2

The Interactive Advertising Bureau's website.

I'll go into a bit more information about the IAB in Chapter 2. You can also find more information and IAB guidelines on everything from ad units to rich media to email to pop-ups on their website located at http://www.iab.net (**Figure 1.2**).

Author's Tip

The Bandwidth Profiler in Flash is a very useful resource when it comes to keeping your banners within the file size allowed by your specs. It also comes in quite handy for seeing how your microsites will download and play with various settings, such as a user with a 56k dial-up modem versus a user with DSL. To get to the Bandwidth Profiler, simply test your Flash movie by pressing both the Ctrl button and the Enter button on your keyboard. Once your test movie is playing, press both the Ctrl button and the B button to toggle the Bandwidth Profiler on and off. I'll get a little more in depth with the Bandwidth Profiler in Chapters 4 and 10.

Flash's Built-in Advertising Templates

A quick word on the advertising templates that come packaged with Flash (**Figure 1.3**). While I personally don't use them, it's worth mentioning that they are built at some of the industry standard sizes as far as height and width. By starting your project with one of these, you'll save yourself the step of resizing the stage. There isn't a whole lot to them, but you can use them as a starting point or you can modify them to suit your needs and save your own custom templates. For example, you might start a new file from the 300 × 250 advertising template, change the frame rate from 12 frames per second to 18 frames per second, and bump the player version up to something more current. Once you have made the modifications you need and you are satisfied with the properties of your new file, select "Save as Template" from the File menu, name your file, and you've got a new custom template made for you, by you.

Figure 1.3
Flash's advertising templates.

Microsites

What exactly is a microsite? Well, it's smaller than a full website but bigger than a banner, and it can be anything from pure information to a full multimedia experience. With microsites you can concentrate on that one specific product or idea that your client wants to push. Since it is being built for that single product, the site can have its own look and feel that doesn't necessarily have to match that of the client's main website. A microsite can be designed to portray how elegant the product is. It can be built to give users a feel for how fun the product is. It can have its own soundtrack so users can hear how exciting the product is. The possibilities are limited only by your creativity, your client's approval, and the end goal of the campaign.

Design to the Campaign

Keep in mind that it's a good idea to tie the design of your microsite in with any other advertising that is going on in the campaign at the same time. This means that you would want to take a look at something like the television commercials or

print ads and you would want to use some design elements from them. The new XYZ Motors car is a very nice one. It's extremely elegant, refined, and generally top of the line in luxury and comfort, and it's being advertised as such offline. So let's take that slick, expensive-looking background from the magazine ad and incorporate it into the site. And let's take the smooth, elegant, classical track from the television commercial to use as background music on the site.

Inside the Industry

 It's very common to use materials online that were originally created for offline production. Essentially anything that was created for print, television, radio, or outdoors (billboards, etc.) can be used in one form or another in your online campaign efforts.

A lot of times when you build a microsite, you'll also build banners to go with it. You've probably guessed that the banners are intended to drive traffic to the microsite and that's exactly what they'll do. In addition to the banners, there should also be a piece on the client's main website that promotes and drives even more traffic to the new microsite.

Microsites are usually very fun projects and you generally have more creative freedom with them than you do with banners. This is the place where you'll have more opportunities to script some new effects or try out that cool new feature that's only available in a newer version of Flash.

Author's Tip

If you know you are going to be working on a microsite for a client, try to get approval to publish out to the latest version of the Flash Player. If they won't agree to that, ask for the next version down. Being able to publish out to the latest version is beneficial for all parties involved: Creative departments get to design with new features in mind, Flash programmers get to work directly with those new features, and clients get cutting-edge microsites that people talk about and pass around to their friends. In addition to those benefits, you'll be helping the penetration rates of that version of the Flash Player. The quicker the penetration rates rise, the easier it is to convince a client that it's safe to use.

Mobile Devices

There are several ways to approach mobile devices: graphics, text, and Java, and then there's Flash Player for Pocket PC and Flash Lite (**Figure 1.4**). An example of a mobile device that supports Flash Player for Pocket PC is one that runs on Windows Mobile, and at the time of writing this, that player was at version 7. Flash Lite is a smaller, more compact version of the Flash Player that is built specifically for mobile devices. At the time of this writing, Flash Lite was at version 2.1 and had a Flash 7 code base with support for ActionScript 2.0.

Figure 1.4
A few of Flash's mobile device templates.

A Growing Medium

The number of mobile devices using one version of the Flash Player or the other is growing at an incredible rate and that means that there is another great medium out there to utilize. With applications ranging from games to maps to animations to magazines on cell phones, there are plenty of opportunities to use it. Design a game around your client's brand or build a map application that discretely plots the

locations of their storefronts while users are looking for directions. Imagine if a user was looking for directions to your client's competition, your application made him or her change his or her mind, and he or she showed up at your client's door instead. Who's the hero now?

Features

So how about some of the supported features of these mobile Flash Players? Let's briefly look at a few for Flash Lite. The dynamic XML data could provide many possibilities by way of updating the content in your ads on the fly. You might use the dynamic XML data to change content like sales prices being offered by XYZ Motors or the available dates of those prices. In addition to the dynamic XML data, you have media support for dynamic images, video, and sound. This means that not only could you change the offered price of a car, but you could change the picture of the car itself. Another nice feature is persistent data that can be used to store information. The information you choose to store can be many things, but one idea would be to keep track of high scores in a game that you built and branded for a client. If users have a retrievable list of past scores, they are more likely to keep playing the game to try to beat their previous records. And the more they play the game, the more they are exposed to your client's brand. All of these features are possible because of the fact that you can program with support for ActionScript 2.0 in the Flash 7 code base. That little fact also makes building Flash for mobile devices very close to building Flash for the Web.

Considerations

There are some considerations to keep in mind while moving forward with mobile advertising. For example, unless things have changed in the United States since the time I'm sitting here writing this, mobile providers have not yet gotten fully in sync with each other on their technologies or any real mobile standards. While the mobile market in general is expanding more and more every day, it seems to be growing in segregated pockets. There are several small bubbles building pressure and about to burst as opposed to one big one. Since that is the case, your ads and applications may be limited to fewer users right now than is potentially possible in the near future. However, I believe these issues will correct themselves and I believe it will happen fairly soon (if it hasn't already happened by the time you're reading this). Once the providers agree to all get on board with the same technologies, and once data transfer finally gets an equal share of the mobile bandwidth pie, the options will open up to near, if not matching, those of online advertising.

There's more information about Flash Lite available for you to read on Adobe's website at http://www.adobe.com/products/flashlite/. You can also get information about Flash Player for Pocket PC at http://www.adobe.com/products/flashplayer_pocketpc/.

Place, Design, Build, and Launch

The time has come to start talking about projects and their life cycles. There are several differences in both the process and the thinking when it comes to banners and microsites. However, as you'll soon find out, there are also similarities between the two. Let's do a quick walkthrough to give you an idea.

Place

By the time an ad makes it to the Flash developer's desk, there are a number of things that have already taken place. For one, the media has already been purchased. When the media is purchased, this means that the list of banner sizes and the sites that will show them have been chosen. However, don't be thrown off by my deceptively simple explanation of that step because choosing the sites to show your ads on takes a great deal of careful thought, consideration, and work. You must think about what the message is that you are trying to get across and who you want to get it across to. In other words, find your target audience and decide how best to give them the information that you want them to have. Know what they are reading online and get your ads running right beside that content. Don't just place that ad for XYZ Motors on any random page of a random website; place it in the automotive section of a newspaper's website or maybe on the search results page of an automobile research site.

Design

Another step that has already taken place is the creative. While every step of the process is important and while an ad can't come to life without development and programming, it is often said that "creative is king" and that's a hard point to try to argue against. If you think about it for a minute, what makes you talk about that television commercial you saw the other night? What made you laugh at that billboard on the side of the road the other day? And what makes you point your friends and coworkers to that website you think is so cool? Aside from the occasional answer of "I like the functions, methods, and classes that must have been used to make that site work," most answers are going to tie right back into creative. Just like the media buy, a lot of thought has to go into the creative step of the process. A couple

of issues to consider are branding and messaging. Again, what are you trying to say and who are you saying it to? Are you selling a new car with all the technical bells and whistles for listening to music or are you selling a luxury car built for comfort? Obviously one of those is going to need to be targeted toward a younger, "hipper" crowd and the other toward a more refined and "experienced" audience. When it comes to targeting your audience, the main difference between the media buy and the creative is that with the media buy you research to find out where they are. With the creative, you have to know what will attract their senses to your work.

> **ALERT** When working on a design for a campaign, you should always be aware of, and adhere to, your client's brand style guide.
>
> !

When thinking about branding, find out if your client has a brand style guide. These style guides will determine certain aspects of the design such as color pallets and fonts. If your client does have one, you should follow it perfectly and without fault. There are many more things to talk about in the creative step and I'll go more in depth in Chapters 3 and 9.

Build

Once the creative step is complete, it's time to move on to development. I don't mind saying that this is my favorite step because this is where the Flash developer gets to breathe life into a design. This is where the creative team gets to see their visions realized. This is where the magic behind the scenes happens, and this is the first place that people can watch the work in moving, functioning action and say, "Wow, that's awesome!"

Whether it's an ad or a microsite, challenge yourself if you are the Flash developer on the project. I remember a set of banners I was working on that started out showing a solid black stage with the first message to users in white text. After giving users several seconds to read the text, a diagonal line of colorful dots swept across the stage from left to right. While dots wiped the first message away as they swept, they revealed an image, a client logo, and the call to action in its place. Well, I think I had about 15 different sizes of banners with 3 different messages in each size (quick math puts that at 45 banners) and that's a lot of repetitive work that would take a

good bit of time to complete. Being not unlike most people I know, I wanted to simplify the large amount of tedious work ahead of me, so I challenged myself a little. Instead of animating each individual banner, I spent a little time figuring out and writing code that I could put into a class. In the end, my class used the Flash drawing Application Programming Interface (API) to draw all of the colorful dots and the mask that revealed the final frame. By using the stage height, I was able to determine how many dots I needed to draw to have a complete line from top to bottom. Once I had those all drawn in, I called a function in the class to run the animation. After all of the code was written, I only needed to change out the message and picture in each banner. No lining up dots, no tweening, no mind-numbing repetitions. So what's my point here? I saved a great amount of time on the back of the project just by spending a little bit up front. Not only that, but a few weeks later, more rounds of those banners were needed and we were able to knock them all out very quickly by using that same class.

So when I say challenge yourself, I mean it in more than one way. There's the obvious way of challenging yourself to write code and do things in Flash you've never done before, and then there's the challenge of working less. Now don't take that the wrong way and start surfing the Web in place of completing your projects, because that may get you in a situation where you aren't working at all. Instead, use the old adage, "Work smarter, not harder."

Launch

Okay, the name of this section is "Place, Design, Build, and Launch." There's only one of those left to talk about and I'm going to make it much shorter. The process of launching your work is going to be different between banners and microsites. Once banners have been through all of the necessary testing and debugging, the approved work is sent to the ad servers or sites and set up to run in the spots mentioned at the beginning of this section. As for the microsite you've been working on for any extended amount of time, the step of pushing it to a live server can be an

exciting one. Not only have you reached the final milestone, but now you get to proudly show your completed work to your friends, family, and anyone who reads your blog or the forums on which you post. I personally like the anticipation of waiting to see how the people I don't know are going to react to the work because it's those people that are going to be the most honest about what they think.

Conclusion

To wrap up the first chapter, let's do a quick once over on what was talked about. The first topic was about blurring the lines that separate the Internet from other mediums like the desktop and television. The blurring of those lines moves us right into the next topic on why you should use Flash for advertising. In a nutshell, a good, compelling experience needs to be created and Flash is just the tool for the job. I also touched on different ad formats like standard banners and rich-media ads. Different sites and ad servers will give you small variations on specs for your ads, but there are general standards and guidelines that are recommended by the IAB. While I was on the topic of standards, I went very briefly into the advertising templates that come installed with Flash. After that, we talked about microsites—what they are, the purpose they serve, and how they can provide opportunity to push some limits. A short talk about mobile devices followed, and then I went on to a quick touch on the points involved in the life of a project. Coming up in Chapter 2, "Constants and Considerations," I'll go a little deeper into specs and IAB standards. I'll also be talking about quality control and version control and why they are both so important to you and your sanity.

CHAPTER 2

Constants and Considerations

As with most things in life and programming, there are certain aspects of creating Flash advertising that remain unchanged as you move from project to project. While planning and working on an ad campaign or microsite, you should consider how these constants will affect your workflow. For example, you will always have to follow specs for your ads and you will always have to meet your deadlines (or come up with an explanation for your client as to why their microsite won't be launching at the same time as the product). A couple of other considerations are quality control and version control—both of which are very important but sometimes overlooked.

ALERT If you aren't using any kind of version control, I highly recommend you start immediately. The simple practice of using version control has been known, on several occasions, to actually save a project that would have otherwise been lost to problems like accidental deletion and/or miscommunication between developers. Being able to save these projects can also save you from potentially losing your client as well.

Before we move on to talking about the constants and considerations involved with creating Flash advertising, here's a quick overview of the sections you'll find within this chapter:

- Ad Specs
- Deadlines
- Quality Control
- Version Control

Ad Specs

Rules, rules, rules. Everywhere you turn there are rules telling you what you can and can't do and ad banners are no exception to that rule. Almost every major site your ads may run on has a section where you can get their specs. If you can't find a link that takes you to their advertising area, simply contact the site to let them know you need their advertising specs and there should be no problem obtaining them. The information you are after are things like the maximum file size your ad can be when published to the final .swf, the amount of timing you are allowed to run animation, and the number of times your banner can loop before finally coming to a stop. Another thing to watch out for is a maximum frame rate. While most sites may not have the maximum frame rate listed in their specs, some do, and your work can very easily get kicked back to you if you exceed it.

Author's Tip

The maximum frame rate at which site specs will allow your work to run can vary from site, but it has been an extremely rare case that I've seen a site allow anything over 18 frames per second (fps). However, it has also been very rare that I've seen any sites set their maximum below 18 (I once ran across a site that would allow no more than 12 fps). With that in mind, I would try to avoid building anything with a frame rate higher than 18.

Keep It Down (Your File Size That Is)

The sites that your ads will run on don't want to bog down their readers' bandwidth with banners that exceed the file size in their specs and you don't want the banners to take too long to start playing. If you built an ad that was 500k, your audience would have to wait for it to load before they ever got to see the product. Sure, with that much file size you'd probably have a pretty amazing banner, but your end goal to intrigue users and get

them to interact with your ad could be lost in all of it. As I mentioned in Chapter 1, most sites usually stick with a maximum file size of 20–30k. There are, of course, exceptions where some sites will accept a higher file size like 50k. Another fairly consistent spec is timing and looping. A lot of sites prefer to set a time limit of 15 or 30 seconds with a maximum of three loops.

More Interactive Advertising Bureau

Since we're on the subject of specs, let's expand on the information about the IAB from Chapter 1. As I was mentioning before, the IAB has voluntary guidelines for what they call "Interactive Marketing Unit (IMU) Ad Formats." These guidelines are updated as needed after the IAB's Ad Unit Task Force meets on a biannual basis. **Table 2.1** shows the sizes in the guidelines at the time of writing this book.

Table 2.1

Example of IAB Voluntary Guidelines for Interactive Marketing Unit Sizes

Banners and Buttons	Rectangles and Pop-ups	Skyscrapers
468 × 60 (full banner)	300 × 250 (medium rectangle)	160 × 600 (wide skyscraper)
234 × 60 (half banner)	250 × 250 (square pop-up)	120 × 600 (skyscraper)
88 × 31 (microbar)	240 × 400 (vertical rectangle)	300 × 600 (half-page ad)
120 × 90 (button 1)	336 × 280 (large rectangle)	
120 × 60 (button 2)	180 × 150 (rectangle)	
120 × 240 (vertical banner)		
125 × 125 (square button)		
728 × 90 (leader board)		

Keep in mind that the sizes listed in **Table 2.1** may have changed by the time you are reading this. To make sure you have the most up-to-date guidelines, visit the IAB's Standards and Guidelines page at http://www.iab.net/standards/ and look for the link to Ad Unit Guidelines. While you are there, be sure to also take a quick look around at the other guidelines for more advertising options like Pop-up Guidelines, Rich-media Guidelines, or Broadband Ad Creative Guidelines. The later is where you'll find information on running audio and video in your banners.

Deadlines

So let's jump right in to talking about deadlines and their importance because they can make or break your client list. When a project is set up and your client "signs off" on you doing the job for them, there will be a time associated with having that work finished and pushed live on the Internet. If you are not the actual person that agreed to and set this deadline, then that person most likely has a pretty good idea of how long it will take you to create the work and you'll be held to that date. Now I won't candy coat this issue by saying that there are never going to be any problems or stress with tight deadlines. Quite frankly, most deadlines will be at least a little bit tight and there will be times when you'll need to work some late hours in order to meet those deadlines. So how big of a deal is it when you start missing your deadlines? Well, on top of the potential embarrassment of not delivering the work when you promised the client you would, you could be facing any one of several levels of consequences from a small warning all the way up to losing your client. The severity of the consequences may depend on several factors like the policies of your place of employment or how many deadlines you've missed in a given amount of time. Just try to remember that deadlines are an extremely important part of a project and they should be taken as such.

Aim Ahead of Schedule

One suggestion I would like to make is to aim ahead of your deadline. If you have four weeks to complete a microsite, try to have it finished in three. If you have three days to build a round of banners, see if you can knock them out in one and a half. If you are the Flash developer on the project, your first deadline will most likely be to get your project handed over to quality control. The quicker you can get it to them, the less crunched they are on time and the better they can do their job. The next deadline you will probably face is the deadline to have the bugs that are found by quality control worked out. This deadline usually ties right in with the launch or

campaign start date. Imagine if you turned the project over to quality control two days early, they find a few issues, report them to you, and you fix them right away. Now you look again at your final deadline, and yes, you've just completed the project three full days ahead of schedule. What client isn't going to want the reassuring comfort that you and your team have everything so completely under control? You are the hero again and all is well in the world.

ALERT Remember that other than quality control, you are usually the last to have your hands in a project before it goes live to the world. Since that is the case, your deadlines are extremely important. Don't miss them.

Creeping Scope

Another good reason to stay ahead of the game when it comes to your deadlines is scope creep. The best way I can describe this phenomenon is the same as it has been explained to me in the past: Scope creep is the inevitable process in which the client or stakeholder, after agreeing to initial deliverables, discovers what those deliverables truly need to be. This process usually occurs gradually over time and only becomes evident once the project is nearing completion.

If it's not managed well, scope creep can very easily translate into many extra work hours. However, by expecting it to happen, you can be prepared to watch for the signs ahead of time.

You're Not Alone

Since we've talked about your deadlines as the Flash developer, let's talk about another deadline: The deadline to have the layouts and artwork delivered to you. After all, how can you start building a banner or site if you don't have the needed assets? If someone other than yourself is doing the creative/art side of the project, they should be given a date by which they need to have these assets to you. The probability of you making your deadline is partially dependent on them making theirs. However, you should keep in mind that some companies may choose to utilize different approaches to these particular deadlines. For example, your employer may have a bit of a loose schedule in this area to allow the timelines of different

disciplines to overlap. This would mean that while layouts are due to you by a certain date, those layouts may only include select pages of a microsite. This method allows the creative talent to keep working on the design of the underlying areas while you start developing the main functionality of the site. The result is a site that has had more attention given to the details and more details given to the site. And we all know the old saying, "It's all in the details."

Keep in Touch

While working with these overlapping work times, it is extremely important that you stay in close contact with the creative person. As you'll quickly learn, this is because parts of the site that have not yet been designed may be affected by the functionality you are programming into the main area of the site or vice versa. While developing the main functionality, let the creative person know what you are doing as you are doing it. Let them know exactly what your functions/methods/classes will do, and ask them to explain the underlying sections that could be affected by that functionality. What you are trying to avoid here is spending a couple of hours coding only to find out that you need to change it in such a way that you are nearly starting over.

Quality Control

Before I start with this section, I'd like to offer a quick bit of clarification: Quality control may go by many other names such as quality assurance or quality testing. However, for consistency, I will always refer to it as quality control within this book. And now that you're aware of that piece of information, let's talk about it.

Much like version control (which I'll talk about next in this chapter), quality control is a step that some developers (and even companies) choose to skip for some reason. The unfortunate choice that is sometimes made against quality control is one that can cost everyone involved and it can cost them dearly. Imagine if you created a piece of work and didn't test it even a single time. You're probably good enough that that one piece of work would be fine and so would the next ten. However, what if you hadn't had your morning coffee yet? Or what if you were at the end of an 18-hour work day? You might just miss something and end up sending your work to the client, bugs and all. Now imagine that you *did* test your work but since you're so close to the project, you missed an error and sent it out anyway. The best solution to all of this is to check your own work and then have someone else check it again.

Test Yourself

You should be testing your own work as it progresses and again after it is complete. Among other things, this testing is another advantage to aiming ahead of your deadlines. If you finish up with the animation and coding with time to spare, you can (and always should) test it out before sending it on to quality control. If you find a bug at this point, that's one less you'll have to fix after you hand it off (not to mention that you will have helped make quality control's job a little easier). The fewer bugs you pass to quality control and the fewer bugs you have to fix at the end of the project, the earlier it can be approved to go live and the quicker everyone can either go home or move on to the next piece of work. I'll go into more detail on quality control as it pertains to banners and microsites individually in their respective chapters later on in the book. For now though, how about a bit of an overview?

The Reason for Quality Control

So what is the focus of quality control? The answer to that question is in the first word of the job title itself: quality. The work you do should be held to the highest standard and quality control is there to help make sure that it is. By making sure your work stays within the specifications that have been set and by attempting to actually break anything and everything you create, they are making your work virtually unbreakable while also making sure it doesn't get kicked back from the hosting company or sites on which it will run. You personally benefit from this process as well, because in the future, you will remember what broke, how it broke, and what you did to fix it. With this information, you become better and better as a Flash developer and/or designer because you have the practice that they say makes perfect and you have made the mistakes from which you can learn. So while doing your absolute best to avoid creating bugs, welcome those that are reported to you as new opportunities to advance your knowledge even if only a little.

You're Still Not Alone

I also have a piece of information that may help you sleep a little easier at night: Not all bugs will rest on your shoulders alone. For example, there may be issues that come up that involve changing something in the original layout of the work. When these issues arise, be sure to get the creative talent involved with the change. It is, after all, their design you'll be altering and it probably shouldn't be altered without the knowledge of the original creator of the work. Another example might be if there is someone else working on the database from which you are pulling information for a microsite. If something needs to be changed that involves the code that person wrote, they obviously need to be informed and involved in the change. Speaking of changes, what happens when you make a change and you later find out that you need to undo that change? Well, hopefully you've got some kind of version control system in place.

Version Control

Have you ever realized that you hadn't saved in quite a while just as the program you're working in was crashing? Have you ever worked on a file for several days or even weeks? Have you ever had one of those files get corrupted or accidentally deleted? How about a coworker? Have you ever opened a file to find that a coworker had changed almost everything in the file and saved it before realizing they had the wrong file open? How about you? Have you ever accidentally messed up any files in any way? Were you able to get your files back and roll them back to the condition they were in when they worked oh so well? If you answered no to that last question and yes to any of the others, then you, my friend, need to get some sort of version control in place and you need to get it in place as soon as possible. Once you have it in place, make sure that your entire team is using it as well.

Options

When it comes to version control you have many options of both proprietary (such as Microsoft's SourceSafe) and free solutions (such as Subversion; **Figure 2.1**). Each of them has their individual advantages and disadvantages, but the end goal to all of them is the same: To save past versions of your work in case you lose the current version or you need to revert back to an older one. A very basic example of simple version control would give a file a version number of 1 on its initial creation. If that file is then modified, the version number is bumped up to 2. The next change would increment the version number again, and so on.

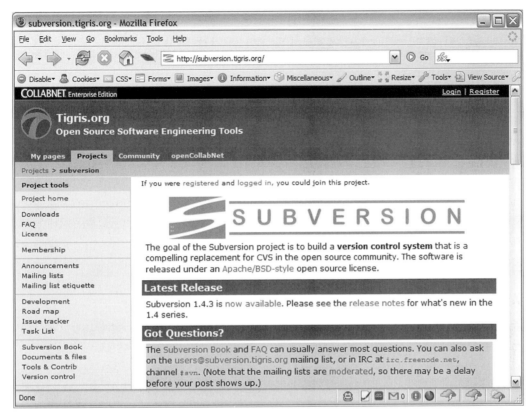

Figure 2.1
The Subversion project: http://subversion.tigris.org.

You may work a little differently with version control depending on the file you're actually modifying. For example, if you're working on an .as file you won't need to check-out or lock the file in the versioning system unless you absolutely don't want anyone else working on it at the same time. This is because the .as file is, in essence, a text file that the versioning system should be able to read and decipher differences. In other words, you and another team member can make modifications to the same file at the same time. If the other developer finishes theirs and updates the file in version control before you do, you'll be notified that there are differences when you attempt to update the file with yours. Your versioning system should then show you the differences and allow you to make any changes needed before actually updating the file. With that said, it's good practice to keep good communication between team members and to avoid working on the same file at the same time if at all possible.

Working with fla files in version control is a little different because fla files are binary files (as are jpg, png, psd, etc.). Since the versioning system can't read the code written within fla files, it can't detect the actual differences that may be within them even though it is able to detect that the files are indeed different. Since that is the case, it is best to check-out or lock fla files so there is no possibility of other team members working on them at the same time as you. Once you are finished making your changes to a file, update it in the versioning system and release the lock to allow other developers access to it in case they need to make additional modifications.

ALERT Always check-in or unlock your files in version control once you're finished working on them. Since some version control solutions won't let anyone access files except for the person who has them checked out, it's important to release the control of those files in case you leave the office or end up being out sick the following day. If you leave the files locked, it will make it more difficult for your team to continue working on them in your absence.

A Version Control Story

John and Mary work for an interactive advertising agency and they have been working on a microsite for one of their biggest clients. Things have gone smoothly throughout the life of the project and they are almost ready to send it to quality control when John notices a problem during one of his own quality tests. He isolates the issue, notes the steps taken to recreate the problem, and opens the fla file that he believes actually contains the error. After navigating to the line of code he suspects as the bad line, he makes his change and publishes the .swf file. Since it's the end of the day and John has a flight to catch for an out-of-town vacation, he saves his work, shuts down his computer, and leaves.

The next morning, Mary passes the project over to quality control as soon as she gets to work. Within an hour, she starts receiving numerous notifications of bugs in the site; bugs in areas she thought she had tested the day before. Mary opens the site in her web browser and starts to navigate to the sections that contain the reported issues, and sure enough, there are a lot of areas that have mysteriously

decided to break. Since the final deadline for this project is fast approaching, Mary feverishly opens the source fla files and starts to search for the cause of each bug. As she digs through the code in each file, she comes across a couple of possible culprits and makes changes to those lines. After making each change, Mary tests the file and finds that the errors still exist. She goes back to the code and, without undoing her previous changes, she tries other options that only end up creating more bugs in areas she isn't currently testing. By the end of the day not only has Mary not been able to solve the original problem, but more have surfaced in her attempts. It has gotten late and Mary is tired and frustrated so she decides to call it a night and try again tomorrow.

The next morning Mary feels rested and refreshed. As she opens the files to take another run at fixing the bugs, she realizes there is one more thing she didn't think of before. She finds her way to the line of code she presumes is causing a problem and discovers that her new suspicion is correct. She makes the change, publishes the .swf files and tests for the problem, which is now corrected. However, since Mary made so many changes to the code yesterday that she failed to remove, the site is now broken in many other areas and she has to try to remember where each modification is in the site. After hours of work, Mary finally resolves all of the issues that were reported to her by quality control and the site is ready to go live … a day late.

What Happened?

When John made his change before leaving town, he misspelled the name of a variable that was extremely important to the rest of the site. Since he was in a rush to catch his plane, he failed to check his work and ended up creating more issues than previously existed. Since Mary was unaware that John had made the change, she went directly to the code that was actually indirectly affected by the change and accidentally created even more bugs in the site.

How Could It Have Been Avoided?

On top of the lack of communication between the team members (especially on John's part), the entire string of events and resulting errors could have been avoided by simply using version control. When John made his change, he should have included a note with the file he updated on the version control server. That note would have let the team know what change he made and in which file he made that change. Even if Mary didn't see the note to the team, she would have been able to "roll back" her files to the state they were in before she started making her changes that created so many more issues. When she rolled them back, the files

would only contain the initial error created by John and she would be able to make that single change to launch the site on time.

Conclusion

As I mentioned at the beginning of this chapter, there will be aspects of your work that will remain constant from project to project and there are considerations to keep in mind as you move between those projects. Once you start to recognize which aspects are reoccurring and to which ones you need to give special attention and thought, you can start fine tuning your plan each time you start a new piece of work. One benefit to the constants is that because you know that every project is going to go through a quality control process, you'll start catching your bugs before they even happen, which can actually improve your coding skills. Also, as time progresses, you will start to be able to tell if a banner will fit within the file size limitations set by the project specs just by looking at the design layout, which brings us to Chapter 3, "Designing Banner Ads."

CHAPTER 3

Designing Banner Ads

While designing for banner ads and designing for microsites can be a very similar process, there are still differences between the two. For example, you have a much larger virtual canvas and file size to work with in microsites, but you are constrained to specific widths, heights, and kilobytes in banners. Another difference is that your microsites can (and should, in most cases) be broken up into multiple files, but you are only allowed a single file with standard Flash banners and a limited amount of additional external files with rich-media banners.

Because of these differences, I'll split this topic into two different chapters. In this chapter, I'll be talking about banners and then I'll go into designing for microsites in Chapter 9, aptly titled "Designing Microsites." The sections you'll find here are as follows:

- Conception
- Goal of the Campaign
- Designing with Transitions and Animation in Mind

Conception

Before you have a final design for a banner, you should create two or three layouts for the client to choose from. These layouts are called "concepts" and they generally can be viewed as the different directions in which the final design can go.

 Every great design that achieves its goal has meaning and planning behind it and that planning is usually done by a planner. While the job title may differ from workplace to workplace, the job itself is essentially the same: to research products, brands, target audiences, clients, and client competition. The research may consist of many different approaches, such as focus groups or even getting your hands on the actual product to test it out. Once the research is complete, a plan is put in place to create a "map" for the campaign. Included in the map is a creative brief, and that's where the design ideas are generated. The creative brief is basically a rundown of all of the information that pertains to the audience, the look and feel of the brand, and the goal of the campaign.

Many different techniques can be used to find the best look for a banner and each designer will have his or her own individual ways of coming up with ideas. With that said, one suggestion to try after reading over the creative brief for the project is to jump right in and start getting creative. Your first impression and your first thoughts about the project at this point are oftentimes going to be very close (if not dead on) to where they need to be for designing your concepts. Try to use your "off the cuff" emotions to drive the initial design, or another way to look at it is to follow your first instincts because they usually work best. Once you get going, you'll hopefully find that your work is feeding your ideas as you go.

Now that I've offered up the thought of basically flying by the seat of your pants in your design, I'm going to attempt to bring you back down to Earth a little. There is some thought that needs to be put into your designs. While much of that thought can be found in the creative brief, some of it will require a little research and client/brand interaction of your own.

Know Your Client

Knowing your clients on a little bit of a personal level can work wonders in the design of your work and you should do your best to talk directly with them as much as you can without going overboard. Of course when you talk to them the first few times it will most likely be all business, but you can usually gauge a person's personality somewhat quickly (they might be fun and personable or they might be

more serious and "corporate"). Once both of you start mentioning topics unrelated to work, you may start to gain some perspective into their personality and possibly some of their likes and dislikes. With this information, you can start to get an idea of the type of design they might like to see (the fact that you'll concept more than one design should relieve any pressure you might feel about missing the "personality target" on the first shot).

Another benefit to knowing your client on somewhat of a personal level is trust; the better they know you, the more comfortable they are with you, and the more comfortable they are with you, the more they'll trust you and your decisions.

It Takes All Types (of Clients)

A great art director once told me that you can generally classify clients into three high-level groups and that you should quickly figure out which one a client falls under when talking to them about your work. Those three groups (for which I've made up my own names) are as follows, in no particular order.

The first type of client is the "tech-yes" type. These clients know about technology, they know that online is in the natural progression of advertising, and they embrace it with open arms. When talking to a tech-yes client, you can usually speak in industry and technology terms. If they don't understand what a certain word (or acronym) means, they aren't often shy or embarrassed about asking. However, you may still want to take the terminology down a notch by lightly explaining some of the things you feel people outside of the advertising and technology fields may not fully understand.

The second type of client is "tech-maybe" type. Like the tech-yes, the tech-maybes know that online advertising is something they need to do and they are willing to do it. The difference is that they are not quite as sure in their knowledge of the technologies. Their instinct is to give you any information you need or ask for and then trust you to be in charge of their project. When you're talking to a tech-maybe, try to keep the industry terminology down a little and explain what you are talking about.

The third type is the "tech-no" type. Tech-nos are your biggest challenge simply because they don't seem interested in the technology realm at all. Whether they are intimidated by it or they just don't have the time to learn about it, they don't seem to care too much for it. A tech-no client will actually create reasons to avoid moving their advertising dollars to online and you may hear something along the lines of, "The results of offline advertising are always measured the same way, so I think

Whether you are talking to a tech-savvy client or a client who isn't sure how to attach a file to an email, you should always explain everything and explain it in a step-by-step fashion. Use simple terms that are easy for anyone to understand while being very careful to avoid sounding patronizing. The last thing you want is for your client to feel like you're talking down to them because you feel like you're smarter than they are.

we'll just stick with that for now." Even though this type of client is a challenge, don't give up on them right away. Remember there was a time when even you didn't understand advertising *or* technology.

Know the Brand

Knowing your client is not necessarily the same as knowing their brand because, as I mentioned earlier, you'll want to know your client on a bit of a personal level. However, their individual personality may likely differ from that of the brand itself. While your client may be a very relaxed, fun, easy-going person who likes skydiving and snowboarding, the brand may be more refined and formal (or vice versa).

Knowing the brand will help you determine how you will design everything from where the logo will be placed to what will happen when users roll their mouse over the banner. If you're dealing with the refined brand, you'll probably want to have a nice, clean design with crisp lines and nice fonts. If you were dealing with an edgy brand, you would want the design to reflect that as well.

While the ideas for your banner concepts can come from many different places, a good place to start is the site that the banners will drive users to visit. From that destination, you should be able to get plenty of ideas based on the look and feel, the motion, and if at all possible, you may even want to use some of the actual graphic elements from the site itself. The design of the site combined with the brand standards will give you items like colors, fonts, logo treatments, etc. And while you need to stay within the confines of the brand standards, you may want to push the limits when you can. Obviously some of your clients' brand standards will be stricter than others and that could, in turn, affect just how far you can push the limits. On the other hand, some brand standards are very loose and forgiving. Pushing the limits on these relaxed standards could lead to more projects (such as microsites), and who knows, you may even influence your client to come up with a new look and feel for their entire brand.

Know the Audience

Much like your clients, there are different types of people at whom you will target your design. These groups of people are called your target audience and they will be another determining factor in the look and feel of your design. The specifics of the target audience, such as age, income, influence, and other demographics, will most likely be found within the creative brief put together by the planner. Using those specifics, you can decide the direction your design will take. For an audience that is regarded as the elite, rich, upper-class decision makers, you might have a very clean, slick, simple design that gets straight to the point of the message. On the other hand, you may want to design something more edgy if you will be going after a younger audience that is deep into gaming, extreme sports, and heavy music.

Know the Placements

Hand in hand with knowing your audience is to know where your ads will be running. There's a lot to be said for knowing your surroundings and coming up with designs for banner ads is no exception to that. If you are aware of how many sites (and precisely which sites) your ads will be shown on, you can take some time to surf around to them for a little inspiration. This is not to say that you should go to those sites and copy their designs into your banners, but that you should look them over to better decide how you can make your ad stand out without doing so in an obnoxious way.

The number of placements in which your ad will be seen can greatly affect this approach. If there are a large number of sites that will be running the ad, it may be harder to find a design that fits within all of them at the same time. On the other hand, you may be dealing with a small or very specifically targeted account that only has the banners running on a single site. Either way, you want your ad to be seen and knowing the look and feel of the surrounding area can help make that happen. Before leaving this section, I would like to reiterate one important note: Avoid making your banners stand out in the wrong way on a site. The last thing you should want to do is annoy and distract people from the content they are actually there to read or view. The real goal should be to gently attract their eye to your design and make them want to interact with your client's brand. After all, they are your client's potential customers and you want them to have a good experience.

Goal of the Campaign

The goal of the campaign will be another on the list of items that will dictate how a banner should look and feel. You may have a different design for a banner that is being created to sell a service versus one being created to sell a tangible product. You may have another completely separate design for a banner with the purpose of raising brand awareness versus a banner being created solely to drive traffic to your microsite.

The overall goal of a campaign will commonly fall into one of two areas: brand awareness or direct marketing. The purpose of brand awareness is exactly what you would think it is: to raise awareness of the brand itself. You aren't necessarily advertising a particular product or service, but you are trying to drive customers to at least consider the brand more closely the next time they see it in the store. On the other side of that coin is direct marketing. When you use direct marketing, you want them to actually purchase the service or product that is being advertised in that ad.

Branding and Selling

As I said previously, your banners will generally be designed to accomplish one of two main goals: selling goods or raising awareness of the brand. That said, a banner whose purpose is to sell will still have branding in it, but a banner built for brand awareness will not necessarily contain any form of sales messaging. To explain exactly what I mean by that, let's look just a little deeper at each of these goals.

Author's Tip

It's important to step back during each step of a project and try to view what you're working on from a user's point of view. Try to imagine how a person is going to experience the work the very first time he or she sees it. Try to determine if he or she will be compelled to take the actions you are trying to get him or her to take and if the paths to those actions are immediately apparent. Remember that a user won't have the benefit of a creative brief or meetings about the project to fully understand the work in question. The work has to do that on its own.

ALERT Since branding is such an extremely large subject that requires much more in-depth explanation than I could fit into this book, I have only given a very high overview on the subject.

Brand It

Raising the public's awareness to your client's brand makes them feel comfortable with it. It gives them something to identify with and at the same time it says, "Hey, I'm here. Remember me. Remember me when you see these images. Remember me when you see these fonts and these colors. Remember me when you think about _____." In addition to asking people to remember the brand, raising awareness also means that you're trying to evoke or solidify an emotion or feeling within them. As I mentioned before, that feeling may be comfort. However, the emotion/feeling that you actually want to call upon could also be something much different like excitement or curiosity. The simplest explanation of branding is that it consists of beautiful imagery, your client's logo, and some short but sweet message that appeals to the targeted emotions (possibly your client's tagline).

Designing for brand awareness can take on different levels of difficulty depending on the consumers' current view of the brand itself. If the public already has good thoughts and feelings about the brand, then the efforts that are currently in place are doing their job and you'll simply need to stay within those design standards. On the other hand, a client may have sought you out to change the public's thoughts of their brand. While there may be questions as to what caused the brand to develop an undesired image, the design process for a new brand direction can be a fun and challenging one. When a brand needs a new image, it needs to shine. This means that the brand design standards are usually very loose or even completely out the window in favor of the new direction.

For both of these scenarios there can be challenges. In the case of continuing successful brand awareness, it can be a challenge for some to stick within the strict (but again, successful) design standards. And when it comes to changing the public's view on a brand, some may find it difficult to have such an open design field to play in.

Sell It

Selling your client's product via online banner ads requires a different approach than raising brand awareness. For starters, your viewers are (hopefully) already familiar and comfortable with the brand. This works in your favor because they may only catch a glimpse of your ad from the corner of their eye as they are reading an article. Since the brand awareness campaigns for this particular client were successful, the viewer remembers the brand and takes a look at the banner. With this banner having the purpose of selling, users will no doubt see different elements

and one of them is the messaging. The banner itself will be more offer oriented and the message within will get directly to the point it's trying to get across: "Buy this product!" or "Look at this incredible price! Now buy this product!"

Something to remember is that while sales-driven banners are definitely harder hitting with less fluff, they should still borrow some techniques from branding ads. While they are highlighting an offer or a price on the surface, they should still have an underlying feeling of comfort and emotion that has come to be associated with the brand.

Designing with Transitions and Animation in Mind

Standard Flash banners are usually constrained to an animation time of 15–30 seconds. Rich-media banners, on the other hand, are most often only limited on animation time up until a user interacts with them. Either way, animation is one of the key benefits to using Flash for online advertising and the design of that animation is just as important as the design of the ad itself. The wrong movement can make an otherwise beautiful banner look amateurish and unplanned while the right movement can actually improve upon the look and feel.

Visualize While You Work

A good practice to get into is to go ahead and try to visualize your animations while you're creating your design. If you come across an asset that you feel would make a good moving part of the design, you should also take care to consider if it will be possible to make that piece move in the way it should. The only time you want something to look like it has unnatural, clunky movement is when the design actually calls for unnatural, clunky movement. In most designs, however, you'll want to try to create smooth, organic-style movement to keep the work from looking like it's trying too hard (and just to make it look good in general).

Some things to keep an eye out for when you're planning animation in advance are moving parts, visual angles of photographs, transparent areas, backgrounds, and several other similar properties of the piece in question. When you're dealing with moving parts of a larger object, are those parts cut in such a way that they can each be animated as needed? In other words, can the object bend at its joints and rotate its gears? If there's a background, do you already have the image cut away from it and do you already have the background filled back in? It can get quite frustrating for a Flash developer to get a request to make a car drive across a background image when the car is actually a part of that background image.

Animation Assets

You can plan an animation all day and all night but when it comes down to it, you can't actually create that animation if you don't have the proper assets. For example, you're working on a banner for your client and they want you to build an interactive 360-degree view of their product. However, you only have two images of the product: one from the front and one from the side. It goes without saying that you can't build much of a 360-degree view with only those images so you're left with some options. You can go back to your client and ask for the extra images of the product (which they may or may not have available), you can inform your client that extra money will need to be spent to do a photo shoot of the product, or you can spend your personal time doing your own photo shoot. There are other options as well, but you get the point here.

Turn Over a Little Control

If you're the person that designed the banner, there comes a time when it's good to let someone else take a little control and animations may be one of those times. Bringing an idea of movement to a Flash developer in the form of words (or even storyboards) may not always get the exact message across in exactly the way you wanted it to. Most times, when you explain something to someone (anyone, not just Flash developers), they are going to visualize it differently than you do. Since that's the case, the end result of the animation will most likely differ from what you originally intended. Step back, let go of your thoughts for a minute, and take a look at what the Flash developer has created. While there is a chance that you could shoot down this new idea, there's also the chance that you may like it better than your own.

Another approach on this topic is to sit with the Flash developer while you both work together to get the major mechanics ironed out. For example, you know that you want object A to move from point B to point C. What you don't know quite yet is the detail of its trip between the two points. Did it bounce to get there? Did it ease into or out of the animation? Did it bounce after it got to its final destination? As the designer, try not to let those details bother you right now and let the Flash developer take care of those questions. There are a couple of advantages to taking this approach with your designs. First, the Flash developer can actually sit there trying different animations from directly within the Flash authoring environment. Once he or she finds the one that feels best, you can both decide together if it's the right animation for the project. The other advantage to this is pride of ownership. Turning

over this control to the Flash developer will make the Flash developer feel more inspired to do a better job on the project due to the fact that the project feels more like it's his or hers instead of feeling like he or she is just another part of an assembly line.

Know the Strengths and Limitations

Because the design of each round of banners will differ, they will each have different strengths and limitations when it comes time to animate or program, and you'll need to be able to recognize them ahead of time in the design process. For example, moving objects over a large area at a very slow rate of speed can end up looking choppy if it's not done correctly. Another example, which I'll talk about in Chapter 6, is the format chosen for images used within a banner. Sometimes moving an object across the stage will require it to have a transparent area. This can be both a strength and a limitation at the same time: a strength because of the ability to support the transparent area of the image, but a limitation because of the extra amount of file size that can be taken by that image (as opposed to an image without transparency). Knowing the strengths and limitations of Flash is something that comes with time. After some experimenting, some trial and error, and needing to rework a few projects, more and more of these strengths and limitations will become apparent.

Back to Step One

Don't forget, just because you completed that first concept, you aren't actually finished yet. As I stated earlier in this chapter, you'll need more choices to offer to the client. In addition to giving the client more options, you can also take this opportunity to do a little mix-and-match exercise. After you've come up with your two or three concepts, take a look back over each of them together and see if you can find pieces to pull out of one design to put into another. You may be able to find ways to enhance your designs and you may even find enough from each concept to develop a forth piece that could possibly end up outshining all of the others!

Conclusion

Designing banners isn't as straightforward and simple as some might think. The amount of thinking and planning that goes on prior to, and behind the scenes of, the actual artwork can get very extensive in some cases. Knowing your client's brand and knowing your client's business is a must when you're designing their banners, but knowing your client on somewhat of a personal level can give you an inside track on their likes and dislikes. On top of knowing your client, you should also know who your audience is and the sites on which they'll be viewing your work.

The goal of the campaign will also be a determining factor in your designs. If you're working on a brand awareness campaign, you're going to treat it differently than you will a sales/marketing campaign. With a brand awareness campaign, you'll generally want to make users feel good about the brand and remember it the next time they see it. With a sales campaign, your overall goal is to drive users to buy a product by highlighting its price and value. At the same time you're asking them to buy, you'll also want to inject a little brand awareness into the design; something that says, "Buy me now, remember me later."

An important factor to think about in designing banners is how they will animate and how they will make transitions from one frame or section to the next. It's a good idea to think about these movements beforehand, because once in development, it can sometimes be difficult to retrofit an animation of a particular object. In addition to thinking ahead, you'll also want to make sure that the assets you're working with can actually animate in the fashion you have pictured in your head. In Chapter 4, "Preparing and Building Ads," I'll start getting into the steps involved in bringing your designs to life, from planning out how it will be built to using code as a time saver to sending your work through quality control.

CHAPTER 4

Preparing and Building Ads

So it's time to start building a round of ads, huh? That's good because that's just what we'll be talking about in this chapter. But you shouldn't just jump right in to animating and coding because you have to make sure that you have everything prepared and that you have all of the information you need. You'll need to know who is involved with project and what role they each take so you'll know who to turn to for any particular question or need. Speaking of questions, think of as many as you can up front. For example: Have you thought ahead to how your ad will work? Is there a layout for default images in case a user doesn't have Flash enabled? Do you have any class files already written that may work with this project? There are more questions to come, so let's get to it by looking at the following topics:

- Planning
- Setting Up Your File
- Cutting Images
- clickTags and Links
- Script to Save Time
- Building to Standards
- Bandwidth Profiler
- HTML/JavaScript
- Default Images
- Quality Control

Planning

Before you start to build your ad, you'll need to do some planning. How will your images be cut? Will you tween your animations, script them, or have a combination? How many destination URLs will you link to? Which areas will users click to get to those destinations? These and several other questions will need to be answered during the life of the project, so you should try to answer as many of them as you can ahead of time and you might even consider making a checklist that you can refer back to on each project.

If you are working with a creative department, you will need to keep in very close communication with the designer who laid out your ad. He or she will most likely have a vision of the animation in his or her head and you want the end product to match that vision as closely as possible. Since most of us can't actually read minds, you should get printouts of the main frames of the ad and have the designer sit with you to explain how he or she imagines the art coming to life. Once you have the designer's description, you will have a better idea as to the important pieces of the puzzle. Pieces like how your images need to be cut, which parts of the animation can be scripted, and at what speed they need to animate.

In addition to all of the information that pertains to the creative aspect of your ad, you will want to know the details of the more technical side. For example, if there is a form in your ad that submits to a client's processing page, do you have all of the correct variable names and possible values? For any ActionScript you may use, check to see if you have snippets you can pull from existing libraries that would meet this project's needs.

Specs

Another side to consider when planning is the specs that you are given by the hosting site or third-party ad serving company. These specs will include the items that were covered back in Chapter 1, such as stage dimensions, maximum file sizes, amount of time and/or loops the animation can play, the highest version of Flash you can use, and sometimes the highest frame rate that will be accepted. It is very hard to say which aspect of the ad is most important and you would probably get a different answer from each person you asked. However, if you fail to stay within all of the specs, your ad will most likely get kicked back to you from the sites and they probably won't run it until it is revised.

A good tool to help plan time spent on your project is a lowest common denominator (LCD) sheet. An LCD sheet is exactly what it sounds like—a sheet listing the lowest specs accepted on each size of your banners by all sites. Let me explain a little further. You have a 300 × 250 banner that is going to run on five different sites. Of those five sites, two will accept a maximum file size of 30k, one a file size of 28k, and the last two will only accept up to 25k. You obviously wouldn't want to create the same banner five times (once for each site). So the next thought might be to create one banner for each maximum file size giving you a smaller total of three banners. Well, as we all know, time is money and you should only spend the time you need to create the banner one time and one time only. Since the 25k version fits within the specs of all sites involved, that's the size you'll want to keep your 300 × 250 banner below.

Setting Up Your File

Okay, so you've received the layouts from the creative department, you've been given direction on the animation and interactivity, and you have your plan of attack ready to execute. Let's get started on the fun stuff by getting a file set up. You can use one of the advertising templates we discussed in Chapter 1 or you can set up your own. For this exercise, let's go ahead and set up our own 300 × 250 banner.

1. Create a folder to house your Flash files. Let's name this folder "myAd."

2. Create a subfolder within the "myAd" folder and name it "cut_art" (this folder will hold all of the images used in your ad).

3. Create a new Flash Document from the File menu or the Flash start page (**Figure 4.1**).

4. Open the Document Properties window by clicking the "Size:" button in the Properties tab of the main movie (**Figure 4.2**).

5. Set the width to 300 pixels and the height to 250 pixels. While we're in here, let's go ahead and set the frame rate to 18 frames per second as well. After you've done that, click OK.

6. Open the Publish Settings window by clicking the "Publish:" button and setting the version according to the specs you received from the site (**Figure 4.3**).

7. Click OK and save your new file to the "myAd" folder.

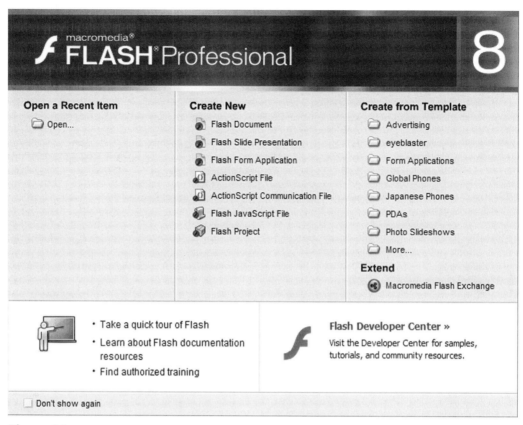

Figure 4.1

The Flash start page.

When you save your file, you'll want to be descriptive in your naming convention. For this banner, we'll use a name such as 300x250_30_my_ad.fla. (I'll cover naming your file in more depth in the "Building to Standards" section later in this chapter.) Once you've saved your file, you're ready to move on to the next step— cutting images.

Figure 4.2
The Document Properties window.

ALERT Version control is extremely important, but often forgotten or just not used. There are several options when it comes to the applications you can use such as SourceSafe or Subversion. I highly recommend you spend a little time doing some research on which application best suits your needs and use it on every project without fail.

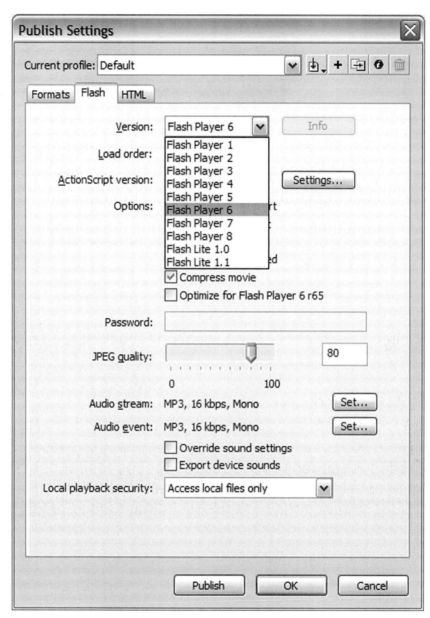

Figure 4.3
The Publish Settings window.

Cutting Images

A raster graphic is a graphic that is made up of a rectangular grid of pixels. Within that grid, each individual pixel is assigned its own color, and the more colors an image has, the larger the file size is going to be. There are both pros and cons to raster graphics. For example, raster graphics can show very nice imagery, but they cannot scale without degradation in their quality. In contrast, vector graphics can scale indefinitely without any change in the quality at all. This is due to the fact that vector graphics are actually drawn to the screen using mathematics. See **Figure 4.4** for a comparison of zooming in on a section of both a raster and a vector graphic.

Figure 4.4
Zooming in on raster and vector graphics.

Choices

In 9.827526 times out of 10 you'll be using at least one raster image in your ad. (Okay, I made that stat up, but you get the point.) Whether it's a photograph of a product, scene, or person, you'll need to figure out the best way to cut those images out of the Photoshop file and get them into your Flash ad. Most of the time, the choice of image format is extremely obvious. A few general rules of thumb that I like to follow are (1) if you will need to use transparency in the image, save it out as png-24, (2) if it's a photographic-type image and you do not need transparency, the best option is most likely jpg, and (3) if it's a drawing or line art of any kind, try the gif format. Whichever format you use, take care not to over compress when exporting from Photoshop. Save the images at a high enough quality that they are very clear and you don't see any pixilation or fuzziness, and let Flash do the compression when it has its turn with the images. Now, for just a moment, let's step back a few sentences to my rules of thumb on pngs and jpgs. According to Flash 8 best practices, the best bitmap format to import into Flash is png. However, the file size for a png image is typically larger than a jpg and one of your major goals is to fit your banner within a certain file size. I'll cover more on image compression later in Chapter 6.

Cut Away

On to the actual cutting of the images. Since you spent a little time planning out your ad, you should be well aware of which elements from your Photoshop file will be static, which ones will be animated, and which ones will be interactive. When cutting out the images that will animate, you want to crop the Photoshop file down to the size of the object you need, hide all of the layers you don't need, and export the image to the appropriate format. As you set the size to which you are going to crop, keep in mind that you should not cut exactly at the edge of the object you are cutting out. If at all possible, you should give yourself (and Flash) a bit of room all the way around the image. This is because of a rendering "feature" in the Flash Player that sometimes cuts off the edge of an image or shifts the image data over by a few pixels. I usually give about a three-pixel buffer and that works out pretty well.

As for the static elements, try to include as many of them as you can in one image that can be used as the background of your banner. A lot of times you can treat interactive elements the same as static elements and include them in your background image. For example, if you have a logo that will remain in the top left corner of the ad and that will link out to the client's home page, why make it its own

image? Unless there is another element that needs to animate behind that logo, include it as part of the static image and place an invisible button on top of it. Just in case you aren't sure what I mean by "invisible button," simply follow these steps to create one:

1. Draw a shape on the stage by using one of the shape drawing tools (**Figure 4.5**).

2. Once the shape is drawn, select it and press F8 to convert it to a Button symbol.

3. Give the Button symbol a name and press OK in the "Convert to Symbol" dialog box (**Figure 4.6**).

4. After you've created the button, double click it to edit it.

5. Move the shape from the "Up" frame to the "Hit" frame (**Figure 4.7**).

Figure 4.5

Draw a shape to the stage.

6. Go back to the main timeline of your movie and there you have your invisible button.

Once you have all of your images cut and saved to the cut_art folder, it's time to start importing them into Flash for animations and interactions based on the direction that was determined in the planning phase of your banner.

Figure 4.6
"Convert to Symbol" dialog box.

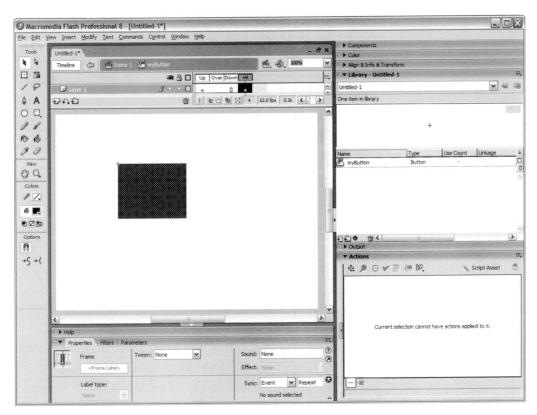

Figure 4.7
Move the shape to the "Hit" frame.

clickTags and Links

To know how your banners are performing after you have released them into the world, you'll need to track a couple of things. For instance, you'll need to know how many people have clicked them and what site those people were actually on when they did so. So how do you get this information? Whether your ads are hosted by the site on which they run or by a third-party ad serving company, such as Atlas or DoubleClick, you will use a tracking tag. That tracking tag will contain the actual URL you are attempting to drive users to as well as a string of seemingly random letters and numbers that are generated by the tracking application. Once users click your ad, they are directed to the destination URL while seamlessly passing information to the tracking application.

One or Many

Unless the site or ad serving company tells you differently, you will most likely be using the variable name "clickTag" to link out of your units. Check with your site or ad server on the actual name you should use if you will be linking to a single destination URL as some will ask that you add the number "1" to the end. For example, ad serving company A might ask you to use "clickTag1," whereas ad serving company B might ask you to use "clickTag" (without the "1"). When linking out to multiple URLs, most ad servers handle it the same way: clickTag1, clickTag2, clickTag3, etc.

Example 4.1 shows two typical onRelease functions that need to be tracked from within the same banner.

Example 4.1

```
myBtn1.onRelease = function(){

        getURL(_level0.clickTag1,"_blank");

}

myBtn2.onRelease = function(){

        getURL(_level0.clickTag2,"_blank");

}
```

Along with the clickTag is the target window. The majority of sites and ad serving companies will ask that you use "_blank" as the target window in your getURL(). There are a few, however, that require you to target "_self," while still others require a target of "_top." It is best to check with your site or ad server for individual specifications.

The Value of clickTag

Now that we have talked about linking out to a variable name, let's discuss how to get a value assigned to it. In most cases of running your units with an ad serving company, you won't need to worry too much about getting the value of your click-Tag variable inside the unit itself. This is because most of the ad serving companies have their own HTML templates that are already set up to pass the value in. However, you will still need to test your banner before it goes live. While there are many ways to pass a variable value into Flash, I'll just show a quick one here that uses JavaScript to assign the actual value to clickTag and then to append it as a query string on your swf. Keep in mind that I've left out a good amount of the code in **Example 4.2** so we could put more focus on the clickTags.

Example 4.2

```
<script language="javascript">

    ...

    var mySwf = "yourFlashFile.swf";

    var clickTag1 = "http://www.yoursite.com"; // main url

    var clickTag2 = "http://www.yoursite.com/your_product.html"; // product url

    ...

document.write('...

<embed src="' + mySwf + '?clickTag1=' + clickTag1 + '&clickTag2=' + clickTag2

...

'</embed>'

...

</script>
```

ALERT In the early part of 2006, the outcome of a patent dispute affected the way ActiveX content (such as Flash) is displayed in Internet Explorer. Because of that outcome, the code in **Example 4.2** will require a user to click the banner before being able to actually interact with it. At the time of this writing, almost all third-party ad serving companies had their solutions in place for this issue. I will, however, still cover a couple of solutions later in this chapter because you will need to use one of them for testing and quality control.

Script to Save Time

As you spend more and more time building ad units, you will begin to find commonalities between them. Some of these will pertain to different ads for a single client, while others will spread across clients. When you start to notice these reusable code snippets and assets, set them aside so you can pull from them when you need them in another project. After all, that wheel has already been invented, right? For example, a large amount of your banners will have a single destination and therefore will contain a single clickTag. In the typical case of having the entire banner clickable, why not utilize the drawing API to create an invisible button that covers the stage as in **Example 4.3**.

Example 4.3

```
var myBtn:MovieClip = this.createEmptyMovieClip("myBtn",this.getNextHighestDepth()
);

myBtn.beginFill(0x000000,0);

myBtn.moveTo(0,0);

myBtn.lineTo(Stage.width,0);

myBtn.lineTo(Stage.width,Stage.height);

myBtn.lineTo(0,Stage.height);

myBtn.lineTo(0,0);

myBtn.endFill();

myBtn.onRelease = function(){

    getURL(_level0.clickTag,"_blank");

}
```

Author's Tip

Note that the moveTo() on line 3 is optional in **Example 4.3**. This is because when you create a new MovieClip object, it is instantiated at an x and y of 0,0 as is the "pen" when you use the drawing API.

In **Example 4.3**, we've created a new MovieClip object, set the fill color to 0x000000 (black) and opacity to 0, followed the stage's width and height to draw out a box, and then applied the onRelease function. That's all there is to it. Now our banner is fully clickable and we can carry this snippet from unit to unit.

You could carry this a little further and create a class file as in **Example 4.4**.

Example 4.4

```
class BorderButton extends MovieClip{

    public function BorderButton(tag:String,clickable:Boolean,outline:
Boolean,lineColor:Number,lineThickness:Number){

        if(outline == undefined){

            outline = false;

        }

        if(lineColor == undefined){

            lineColor = 0x000000;

        }

        if(lineThickness == undefined){

            lineThickness = 1;

        }

        var bbMc:MovieClip = _level0.createEmptyMovieClip("bbMc",_level0.-
getNextHighestDepth());

        if(outline){

            bbMc.lineStyle(lineThickness,lineColor);

        }

        bbMc.beginFill(0x000000,0);

        bbMc.moveTo(lineThickness/2,lineThickness/2)

        bbMc.lineTo(Stage.width-(lineThickness/2),lineThickness/2);

        bbMc.lineTo(Stage.width-(lineThickness/2),Stage.height-(lineThickness/2));

        bbMc.lineTo(lineThickness/2,Stage.height-(lineThickness/2));

        bbMc.lineTo(lineThickness/2,lineThickness/2);

        bbMc.endFill();

        if(clickable){

            bbMc.onRelease = function(){

                getURL(tag,"_blank");

            }

        }

    }

}
```

Something to note in **Example 4.4** is in the moveTo() and lineTo() methods: Instead of drawing the border line from an x and y of 0,0 to the full stage width and height, we need to pull it back in by about half of the line thickness. This is due to the way Flash renders the border when it's all the way at the edge. Try changing those numbers up to draw the border all the way to each edge and see if you lose the bottom and right side of the border. **Table 4.1** outlines the BorderButton parameters.

Table 4.1

BorderButton Class Parameters

Parameter	Explanation
tag	The URL that users will be taken to when they click on the banner. The tag parameter should be passed in as a string.
clickable	A Boolean value that indicates whether or not the area is clickable. If set to true, the entire banner becomes clickable. If set to false, only the border is drawn.
outline (optional)	A Boolean value that indicates whether or not to draw a border around the banner. This parameter is set to false by default.
lineColor (optional)	A number value that determines the color of the border. The lineColor should be passed in the form of 0x000000. The default value of this parameter is 0x000000 (black).
lineThickness (optional)	The thickness of the border in pixels. The lineThickness should be passed in as a number and is set to 1 by default.

Now let's look at what's actually happening inside the class. The first thing we do is check the optional parameters to see if values have been passed for them. If not, we assign the default values. This takes place in lines 3–11. Next, we create an empty MovieClip in line 12. Then we check back to the outline parameter to determine whether or not we will draw the outline. If we find a value of true, we use the lineColor and lineThickness parameters to set the lineStyle() accordingly. After that, we begin the transparent fill and draw a rectangle (or square depending on the banner size) to the stage in lines 16–22. Finally, we check to see if our BorderButton is clickable. If it is, we set up the onRelease function to go to the intended URL. That's all there is to it. Now when you are ready to use the class, you simply type one of the lines from **Example 4.5** into your ActionScript window.

Example 4.5

```
//A BorderButton that is clickable and has an outline

var fullBtn:BorderButton = new BorderButton("http://www.flashadbook.com", true,
true, 0xff0000, 3);

//A BorderButton that only draws an outline on the banner

var fullBtn:BorderButton = new BorderButton("http://www.flashadbook.com", false,
true, 0xff0000, 3);

//A BorderButton that is clickable and does not draw an outline on the banner

var fullBtn:BorderButton = new BorderButton("http://www.flashadbook.com", true);
```

Forms

Another good example of a reusable asset is a form. Forms will be covered in more depth in Chapter 5, but for now let's assume we've already created one and let's simply call it "Our Form." Our Form was created to be used from within a banner that we've built for client X and its purpose is to search client X's inventory for a user's desired product. Once we have Our Form built and functioning properly, we should set it aside in its own fla, so that each time we need to use it in another banner we can just grab it, place it in a new banner, and resize it or move elements around as needed.

> **Author's Tip**
>
> In addition to reusable code, you should also keep an eye out for reusable graphics such as logos, products, backgrounds, etc.

Building to Standards

When someone uses the phrase "building to standards," I can't help but think of World Wide Web Consortium (http://www.w3.org) compliance and accessibility for users with visual or auditory disabilities. And while accessibility is very important in sites and microsites, it's not what I'll be talking about in this section on banners. Instead, I'll be discussing standardizing in the sense of code design, naming conventions, folder structures, etc. At some point, you will be sick or on vacation and a coworker will need to open your files to make some changes. Or maybe the coworker is out and you're the one who has to make the changes to their files. Wouldn't it be nice to open their code and, within a matter of seconds, know exactly what they were thinking as they wrote each line? Some local standards would fit perfectly into this little scene.

Naming Objects

How about if we start with object naming conventions. When naming your objects, you want to be descriptive so you will know exactly which object your ActionScript is communicating with and what kind of object it actually is. **Table 4.2** shows a few examples of object names.

Table 4.2

Naming Convention Examples

MovieClip containing form fields	myFormMc
Input TextField for user's email address	emailInputTxt
Button to submit form	formSubmitBtn
Sound object for background music	myMusicSnd

Along with naming your objects, you should set up folders in your library. My personal favorite library setup uses folders named by type, where the "MCs" folder contains MovieClips, the "bitmaps" folder contains imported images, the "graphics" folder contains graphic symbols, the "sounds" folder contains audio files, etc. You get the gist of it. Of course, all of these names are just suggestions, and, if you haven't already, try to set up a time to talk about these conventions with your co-workers to make sure you are all on the same page.

Code

Another standard to be agreed on is that of code design. A few questions to ask yourself and your coworkers when you are discussing code design are: Will you try to keep all of the code on the main timeline (rather than scripting directly on objects such as buttons)? How will functions, variables, etc. be named? If the situation gives you the option, do you use setInterval or onEnterFrame? There are, of course, other similar questions that will arise when you start to talk about this subject, and you probably shouldn't expect to get every possible naming and/or coding convention hammered out in one sitting. However, the quicker the conventions can be agreed on, the quicker everyone will be creating files and writing code that is easy for the rest of the team to understand and work with.

File Names

One more thing that should be consistent throughout your projects is the naming of your files. Your file names should be descriptive and easy to understand at a glance because you may need to revisit one of them later. An example of this would be if a particular ad performed very well and your client wanted to use the

same creative, but to change the message within it. There are many naming conventions you could choose to go with, but I would like to recommend one here. If you refer back to the section "Setting Up Your File," you'll notice we named that file 300x250_30_my_ad.fla. This is a pretty self-explanatory name because it contains all of the information you need and each part of that information is separated by an underscore. The first part of the name is obviously the size of the banner (300 × 250). After that is the maximum file size, in kilobytes, allowed for this particular ad (30). Next in line we used the word "my"; this is where you would place either an abbreviation or the full name of the client for which the banner is being built. Finally, at the end of the file name, you'll want to use another abbreviation to describe the creative being used. For example, if the creative is that of water being poured into a glass, use the word "pour." Another good standard to practice is limiting your file names to a certain number of characters (including the file extension); somewhere around 30 is usually a good number to go with.

Bandwidth Profiler

While Flash's Bandwidth Profiler can be more helpful in the development of microsites, it can also be invaluable when you are creating banners. The most useful part of the Bandwidth Profiler during banner development is going to the left side, which contains all of the information about the banner (**Figures 4.8** and **4.9**).

Figure 4.8
Opening Flash's Bandwidth Profiler.

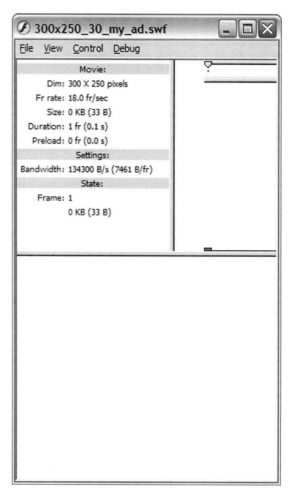

Figure 4.9
Flash's Bandwidth Profiler.

What You See

A quick rundown on the left side of the Bandwidth Profiler (see **Figure 4.9**) gives us the following information under the "Movie" heading: "Dim" signifies the dimensions of your stage; "Fr rate" shows the frames per second at which the banner will play; "Size" is one of the more important ones here because it shows the file size of your published banner; "Duration" lets you know how many frames long your banner's main timeline is and then goes on to do the math and show you the actual number of seconds it will take for your banner's main timeline to get to the end (this is very useful when you are dealing with time constraints in your specs); and finally, "Pre-load" will tell you how long it will take your banner to download to a user's computer.

4. Preparing and Building Ads

Next is the "Settings" header, which has only one item under it—"Bandwidth." This is where you see the bandwidth that the Flash movie is being tested against. You can change this setting by choosing one of the options in Download Settings under the View menu of your tested movie (**Figure 4.10**).

Figure 4.10
Select on option to change the bandwidth setting.

The last section of information you see on the left side of the Bandwidth Profiler is "State." Like the Settings heading, the State heading only contains a single item—"Frame"—which shows both the current frame of the movie that the Flash playhead is on at any given time and the amount that particular frame is contributing to the overall file size of the banner.

HTML/JavaScript

Before the legal dispute I mentioned in the "click-Tags and Links" section, we could create our banners and write the containing HTML using the old object and embed tags. However, times change and so has the way we have to present our files in the browser. These days we need to get rid of those tags and use JavaScript in their place. So how do you embed a Flash file in a page without using the object and/or embed tag? The best place I would say to start is with SWFObject by Geoff Stearns or the Unobtrusive Flash Object (UFO) by Bobby van der Sluis. In a nutshell, both of them are external JavaScript files that you reference from your HTML. The JavaScript file then writes the code back to your HTML file and displays the Flash file. Another nice perk to this is that you can build what I've heard Geoff Stearns call "the site behind the site." This is because when using either of the options, you start by creating a block element, such as a div, in which you place HTML content. When your Flash file is written to the page, it actually replaces this content. However, if a user doesn't have Flash, he or she will still see the content in the div. This works out perfectly, because you will be prepared for that user with the default image we'll talk about later in this chapter. In addition to being able to show a default image for banners, you can also use it to make your sites more readily available to search engines. But let's wait until Chapter 10, "Preparing and Building Microsites," to get into that. For now, let's take a little deeper look at SWFObject and UFO.

SWFObject

Geoff Stearns' SWFObject can be found and downloaded from his blog at http://blog.deconcept.com/swfobject/. It's a nice, simple way to not only embed your Flash content into the page, but have plenty of control over it as well. When you download SWFObject, you'll find the swfobject.js file, which you will include in your HTML. The following example from Stearns' blog shows the minimum amount of code needed to use the SWFObject.

Example 4.6

```
<script type="text/javascript" src="swfobject.js"></script>

<div id="flashcontent">

  This text is replaced by the Flash movie.

</div>

<script type="text/javascript">

  var so = new SWFObject("movie.swf", "mymovie", "200", "100", "7", "#336699");

  so.write("flashcontent");

</script>
```

Since the full breakdown of what the code is doing is also available on his blog, I'll only cover a few things here. Let's jump right to making the call to create a new SWFObject and the six required parameters. First is the swf parameter ("movie.swf" in **Example 4.6**). This is where you'll place the name of and path to your swf file. Next up is the ID parameter ("mymovie" in **Example 4.6**), which is the ID of your <object> or <embed> tag. After the ID are the width and height parameters ("200" and "100," respectively) and the version parameter. The version parameter is where you declare the required player version for your content. It must be a string and can either be passed as just the majorVersion ("7" in **Example 4.6**) or in the format of majorVersion.minorVersion.revision such as "6.0.65." Last we see the background color parameter that controls just what you would guess from its name. The background color should be a hex value like "#336699" in **Example 4.6**. In addition to the required parameters, there are also some optional parameters such as quality and redirectURL. You can find the full list of these parameters and more information about SWFObject at Stearns' blog.

Unobtrusive Flash Object

Bobby van der Sluis' Unobtrusive Flash Object (UFO) can be downloaded at http://www.bobbyvandersluis.com/ufo/. As with SWFObject, you'll have a great amount of control over your content when you use UFO. Again, UFO is using JavaScript to write your Flash movie to the page. Let's take a look at the example from van der Sluis' site.

Example 4.7

```
<!DOCTYPE html PUBLIC "-//W3C//DTD XHTML 1.0 Strict//EN" "http://www.w3.org/TR/
xhtml1/DTD/xhtml1-strict.dtd">

<html xmlns="http://www.w3.org/1999/xhtml" lang="en" xml:lang="en">

    <head>

        <script type="text/javascript" src="ufo.js"></script>

        <script type="text/javascript">

            var FO = { movie:"swf/myMovie.swf", width:"300", height:"120",
majorversion:"6", build:"40" };

            UFO.create(FO, "ufoDemo");

        </script>

    </head>

    <body>

        <div id="ufoDemo">

            <p>Replacement content</p>

        </div>

    </body>

</html>
```

As you can see, there are slight differences between SWFObject and UFO. However, you still need to pass in parameters. How about a quick look at the essentials?

The movie parameter is the path and name of your swf file. The width and height parameters are ... you guessed it, the width and height. The majorversion parameter is the major version of the Flash player needed to view your work, and the build parameter is the build number of that major version. UFO also has a good list of optional parameters to give you even further control and you can find that list at van der Sluis' site.

When you have a couple of minutes, I suggest visiting both Stearns' and van der Sluis' sites to get more detailed information on their work. Read up on them and figure out which one of them will best suit your needs and work best for your particular project. You may even find that you'll want to use one of them for certain projects and the other one for different projects.

Default Images

Now, I know this is going to sound really crazy, but what if an end user doesn't have Flash installed? Or what if he or she doesn't have JavaScript turned on? Sure, you could just say it's his or her loss, but it's really your client's loss (and thereby your loss). In the interest of driving all possible users to your client and to keep your client happy with you, let's serve up a default image in place of the Flash banner to these unfortunate few people. Basically your default gif or jpg is either a still frame or animation (gif) that can get the same branding and messaging across that your Flash file does. While designing and saving your default images for the Web, keep file size in mind because the sites that will be showing them generally give you less than they do for your Flash files.

Quality Control

Once you have built your ads, it is best to have someone other than yourself test them. This is simply because you are too close to the project and you know exactly what to do and when to do it. Quality control's job is not only to make sure your work is within the specs it should be, but also to basically try to break your work by doing nearly anything it takes to do so. While in this step of the process, your ads should be hammered as if an end user wants to prove that he or she can render your ad useless (yes, there are people out there that will do it just to show someone else that they can). In addition, your ads should be tested on different operating systems, in different browsers, with different versions of the Flash player, with and without the Flash player and/or JavaScript, and pretty much anything else that may cause them to either perform in an unexpected manor or not perform at all. The end goal of all of this is obviously to make sure that your ad shows, plays, and is as interactive as it should be. As I mentioned in Chapter 2, you should expect to receive fixes and revisions from your quality control person. You'll also remember from that chapter that I talked about doing the best you can to test and catch bugs even before your work is sent to them in order to make everyone's job just a little easier.

Sign-off Sheet

Because it can be a little frustrating for several people if there are changes to be made after the work has been tested for bugs, fixed, and is ready to ship out, you'll want to complete another quick task before sending it to quality control: a sign-off sheet. The sign-off sheet should contain a checklist with items that are common to all banners that you create. Some of those items might be that the final swf is within the maximum file size, that the width and height of the final swf match the specs, that you have a backup image for users without the Flash player, and that the banner matches the original creative layout. Of course there should be several other items on the list, but you get the idea. Once you have checked that all of the items in the list are complete, you'll need to get the sign-off sheet from the creative person and the person in charge of the client account. By getting these sign-off sheets, you're minimizing the chance of things like creative changes after the banners have already been tested.

Inside the Industry

 A good tool to use for quality control is some kind of issue tracking software. One of those is OnTime Defect and Feature Management System by axosoft and you can find it at http://www.axosoft.com.

Prioritize

I have found that when I do receive my changes, it is best to read through them before jumping right into making them. By doing this, not only can you prioritize, but you can determine which changes may affect other changes. As I'm sure you're well aware, making changes to one piece of code can cause other codes to react in unanticipated ways. On the other hand, fixing one problem can also sometimes cascade into correcting other errors at the same time. When it comes to prioritizing the changes, there are some things to consider. If the ad is acting differently in a very, very minor way in a very particular version of a particular browser on a particular operating system, the change that's causing that issue may be put lower on the list. On the other hand, if the ad opens up and doesn't play or link out to anywhere, that one needs to go closer to the top. Now, to take it a step further, prioritize by how long each task will take you to complete or by how involved it is. To be perfectly honest, I switch this one around depending on how I'm feeling on a given day. What

I mean by that is that sometimes I do the tasks that are more involved and take longer first and sometimes I knock out the quick ones first. It's really a personal preference and you should figure out which way of prioritizing works best for you today and then again tomorrow and again the day after that.

Check Again

So now that you've corrected all of the issues that were reported to you, it's time to start the quality control process again. The difference in this round is that the testing will be mainly focused on the bugs that you fixed before. If any more problems are found at this time, you'll need to do another round through quality control and continue to do so until your banner is virtually unbreakable. Once it has proven itself worthy, it's ready for the big show—the Internet.

Conclusion

So what did we cover in this chapter? Well, I started it off with planning. With a good plan, your work can move much faster than it would without one. Think of how you want to build your ads before you actually start building them. In your head, picture how you are going to get from a blank white stage to an interactive work of art in a banner. From there I talked about setting up your file and we started a new file for a 300 × 250 Flash banner ad. After that, I talked about cutting images to work in just such a file. In the next section I went on to explain how to link out of an ad with clickTags. While you can still hard code your URLs directly in to your movies, click-Tags are the industry standard for clicking on links that you want to track. Another topic that I talked about was scripting to save time. This basically means using any class files or code snippets over and over again as opposed to rewriting them every time. Next up, I talked about standardizing your naming and coding conventions within your team or organization. Local standards can dramatically improve production time and make your work easier for you and others to decipher at a later date. I also talked about HTML and JavaScript for your ads. I introduced (or reintroduced) you to Geoff Stearns' SWFObject and Bobby van der Sluis' Unobtrusive Flash Object or UFO. After the HTML and JavaScript came a little information about default images, and we wrapped it all up by sending our ads through a round of quality control.

If you remember back in the "Script to Save Time" section, I briefly mentioned forms in your banners. In Chapter 5 I'll be going more in depth on setting them up, using them, and what they mean for your ads.

Forms and Data in Ads

In some ads, you'll need to gather information from your users to improve their experience. You may want to give them the opportunity to select options on a new car as in the XYZ Motors example earlier in the book or you may want to let them fill out information for something else altogether. A good example of an ad to use a form in might also be one for a travel company. Again, for the sake of an example, let's choose a fictional name for our travel company—how about TravCo.

TravCo comes to you and says they want to let people know about discount prices for flights and hotels that people need to reserve for the upcoming holidays. You or your creative team sit down, design some layouts, and show them to your new client. After choosing one of the designs, TravCo lets you know that they would like to include a form to let users choose the city they are leaving from, city they are traveling to, their departure date, and their return date (the length of stay in the hotel can be determined from those dates). Once the information is filled in, users can press a submit button to not only go to TravCo's site but be taken to a specific page showing the results of the information they entered in the form.

So what did users experience in this? Well, let's assume they were reading an article about upcoming holiday events in the city they plan on visiting. While reading, they came across your TravCo banner and decided to go ahead and fill out the form to see what kind of prices TravCo had to offer. Since they were taken directly to a results page upon submitting their data, they can choose the flight and hotel they like and book them right away. There's no need to search around the TravCo site to find what they are looking for because you seamlessly took them directly where

you knew they wanted to go. So now let's go back behind the scenes again and talk about what it took to get them there by going through the following sections:

- Where Are You Going?
- File Size Consumption
- Collecting and Passing Data

Where Are You Going?

The biggest piece of information you'll need when using forms in your banner ads is exactly where you need to send your users. In some cases, you'll send them to a page where the information from the form only partially completes all of the information needed for results. Our XYZ Motors example would be a good example of this because there usually isn't enough room in a banner to include a form that would ask for all of the information needed about selecting a new car. There's trim packages, engine sizes, custom wheels, leather or cloth interior, etc. So you use a couple of options such as the trim package and paint color and then leave the rest for users to fill out on the site. While this way doesn't instantly return the results a user was looking for on a new car, it does get him or her one step closer to that end goal. On the other hand, our travel company, TravCo, only needs to know the dates and cities that a user will travel to and from. With only four pieces of information to gather, this can easily fit within our banner size and the user can be taken to a page with full results.

Required Variables

You can probably guess that knowing where you need to send your users is really only a part of the information you need to complete your task. You'll also need to know name and value pairs for the form you're asking them to complete. You can get this information in a couple of ways: You can ask your client to get it for you or you can get it directly from the forms on their site (assuming you can view the source of their forms). I often choose the latter of those two options simply for the sake of speed and efficiency. The reason I say speed and efficiency is because your contact at your client's offices is not very often one of the people who wrote the code on their site. Knowing that, you may have to ask your contact for the information and expect some delay. The delay is simply because your contact may need to get your requested information from their site developers before they can relay it

back to you. Depending on how large of a company your client is, it could possibly be a day or more before you get your answer. So let's go back to the quicker option of viewing the source of the forms on their site. Just in case you are unfamiliar with viewing the source of a website, follow these steps:

1. Open your web browser and navigate to the website from which you need information.

2. Right-click (opt + click on a Mac) and choose the option in the menu to view the source of the page. In Firefox, the menu option is "View Page Source," and in IE it's "View Source."

3. Search for a word or phrase that you know is next to a field in the form from which you want to gather information.

4. Once you find the form in the code, you'll see the name/value pairs you need.

Now that you have the name/value pairs, you can build out your form and test it to make sure it works. "But Jason," you say, "when I build the forms into my banners, my file size goes way up and I have to crunch the quality of my images so much that the client will never approve them!" Ah yes, the file size consumption of Flash components.

File Size Consumption

A key factor to keep in mind from the very beginning of a banner that will contain a form is the amount of file size that is taken up by the Flash components you may need to use. Don't get me wrong, I love the built-in Flash components. I just wish they were less of a strain on file size. And don't include textFields in my little warning here because they take up virtually no file size at all (and also because they aren't actually components). The main one you'll need to be concerned with while working on banners is the comboBox (a.k.a. the dropdown menu) component.

Author's Tip

If you have a form that requires users to type in their information, use a textField set to input text rather than a textInput component. The file size consumption for the textInput component is around 25k, whereas the file size consumption of a textField is much lower at around 118 bytes (**Figure 5.1**).

Figure 5.1

A dynamic textField (*left*) uses less file size than a textInput component (*right*).

The Bulk Is Up Front

When using the comboBox component, you'll need to plan on it using about 15k. That's if you're using the Flash 6 or 7 components. If you're using the Flash 8 components you can expect more than double that size at about 55k (**Figure 5.2**). So if 15k is already taken out of the 30k you're allowed in your specs, what happens when you need more than one comboBox? This is where you can relax at least a little and know that the initial hit was the hardest because each additional comboBox after the first one adds a minuscule amount of file size.

The reason for all of the bulk up front is due to the fact that components inherit from each other. In other words, when you put that first comboBox in your file, it also has to pull in the framework for the comboBox component (as well as the

scrollbar and buttons used within). However, when you add the second comboBox, the framework is already in the file. Since the amount of added file size by the subsequent comboBoxes is so small, it would be safe to say that one comboBox is equal to three comboBoxes and that's also equal to five comboBoxes as far as that file size is concerned.

Figure 5.2
A Flash 6 comboBox (*left*) uses less file size than a Flash 8 comboBox (*right*).

So now that you know how much of your file size is going to be used up by components, you'll quickly realize that you don't have much left to use toward the creative. This leads me back to the design process of the banner; if you know there are going to be dropdown menus in the ad, don't plan too much animation involving the raster images of the layout. One way to combat this issue is to build your banners

to be served by a rich-media company such as those I talk about in Chapter 7. Since running your ads from these companies gives you more file size and the option of loading child movies, you obviously won't have to worry as much about going over the size listed in your specs. On the other hand, you may not have the option of using a rich-media company. In that case there's the option of building your own custom comboBox component.

Custom Components

As I mentioned earlier, a Flash component brings its framework into your file when you place it on the stage and that increases your file size by a relatively large amount. If you are able to take the time to build your own component, you can save a large amount of that file size and you'll be able to customize and reuse it elsewhere.

 ALERT Component creation is a large enough subject that an entire book could be (and has been) written on that subject alone, so I won't go into the actual process myself.

The amount of time it takes you to create your own custom component will depend on the component itself. Some may take under an hour to build and others may take days to perfect. The good news is that, if built correctly, you won't have to go back to rebuild it when you need it on another future project. Instead, you would be able to simply place your component on the stage, assign values to its parameters (if it requires any), and move on with your work. Much like a built-in Flash component is heavy with the first use and less thereafter, the bulk of the amount of time involved in creating and using a custom component is up front as well.

Collecting and Passing Data

Now that you have your form put together and you know where it's taking users, you need to pass their input to the target location. The details of how you collect the information might vary from form to form, but how you pass it will generally remain the same in most cases. The vast majority of the time you won't be storing the information directly from the banner itself, but it may be captured and stored once it reaches the destination site. On the other hand, the information may only be used to display the correct page or data once a user has made it to the destination.

LoadVars() and send() the Data

Once a user has filled out the form and hit the submit button, you'll need to do some quick processing behind the scenes to get the information packaged up and sent over to the correct destination. Granted, you could create a string that is made of the destination URL plus the concatenated values of the textFields (and you may actually *have to* in some cases). This is where I personally think the wonderful Load-Vars() object comes in very handy and more specifically, it's send() method.

The LoadVars() object is used to pass variables between Flash and a server. It's basically an object for storing variable name/value pairs to send to a URL. It can also be used to receive variables from a URL, but that isn't our goal in this case. In a banner, you'll want to use the send() method to—you guessed it—*send* the variables to a processing page or other destination URL. In **Example 5.1**, you can see a simple function that uses the LoadVars.send() method to pass the information gathered in a form containing a few textFields. This function assumes your form has textFields named firstNameTxt, lastNameTxt, and zipCodeTxt.

Example 5.1

```
function sendForm(){

        var sfLv:LoadVars = new LoadVars();

        sfLv.userFirst = firstNameTxt.text;

        sfLv.userLast = lastNameTxt.text;

        sfLv.userZip = zipCodeTxt.text;

        sfLv.send("http://www.flashadbook.com/loadVarsSend.php","_self","POST")

}
```

In this example function, the first thing we do is create a variable named "sfLv," which stands for sendFormLoadVars, and make it a new LoadVars() object:

```
var sfLv:LoadVars = new LoadVars();
```

Next, we give sfLv some variable names (remember that these variable names *must* match the corresponding variable name on the destination URL) to store the information, and, at the same time, we actually assign the values to those variables using the text from the textFields in the form:

```
sfLv.userFirst = firstNameTxt.text;

sfLv.userLast = lastNameTxt.text;

sfLv.userZip = zipCodeTxt.text;
```

Now that we have the variables packed up and organized all nice and neat, it's time to send a user and his or her package of variables on over to his or her destination. The parameters for the LoadVars.send() method are (in this order): the destination URL, the target window or frame (if no value is given, "_self" is used), and the optional HTTP protocol method to use with your variables (the default is "GET").

```
sfLv.send("http://www.flashadbook.com/loadVarsSend.php","_self","POST")
```

The destination URL used in this example has been set up to receive the variables used in this example. If you would like to test this function, you can either set up your own Flash file that uses it (leave the variable names and destination URL as they are), or you can go to http://www.flashadbook.com/loadVarsSendForm.php to see my working version.

Conclusion

When you're working in advertising, your end goal is to get users to do something. You want them to complete some sort of task and exactly what that task is depends completely on the client and the product or service being advertised. If you work on enough online advertising projects (and it doesn't take many), you'll inevitably be involved with one that is asking users to complete the task of filling out a form of some kind.

Whether you're asking users to fill out a form with information pertaining to the color, trim level, and engine size of your client's new car or you're asking them to fill in the dates that they would like to book a flight and hotel for their vacation, you'll need to know where to send that information. On top of that, you'll need to know what variable names and possible values the processing page will expect when users are sent to it. There are many ways to get this information including asking your client for it or even visiting and viewing the source of their version of the same form on their website.

Something to keep in mind when you're building banners with forms in them is file size. If your forms contain a comboBox component, you can plan on it eating up most of your permitted file size if not all of it. In order to avoid this issue, you can either run your ads as rich-media banners or do a little research into building custom components.

After your form is all laid out and ready to program, you'll want to use the send() method of the LoadVars() object. As I said in the "LoadVars() and send() the Data" section, this organizes all of your variables into a nice little package. Once your variables are all packed up like a suitcase, you can send users on their trip to the destination website. Once there, they'll unpack all of the variables and receive the information they were after when they started filling out your form.

CHAPTER 6

File Optimization

Whether you're building banner ads or microsites, it's always good practice to do your best to keep your file sizes as low as you can while still achieving your design and animation goals. While microsites are going to be bigger than banners, you don't want them to be too big, because you may risk the loss of potential viewers. Those potential viewers are, in turn, potential customers for your client. Banners need to be kept down in file size for a different reason: specs. When you go over the file size allowed in the banner's specs, your banner will most likely get rejected by the site(s) on which it is running.

Enter file optimization. Optimizing your Flash files can consist of anything from changing the compression settings on your images to slimming down your code or using vector drawing instead of imported images. There are several ways to reduce your file size and knowing some of them cannot only help your sanity, but it can also help you create your banners or microsites without the need to remove any features or images.

There are generally two major areas in which you can optimize your files: graphics and code. Within those two areas, there are smaller areas of discussion that I've split into the following sections:

- Image Types
- Image Compression
- Vectors and Fonts
- Optimizing Code

Image Types

Different images call for different formats. If you have a picture of a person, you'll want to use a jpg (you could also use a png, but the jpg's file size is most likely going to be smaller). If you have a line drawing, you'll want to use a gif. You'll probably want to save the png for an image that contains any transparency.

jpg

As mentioned previously, jpg files are best used for photographs or images with smooth variations of tone and color. They use what is called "lossy" data compression method, which basically means that the data are compressed in such a way that they are actually different from the original data but still close enough to be used. As the compression levels rise, the resulting file size lowers. However, with that higher compression and lower file size you start to see image artifacts that give less quality to the pictures. **Figures 6.1** through **6.4** illustrate the same image with four different quality settings: 100%, 80%, 60%, and 1% (higher quality setting = lower compression).

Author's Tip

Both gif and png formats support transparency. However, gif files will give you a single pixel border (usually white) that appears as an outline around the opaque area of the image. In addition to the absence of the pixel border, png files usually have better image quality than gif files. The cost of that better image quality is, of course, file size.

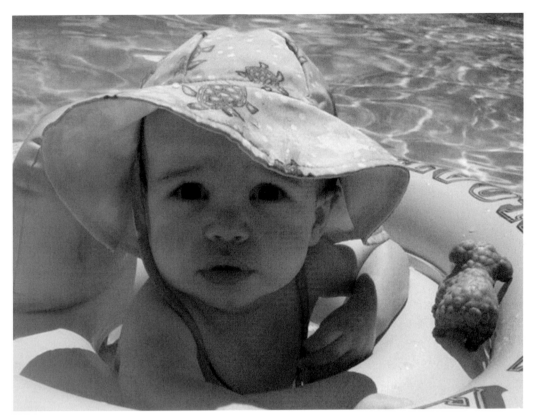

Figure 6.1
Image quality: 100%; file size: 224k.

The image in **Figure 6.1** has a quality setting of 100% and is hard to distinguish from the original photograph even though the original would normally take up to six times more file size. If you are using Photoshop's "Save for Web" function, you'll notice that 100% is also called "Maximum" quality under the jpg settings.

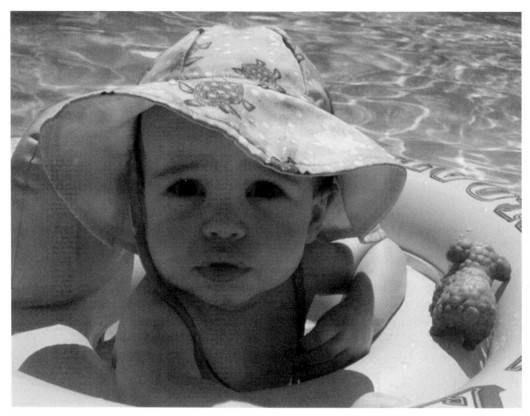

Figure 6.2
Image quality: 80%; file size: 104k.

With a quality setting of 80%, **Figure 6.2** is around ten times smaller than the un-compressed original image. At 80%, the image still looks great, but we can still go lower for the Web. Photoshop's "Save for Web" function labels 80% as "Very High" quality.

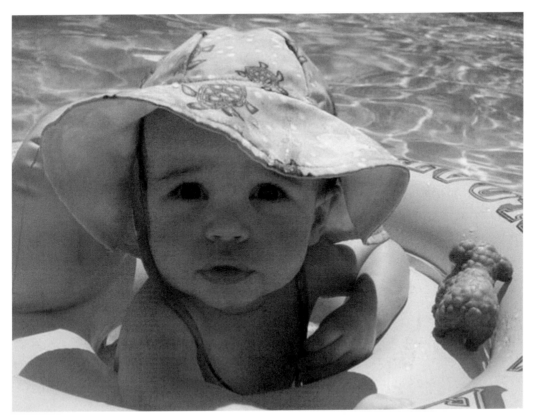

Figure 6.3
Image quality: 60%; file size: 59.2k.

Figure 6.3 shows the quality that you'll most likely want to use for your Flash projects (or almost any project on the Web). This is because at 60% quality, the image artifacts that start to appear because of compression are extremely small and mostly unnoticeable at the 72 dots per inch (dpi) that computer monitors display. The final file size of a jpg saved at 60% quality is typically going to be 20 times smaller than the original image. In Photoshop's "Save for Web" function, 60% is also called "High" quality and can be found as a preset.

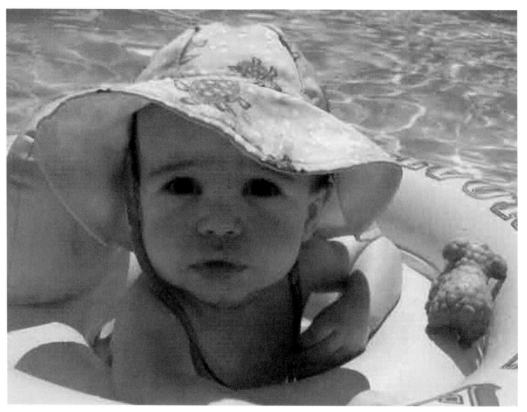

Figure 6.4
Image quality: 1%; file size: 12.9k.

Author's Tip

Image artifacts are basically blocks of color that become larger and more visible as the compression rate of an image gets higher.

The only real use for including **Figure 6.4** at 1% quality is to illustrate what is happening at a much more refined level in the previous figures. With the quality set this low, you can really notice the image artifacts. With such a poor visual quality, you should never use an image compressed by this much.

gif

Due to the cost of graphics cards to render more than 256 colors at the time the gif format was first introduced, gif files themselves are limited to a palette of 256 colors. Because of this limitation, gifs are most useful for graphics with relatively less colors than you would find in a photographic style image; graphics such as diagrams or cartoon-style drawings. Gifs use a different compression method that is called "lossless." Lossless data compression differs from lossy data compression in that it allows the exact original data to be re-constructed from the compressed data. This exact reconstruction is very important when image details must be seen clearly.

Unlike jpgs, gifs support image transparency. As mentioned earlier, however, you'll notice that when you create a gif with transparent areas, you'll get a single pixel of solid color (usually white) around the nontransparent area. This works fine if the back-ground of your animation is the same solid color, but not so well if your background is multicolored or gradient. See **Figures 6.5** and **6.6** for examples of the same gif on different backgrounds.

Author's Tip

It should be noted that gifs sup-port frame-based animations and that these gif animations may be used for your non-Flash backup image. Since you'll be animating within Flash, how-ever, the subject of animated gifs is probably better suited for another book.

Figure 6.5
A gif with transparency on solid white background.

Figure 6.6
A gif with transparency on a gradient background.

png

The png format was specifically created to replace the gif format. While the file size of a png graphic may be larger than that of a gif, keep in mind that pngs support true-color imaging. Like gifs, png files use lossless data compression and support transparency. Unlike gifs, pngs don't include a pixel border around the nontransparent area of your images. Because of the true-color imaging and better alpha transparency, pngs are ideal when you have photographic-style images that need to animate across a multicolor or gradient background. **Figure 6.7** illustrates the same image from **Figures 6.5** and **6.6** on the same background. However, the image on the left is a gif and the image on the right is a png. Note the lack of a pixel border around the nontransparent areas of the png.

Figure 6.7
A gif (*left*) and a png (*right*) on the same background.

Image Compression

When it comes to optimizing images for use in Flash, I've heard advice stating that compressing your images before importing them is better and that letting Flash do the compressing is better. I'd like to offer the following "middle of the road" advice: Compress a little before importing and let Flash do the rest. By that, I mean you should save your images at a high-quality compression setting and then adjust as needed within Flash.

High-quality Images

Because you are most likely creating work to be viewed on a computer monitor, you don't need to worry about your images having high resolutions as you would for another medium such as print. The fact that computer monitors show everything at 72 dpi also helps with your file size. One mistake I've seen made by various people is to save an image from Photoshop with the "Save As" command as opposed to using the "Save for Web" option in Photoshop's File menu (**Figure 6.8**). The reason I consider this a mistake is due to file/image control and resulting file size. While the difference in the resulting file sizes may not be huge in some cases, there is still a difference that could end up pushing your work just over the constraints set by your

project specs. The "Save for Web" option is a very easy process that I've outlined in the following steps:

1. With your image already open in Photoshop, choose "Save for Web" from the File menu (or press Alt + Shift + Ctrl + S) (**Figure 6.8**).

Figure 6.8
The Photoshop File menu.

2. In the resulting window, choose "JPEG High" (or any other available choice) from the Presets menu on the right and press the Save button above the menu (**Figure 6.9**).

Figure 6.9
The Presets menu in the "Save for Web" window.

3. When the "Save Optimized As" window opens, navigate to the correct folder where your image will live and name your file accordingly (**Figure 6.10**).

4. Use your saved image in your banner or microsite.

Figure 6.10
The "Save Optimized As" window.

Manage Compression in Flash

Once your images are saved, it's time to bring them into Flash and fine tune some compression settings. In some cases, you'll only have a couple of images and a large file size to work within. So, before you do any compressing, build and test your Flash movie to make sure you absolutely need to tweak the settings. If you find that you

need to lower the file size of the resulting swf, it's time to start modifying some compression settings.

It's tempting for some to use the JPEG quality slider in the Publish Settings dialog box (**Figure 6.11**), but this will result in changing the compression for every image in your file. One reason to avoid this is because sometimes you can get away with applying a lot of compression to something like a blurry background image, but not on the picture of the main item of focus within your movie.

Author's Tip

If the images you'll be using are going to be "pulled in" as external files, you'll want to manage their compression from your image manipulation software such as Photoshop.

Figure 6.11
The JPEG quality slider in the Publish Settings dialog box.

If you need to lower your file size, you'll want to optimize each image on an individual basis by adjusting the bitmap properties of the images in your library. The following steps and **Figures 6.12** through **6.15** explain the process with the assumption that you already have a Flash file open that contains images in the library.

1. With your Flash file open, choose "Library" from the Window menu (or press Ctrl + L) (**Figure 6.12**).

Figure 6.12
The Flash Window menu.

2. In the Library window, right-click on the image for which you'd like to alter the compression settings and choose "Properties" from the menu (or double-click on the bitmap icon to the left of the image name) (**Figure 6.13**).

Figure 6.13
The right-click menu for a Library item.

3. In the resulting Bitmap Properties window, make sure the "Compression" dropdown menu is set to "Photo (JPEG)" and that the "Use imported JPEG data" checkbox is *not* selected (**Figure 6.14**).

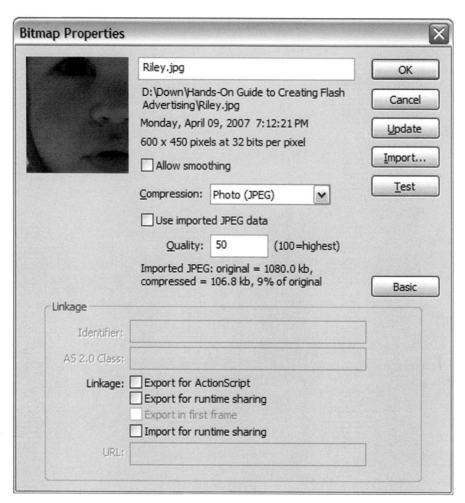

Figure 6.14
The Bitmap Properties window.

4. Change the number in the "Quality" input box and press the "Test" button to see the original file size and the compressed file size of your image (**Figure 6.15**).

5. Once you're happy with the compressed size, press OK and your image is ready to go.

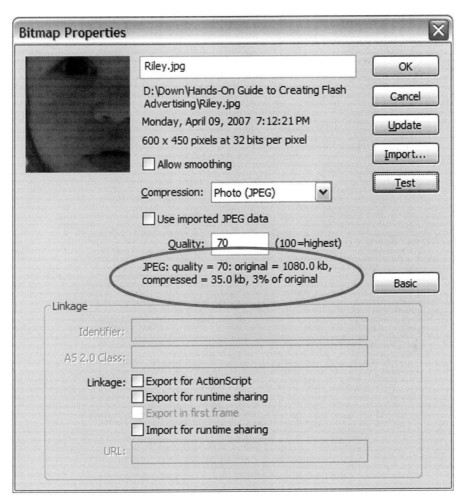

Figure 6.15
Original and compressed file sizes of the modified image.

Vectors and Fonts

There are times when a simple image can be recreated as a vector graphic instead of using a raster (bitmap) graphic. Due to processor usage, the simplicity of the image itself should play a key role in your decision to use vector or raster. Keep an eye out for images that can be redrawn with a small number of lines as well as flat colors instead of gradients. If you find that you have come across one of these images in your work, take the time to redraw it as a vector graphic, and you'll generally save some file size, because the vector image is made up of calculations that are drawn to the screen rather than a large number of static, colored pixels.

Scaling and Zooming

When used correctly, vector graphics will not only lower your file size, but, unlike raster images, they offer the ability to be indefinitely scaled up or zoomed in on without any loss in quality. For example, if you scaled a jpg of a plain red circle with a black outline to 500%, you would find that the curve of the circle is not actually a smooth curve at all, but a series of pixels whose square shape creates a jagged edge. On the other hand, the same red circle created as a vector graphic proves to have nice smooth curves no matter how much you increase its scale. In **Figure 6.16**, I've created a drawing of the red circle and saved it as both a raster and a vector graphic. I then zoomed in on the same area of each to show the results. The smoother vector graphic is on the left while the raster image is on the right.

Vector Considerations

While using vector graphics correctly can save file size and increase the scalability of the image, there are some things to keep in mind such as the number of colors, the use of gradients, and the complexity of the graphic as a whole. If your artwork starts to get too complicated and has lines numbering in the high hundreds, or even reaches above one thousand, you may want to reconsider using a raster image instead. While the vector recreation may be prettier and you may be able to zoom in on it much closer, you have to remember that the Flash Player on the end user's computer will have to recalculate every line contained within your drawing every time that drawing moves even a single pixel. On its own, a very complicated vector line drawing can end up slowing the frame rate of your movie to a mere crawl. When you start adding other factors like user interaction, other animations happening at the same time, and functions running their code when they're called, you can imagine the potential consequences.

Figure 6.16
Vector versus raster zooming and scaling.

The colors you use in your vector art should be just as much of a consideration as the complexity of the lines. As you might imagine, gradients are more complicated than solids and they contain a good deal more data for the Flash Player to process. Obviously gradients can't be avoided 100% of the time, but you should try to limit how often you use them and how many you have on the screen at any given time (especially if they will be animated).

Text and Fonts

Something else to consider in the optimization of your work is text and fonts. I'm including them in this chapter because they can sometimes bloat your file size by great amounts without you even realizing it's happening. They can also be treated in the wrong way and end up looking like a big blurry, unreadable mess. When you're working with a specific font that is used by your client, don't embed the entire font if the text is going to be static. Instead, embed only the letters, numbers, and

punctuation that will actually be used. Another option for static areas of text is to use an image. It might sound a little anti-productive in the sense of optimization, but if you only have one or two words in a particular font, sometimes an image produces a smaller file size than embedding any of the font at all.

Optimizing Code

Optimizing your code can be just as important as optimizing your images in terms of both file size and processor usage. As with most steps in your projects, it is always best to keep code optimization in mind from the very start before you have written a single line. However, we all know that there are times when we just need to make it work as quickly as we can, no matter what it takes. The trick to those hurried times is to remember that we need to set time aside that we can use later to go back and optimize, or "clean up," our code. In the rest of this section I'll be passing on a few suggestions that have either been passed on to me or that I have found in my own projects over time.

Don't Repeat Yourself

I often find that I remind myself not to reinvent the wheel while I'm working on projects. An example of what I mean would be that if I find myself writing a function that does something very similar to another function I've already written within the same project, I can usually modify the first one to serve the needs of both. I remember a particular micro-site I was working on at the same time I was working on a large round of banners. While it's not unusual to work on more than one project at a time or for those projects to have tight deadlines, this site had grown

in size and scope as it progressed. While the project was in mid-swing, new sections and functionality were being added that affected the way the site was being programmed. The deadline, however, could not be adjusted due to critical timing on a product launch.

In order to get the new sections built into the site, I had to work fast. And because those sections were added after all planning had been completed, I had to get a little "creative" in my programming. The end result, I'm a little embarrassed to say, was a fairly tangled web of messy code in which I had multiple functions completing the same tasks on the same objects and variables. If you've ever run into this situation, you know how confusing it can be to go back in and make changes or fixes to that kind of "spaghetti code." You quickly discover that you're asking questions like, "Did I call function A from there or was it function C?" or, "Well, I had to fix function A and function B does the same thing … do I need to fix it as well? Am I even calling function B from anywhere?" Once you hit that point, you have no choice but to take the time to go back and optimize your code.

Allow the Flash Player to Relax

Computers have come a long, long way since I first sat down in front of my dad's Apple II with a beginner's game programming book for children (how's that for dating myself?). They've come a long way in graphics, hard disk space, physical size, memory, and speed (as well as many other aspects). As the computers were advanced in all of these ways, software developers wrote their programs to utilize the changes, and we, as Flash developers, have done so as well. However, for as fast and efficient as a computer may be, it can still be "bogged down" without too much effort. And, like the computer itself, the Flash Player in which your work is viewed can be bogged down or even stop responding if the correct preventative care is not taken.

The Flash authoring environment will let you know about a few problems in this area such as an infinite loop. What it won't tell you is how to optimize and/or speed up your working processes. Here are a few tips that will help the Flash Player run more smoothly:

If you're looping through several objects and you're calling a simple function that affects each of those objects individually, move the contents of that function inside the loop. In other words, don't make the Flash Player start a loop, find the object to

be affected, go outside the loop to find the function you're calling, run the function contents on the object, and then return to the loop only to do it all again with another object. Instead, let the Flash Player start the loop, find the object, affect it, and move on to the next one.

When you give your objects data types, avoid overusing the ambiguous object type. Instead, figure out which type is better suited for the needs of the object, such as string, number, or array. While those three types are very different, there may be times when more than one type will suit your immediate needs. The object type should only be used when there is no other option, and if you're unsure which type to use, the Help section of the Flash authoring environment should be able to answer your question.

If you're writing a for loop that is running the length of an array, avoid actually using Array.length in the for statement. Instead, assign the value of the array length to a variable that you can then reference. **Example 6.1** shows the two different ways.

Example 6.1

```
//Assign the value of myArr.length to a variable before using it in a for loop:

var myArr:Array = new Array("item1","item2","item3","item4");

var myArrLen:Number = myArray.length;

for(var i:Number = 0; i < myArrLen; i++){

    trace("Array item at position " + i + " is: " + myArr[i];

}

//Instead of accessing it directly:

var myArr:Array = new Array("item1","item2","item3","item4");

for(var i:Number = 0; i < myArray.length; i++){

    trace("Array item at position " + i + " is: " + myArr[i];

}
```

Conclusion

As I've covered in this chapter, optimizing your files can be achieved on several levels. When it comes to file size, you should always optimize as much as you can without making heavily noticeable sacrifices to image quality or functionality. When you prepare your images for your Flash files, remember to choose the best file type for the individual image and to save that image at a high enough quality so that it's clear on your monitor. If you see obvious image artifacts, raise the quality of the image before you use it in Flash. Once inside Flash, manage the compression of your images on an individual basis from the Library window instead of globally from the File Publish Settings window.

Use vector images when you can, but remember to use them wisely. If you've got a visually complicated image, go ahead and use the raster version. However, if that image can be recreated with a minimal number of lines and colors, you may benefit from drawing it in vector format in order to achieve a possibly smoother representation that can be scaled without worry of quality loss. In addition to keeping the number of lines and colors to a minimum, do the same with gradients, as they require the Flash Player to work just a little harder. As for fonts, try to embed only what you need to embed and only if you need to embed them at all. If you need to use a specific font for only one or two words, try using a raster image of those words, and try to avoid breaking the text apart with the Ctrl + B combination or the "Break Apart" from the "Modify" menu.

Your code should be optimized not only for performance, but for readability and ease of modification as well. As you are writing your ActionScript, pay attention to what your different functions are doing. If you have two functions that are doing very nearly the same thing, consolidate them into one function that can handle both of your objectives. Another thing I like to suggest is to look back through your code at certain intervals to make sure you aren't repeating yourself or that you haven't left any code that you aren't using anymore. Remember that making your code base smaller optimizes your file now and your time later.

In Chapter 7, I'll be talking about some third-party rich-media companies like Eyeblaster and PointRoll. As you read about them, you'll learn that one of the benefits to utilizing their technologies is that you are allowed more file size for your banners. However, that fact should never keep you from optimizing your work, because one of the overall goals of any project should be an end product with a file size that's as small as it can reasonably be.

CHAPTER 7

Third-party Rich-media Technologies

Third-party rich-media technologies are a powerful tool when it comes to advertising. As I mentioned previously, these technologies are available through companies who specialize in opening new, more captivating channels for advertisers to utilize. Without these technologies in place, Flash banners would most likely be limited to the regular old standard ads and constrained to 20–30k in file size. However, since they *are* available and ready to be used, we can create banners that are capable of everything from playing video to expanding out to a larger size to working like tiny websites (mini-microsites, if you will). All of these options offered by rich-media companies afford us the room to give users more information than we could fit in a standard Flash banner. And did I mention that the file sizes allowed are usually much larger than standard ads, or that unlike standard ads, you can load external files such as child swfs, xml files, and jpgs? There is even an option out there to stream full-screen video. So let's get to the sections in this chapter:

- When to Utilize a Rich-media Technology
- Rich-media Companies

When to Utilize a Rich-media Technology

One question that is often asked is, "How do I know when to choose between a rich-media technology and a standard Flash ad?" As I mentioned in Chapter 1, a key factor in this decision can be cost. However, because there are so many extra features and advantages gained through using a rich-media technology, your clients may decide that it's well worth the extra money and it's up to you to inform them when they should and shouldn't utilize the technology.

Audio/Video

Inside the Industry

 With the audio and video capabilities of the Internet increasing by leaps and bounds every day, more and more video is being produced specifically for online use. While some ads and microsites may show video that was originally created for television, others are allowing viewers to watch content that was scripted, directed, and produced especially for that ad or site.

For those that have done any work with audio and/or video, it's pretty obvious that you'd be safe betting against much (if any) of it fitting in a Flash file that's constrained to 30k. Those banner ads that will use audio or video are prime candidates for use of a rich-media technology. With companies like Eyeblaster, PointRoll, and DART Motif by DoubleClick, your media can actually be streamed in to the ad.

The only usual requirement is that you can't start the audio until a user interacts with the banner. While it may seem that it would be beneficial to start playing your audio as soon as the banner appears on a user's screen, this requirement can actually work in your favor. If a user went to a website that was running your ad and your ad immediately started playing sounds, that user could very easily get annoyed with your banner and thereby annoyed with your client. Imagine a user at work in a quiet office and he or she doesn't realize the speakers are turned up, and all of the sudden your ad starts blaring out the audio from one of your client's radio commercials. Another bad situation would be the potential consumer that is using a dial-up connection (yes, they are still out there in fairly large numbers). While the key word is "streaming," you still don't want to be a bandwidth hog unless users want you to

be one. If any of these users run into your banner again, they may start to build a worse opinion about your client than they would have otherwise. On the other hand, if you put users in control, the opposite may happen. They may watch the video and be entertained by it or they may pay more attention and learn something about your client that they didn't know before. The key, again, is putting users in control rather than forcing it on them and eating up their bandwidth without their consent. Another good thing about waiting for user interaction is that you generally start the video over when they click. By doing this, you can be sure that users viewed the entire video (or at least that they didn't miss the beginning of it).

Dynamic Content in Your Ads

I was once approached to answer a question about feeding dynamic content into a banner. The reason, in this particular case, was because we had just launched a microsite that was entirely driven by user-generated content. In the site, a user could fill out a form to submit two different sides on any topic. If the topic was approved by the microsite's administrator, then other users could go on to debate which of the two sides of the topic was better. For example, one topic might be sports and one discussion in that topic might be about football and fútbol. Users would go to the microsite to use text, audio, or video to weigh in on the side they liked better. In addition, users could simply click a button to vote on their favorite side without saying anything at all.

> **Author's Tip**
>
> When you're working with video in a rich-media banner, check with the rich-media company to see if they have a Flash video player already built for use in their system. They may have special code to work with their streaming servers, and you'll just need to skin their player to match your design.

Getting back to the banner ads with the dynamic content; with such a site running off of user-generated content, the topics of discussion are always current and up to date with real-world events. Since the microsite always has current information, the banners needed to have current information as well. The answer was to build a single round of banners that could be updated "on the fly." Since regular 30k standard Flash banners don't allow the luxury of loading external files or content, rich media was the only way to go.

> **Author's Tip**
>
> Remember that if you want the capability to load external files such as xml or images, you're going to need to use a rich-media company to serve your ads.

Once the banners were built, they would pull their content from an external xml file that could be changed at any time deemed necessary. And since all of the content within the banner was dynamic, only one banner had to be built for each size. In other words, even though there were ten different sites running the 160 × 600 ad with different content on each banner, there was only one 160 × 600 banner built. The readers on site A might be interested in different topics of discussion than the readers on site B, and using the rich-media technologies allowed us to give them each the dynamic content they were interested in.

Extra Loads

If you have clients who refuse to show anything less than their entire line of products in a single banner, they're going to need to understand what that means in terms of file size. Once you find yourself having to use a certain amount of photographs in a banner, it doesn't matter how much you compress your images, they simply won't fit inside a file size constraint of 30k or less. Enter the rich-media technologies with their increased file size limitations and ability to load external files (such as jpg or swf).

This is one of the easy ones to explain to clients who are having a hard time understanding why they need to incur the extra cost involved in utilizing rich-media technology. If you run into any issues in this area, you can simply show your clients the file size of a Flash movie with all of the required images. They will appreciate that you have actually taken the time to both explain *and* show them why their banners would be turned away from any site on which they are supposed to be shown. If they still insist on having the same number of images in the banner, they will feel better about spending the extra money.

More Interactivity

Another thing to consider when choosing between a rich-media technology and a standard Flash banner ad is the level of interactivity available with each. Regular ads basically give you a defined area in which to show your content and a set file size in which to do so. On the other hand, rich-media technologies offer not only the previously mentioned option to load external files and content, but the ability to literally take your creation outside of the box. With floating ads, expandable ads, interactive video ads, and many more options, there isn't much that you can't accomplish in terms of communicating your message to your clients' potential customers.

Floating Ads

Floating ads are ads that actually appear over the content of the page on which they are played. Since they are played on a transparent layer above the page, they can take on any shape you like within a certain defined area. An example might be if you created a floating ad for an auto manufacturer and you actually built the ad to take on the shape of their newest car.

Expandable Ads

Expandable banners are a great place to pack a large amount of information into a small space. These ads are where the mini-microsites I mentioned at the start of this chapter would fit in. In a nutshell, your expandable banners will be made of more than one Flash movie: the main movie, which might be put together like a regular 160 × 600 (or one of several other sizes), and the child movies or "panels." The number of panels your ad has depends on how much information there is and exactly how it will be presented. When a user interacts with the main banner, a panel movie is loaded and expands the overall size of the advertisement. From there, the user might be able to open more panels or simply click the (usually required) close button if he or she is finished.

Rich-media Companies

There are many choices out there when it comes to rich-media companies, and while several of them started out specialized in one or two products (such as expandable units, floating ads, or video ads), most of them have come to offer a wide range of options in recent years. Some, like PointRoll (http://www.pointroll.com) and DART Motif by DoubleClick (http://www.dartmotif.com), offer a downloadable file that integrates directly into the Flash authoring environment to help speed up and streamline your work. Some other companies, like Eyeblaster (http://www.eyeblaster.com), offer an online tool for setting up your ads. Once you log into their tool, you simply upload your files, change a few settings accordingly, and assign the ad to the correct placement. Among the seemingly endless amount of other options available are companies like Vividas (http://www.vividas.com) with their full-screen video products, or Viewpoint (http://www.viewpoint.com) with their Video Cube that allows you to utilize each of six sides on a user-controlled three-dimensional cube.

Author's Tip

The different rich-media companies offer several of the same ad formats, but at the same time, each of them may also offer something a little different than the rest. I won't try to sway you one way or the other, but it's not an entirely bad idea to utilize one more than the others. The reason being is that the processes involved in running ads with each company are different, and it's good to use the same process as much as possible. If you need to run an ad format that isn't available with your primary rich-media company, simply move it over to the company that has that format.

They're Different Like Each Other

As I'll discuss in Chapter 8, "Trafficking and Tracking Your Ads," all of these rich-media companies have some form of tracking and reporting. However, their reporting is not currently as robust as a standard ad serving company's reporting. In general, you'll be able to get reports on clicks, interactions, and impressions. The main thing that won't be as detailed in the reporting is the conversions.

Since the majority of the rich-media companies you'll work with have come to offer a lot of the same options when it comes to ad formats, you may want to research their costs and get a feel for their levels of service. Just like with any product or service, you're going to find different rates and you're going to be happier with how you are treated as a customer by one company as compared to how you are treated by another company. Keep in mind that levels of service shouldn't only be measured on how you were treated as a person

and customer, but how much help and support the company is able to provide when you need them to.

Conclusion

As online advertisers, rich-media companies and their technologies offer us the means to create advertising experiences that might otherwise be unavailable. While those options are nice to have at our disposal, it's important to know when to use them and when to stick with a standard Flash banner. A major aspect of any campaign that will come into play when you're making the decision is cost; since you're getting more out of the advertising and technology, the price is going to be higher.

As I mentioned in this chapter, the options you have with a rich-media advertising technology will allow you to create banners that incorporate more engaging content such as audio and video. You're also afforded the luxury of loading external "child" files, which you wouldn't be able to fit within certain file size constraints, and the ability to load dynamic content from something like an xml file.

When it comes to the companies that house these technologies, you'll want to spend a little time doing some research to see which one you should go with. While there are those that offer options not available by any others, a majority of them offer many of the same ad formats. The main differences you'll find between them may come down to cost of their products and their customer service levels.

Trafficking and Tracking Your Ads

Trafficking your ads is when you actually load them into an ad server system or on the hosting site. This is the step in the process when your work is actually made "live" on the Internet. This is very obviously an important step in the life of a project, because without it, no one would ever see the ads and no one would ever make it to the site that is being promoted within those ads (at least not by way of the ads themselves).

Once the banners are live, you will be able to track aspects like impressions, interactions, and clicks (I'll explain these later in this chapter), as well as determine the cost of these metrics. You can then use the gathered information to optimize the campaign. Before any of this is possible, and even before the banners are built and programmed, there are other steps that take place, such as the media buy. If you have a media team, they are no doubt involved from the very beginning of a campaign all the way through to the end (and even beyond). It's the steps they take that I'll be talking about in this chapter, and I'll lay those steps out in the following sections:

- The Media Buy
- Ad Server Tools
- Tracking Your Ads
- Rich-media Ads
- Site-served Ads

The Media Buy

Aside from actually gaining a new client or having an existing client let you know they'd like to run a new campaign, the media buy is one of the very first steps that take place in the life of a banner project. Much like trafficking your ads at the end of the project, the media buy is a very important step that could very well decide the fate of the campaign itself. If done properly, the ads will be seen by the correct target audience and they will perform very well. However, if the wrong placements are purchased and the ads end up running on sites that have absolutely nothing to do with your target audience, they will perform poorly and large amounts of money can be lost in the process.

Target Audience

There are certain people who you want to respond to your campaign, and as harsh as it may sound, there are also certain people whose response is less important (on a particular campaign). Those people who you are trying to reach are called your "target audience," and they will vary from client to client and sometimes even from campaign to campaign. They are groups of people who fit into predefined categories involving their lifestyles, behaviors, and other key factors.

The audience can generally be narrowed down using different levels of targeting such as demographics. Demographics are essentially the characteristics of a given population and include variables like race, age, gender, income, employment, and location (as well as others). With the information gained by demographic studies, you can gain information like what type of person is visiting a given website. For example, upon doing a study for website A, you may find that the vast majority of its visitors are married, middle-class females in the 25–54 age range.

Another part of the study of your audience might be the psychographics. Similar to the demographics, the psychographics offer insight to different aspects of the given population. The difference is that with psychographics you gain a little deeper information than with demographics. The information gained here would be attributes related to users' personalities, attitudes, interests, and several other "under the surface" factors. You may also hear these factors called "IAO variables," which is short for interests, attitudes, and opinions. By combining your demographics with your psychographics, you can further narrow your audience to make sure your ads are being seen by the correct people. To carry the demographic example a step further, we may now have targeted married, middle-class females who are 25–54

years old, and are interested in entertainment and have purchased items online in the past six months. With that kind of information sitting directly in front of you, it's hard not to hit your intended audience.

The target audience for a given campaign will most likely be given to you by your client, and it will not always be the audience you thought it would be. For example, you may have a client whose product or service is typically associated with senior citizens. When your client tells you they want to target men who are 25 and older, you may be surprised. However, when you stop to think about the fact that your client's product is already associated with senior citizens, you'll find out that they most likely already have a hold on them. Therefore, it would make more sense to spend the advertising dollars targeting a new group that is not currently using the product/service to its full potential.

So now that you know who your target audience is, the next challenge is how to find them. There are several ways of doing so right at your fingertips. If you do a search online for something along the lines of "Internet market research," you'll get results pointing to many websites and companies where you'll find both free and fee-based information. As you might guess, the fee-based information is going to be much more in depth and probably more reliable as well. One of the industry leaders in market research is Nielsen//NetRatings, which can be found at http://www.nielsen-netratings.com. Nielson//NetRatings' extensive audience research and solutions offer advertising agencies an easy way to find their target audience for any given campaign. By utilizing the information found in their re-search, you'll know that your ads are being shown to the intended viewers thereby maximizing your client's advertising dollars.

Placement Availability

As I've said about most of the topics in this book, placing your ads on a website takes forethought. While there are some sites out there that may be able to run your ad the very day you first call them, they are getting to be few and far between. Most websites' policies and procedures require advance notice before running any ads on their pages, and exactly how far in advance can depend on several factors. Some of the factors involved can include things like what dates you plan on running your banners or how many other advertisers are running ads at the same time in the same place.

It is a good idea to plan on purchasing your placements about three months in advance. However, there are special dates where you may be better off getting your order in six months or more in advance. The Super Bowl is a good example. We all know and love the television commercials that air during the Super Bowl, and with more and more of those commercials directing viewers to websites, the traffic to those sites is increased by leaps and bounds during (and after) the game. In addition to that online traffic is the increased number of visitors to sports-related sites leading up to, during, and after the Super Bowl. Since the traffic to all of these sites grows so much during these times they have become prime spots for online advertising, and, as with anything in high demand, this leads to placements selling out more quickly.

Ad Rotation

Since I've used the analogy of a time-share condo to explain placements selling out, I'll go ahead and use it again for ad rotation. If the placement itself is the condo, then your ad is a renter. There are other renters (ads) out there that are sharing the condo (placement) with yours, but they all get it at individual times. However, the placement isn't normally purchased by the day or week; it is instead purchased in blocks of 1,000 *impressions* (each time your ad is viewed, it's called an impression).

A common misunderstanding about ad rotation is how the time is split up among banners. If you maintain your own website, you may have seen ad rotation scripts that other developers have so kindly distributed free of charge. Most of them (that I've seen) display different ads, which have been predetermined by you, based on percentages. For example, you may tell the script to show banner A 75% of the time and banner B the other 25% of the time. However, running banners with ad servers doesn't work this way due to the fact that percentages vary greatly from site to site. Where two million impressions may be equal to 1% on a very popular and busy site, that same two million may be equal to 50% on a less popular site. This all leads back to the previous mention on purchasing placements in blocks of 1,000 impressions.

Ad Server Tools

A huge plus to using an ad serving company to host your banners is not only the level of control you keep over your work, but the set of tools they have available to do so. The ad server tools allow you to set up your entire campaign, upload your work, enter every piece of important information that pertains to the campaign, and have the ability to actually look back at that information to track how the campaign is performing. I'll go into more detail on tracking later in this chapter.

Each ad server is different, but they all have pretty much the same capabilities when it comes to the workflow for getting your banners up and running. Here's a very general breakdown of the steps involved.

1. Enter your media plan.
2. Load your banner files and destination URL.
3. Test your banners.
4. Assign each banner to its placement to get the "tag."
5. Send the "tag" to the site that is running your ad.

Enter Your Media Plan

The first step involved in getting your banners running on an ad server is to enter the media plan into the ad server tool. The media plan will consist of items such as the placements for your banners, the number of impressions that have been purchased for the campaign, all of the costs involved with running the banners (such as the cost of the impression), and the dates your banners will actually be running. This information will be extremely important in tracking the performance of your ads.

Load Your Banner Files and Destination URL

This step in the process is pretty self-explanatory. Each ad server tool has an interface that allows you to upload your files to their servers. For each file you upload, you enter the URL that users will be directed to when they click on the banner. The URL that is entered here is the URL that is passed in to the variable you may know as "clickTag" (see Chapter 4).

Test Your Banners

Test, test, test. While writing this book, I've come to notice just how much testing we do on each and every banner that gets created. I've also come to notice that the testing itself becomes such second nature in the work that some of us may not even realize just how often we're doing it, and that's not a bad thing by any stretch of the imagination. As noted by this step, testing should continue all the way through the life of a project, and testing the banners at this point is very important because they are only a few clicks away from being visible to the rest of the world.

Get the "Tag"

Once the banners have been uploaded and tested it's time to generate the "tag" for the banner. The tag is basically a reference back to the code that will house the banner. That code may be for something like an iFrame or the JavaScript that will place the banner on the page in which it will be shown. Your ad server will typically have a wizard that will walk you through steps to generate the tag.

Send the "Tag"

After the tag has been generated and everyone has approved the banner, it's time to take the final step in releasing your banner to the world by sending the tag to the site from which you have purchased your impressions. As I mentioned before, the tag is a reference to a piece of code that will house your banner, and by sending a tag to the site, you are not sending your actual files.

Tracking Your Ads

After your ads have been set up in the ad server tools, the next thing to do after a predetermined amount of time has passed is track their performance. Tracking the performance of your banners can give you a wealth of information that can be used, in part, on future projects. Information relating to how many times the ad was viewed, how many viewers clicked on it, and whether or not the ad ended up helping your client make a profit on their advertising dollars. All of this information is available in the same ad server tools that were used to launch your banners. It's the reason you entered all of the details about the media plan in step one of the previous section, and because of the tracking, you will be able to show your client their return on investment (ROI) in regards to a particular campaign.

Impressions, Interactions, Clicks, and More

People often get the terms *impressions*, *interactions*, and *clicks* confused with one another the first few times they hear them. I'll go ahead and admit now that when I first came into the advertising field, I wasn't 100% sure if I was using each term correctly when I spoke of them. However, I'm happy to say that I quickly caught on and can now confidently pass the information on.

When the tag that was explained in the previous section is called, your banner is shown and an *impression* is counted. Also mentioned earlier in this chapter is the fact that the number of times your ad will be shown is predetermined by the amount of impressions that have been purchased in the media plan.

Author's Tip

When you sit down to figure out the ROI for a direct marketing campaign, keep in mind that the number of sales for the particular product or service may be skewed. This is due to a gray area that lies in between the direct marketing approach and the brand awareness approach. The most likely course of customer action that would fall into this gray area would be if they viewed your ad for a product and then later drove to the store to purchase (as opposed to buying online). Since the in-store purchase cannot be directly tied to the banner view, the sale cannot be figured in with the ROI.

Interactions and clicks can be very easily mixed up just by looking at the words themselves. The difference between the two is that when an *interaction* is counted, it means that someone interacted with something in the banner, but didn't actually visit the destination site. Interactions can be anything from rolling over a certain

item in the banner to scrolling through images in the banner. A *click* is different, because when a click is tracked, it means someone literally clicked on the banner and was taken to the promoted website.

Since you now have the numbers on hand for how many times your ad was shown (impressions) and the number of times someone clicked on the ad to visit the destination website (clicks), you can find out what the *click through rate* (CTR) is. The CTR is the rate at which users click on your ad based on how many times it was shown. In most cases the math will be done for you by the ad server tool, but just in case, the formula is simply clicks divided by impressions (clicks ÷ impressions). So if you have 1,000 impressions and 100 users clicked on the ad, your CTR would be as follows: 100 ÷ 1,000 = 0.1 or 10%.

Finally, a *conversion* is counted when a user has clicked on your banner, been directed to the destination website, and performed the action that you intended for him or her to perform. For example, your banner may have directed a user to a page with an email sign-up form. If he or she fills out the form and submits it, a conversion is counted. Likewise, you may have directed him or her to a page where he or she could instantly purchase your client's product. Again, if he or she makes the purchase, a conversion is counted.

Determining the "Cost per Everything"

Now comes the part where you find out how well the banners are working for their money. If you aren't already working in the online advertising world, you may have never heard several of the terms I'm about to talk about. Then again, you may be working in online advertising but never paid much attention to what these terms mean. Either way, I'm about to explain a few costs that are determined by the information gained from tracking your banners' performance.

In regard to figuring out how well an ad was performing on a cost basis, I was once jokingly told that "We have a cost per everything." There's a cost per click, a cost per interaction, a cost per conversion, etc. There are formulas for figuring out each of these costs but they will most likely be done for you in the ad server tool. In short, the ads that are performing better will have lower costs associated with them, and the ones that are performing worse will have higher costs. The importance of knowing how much each aspect of your ad is costing comes into play on several occasions and one of those is when it's time to optimize the campaign.

Optimize Your Campaign

At some point enough time will have passed that you can use the numbers from your tracking and costs to optimize your campaign. When you optimize your campaign, you're making the banners work more efficiently for the money spent, which in turn means that your client is getting a better return on their advertising dollars. To figure out how exactly your campaign should be optimized is pretty straightforward. The first step is to study the performance of each banner on each site. After comparing them all against each other to find which ones are doing better, you'll know which ones to remove and which ones to keep. However, removing some and keeping some is only part of the optimization. After you remove the ads that are performing poorly, you need to increase the number of times the better performing ads are shown. If an ad is performing well, increasing the number of times it's shown will mean even more clicks, and, as I mentioned earlier, more clicks equals lower costs and lower costs equals happy clients.

Rich-media Ads

Trafficking and tracking rich-media ads is a little bit different since there is a necessary third party involved in the process. While these companies (see Chapter 7) may offer their own forms of tracking and reporting, it is far less robust (at the time of this writing) than the reporting you will get from a general ad serving company. Additionally, the final piece of reference code that you send to your client will be different as well.

Trafficking Rich Media

When you traffic a rich-media banner, the steps taken may differ a little from rich-media company to rich-media company. For example, if you are using DART Motif, then you should have their Flash extension (see Chapter 7). In short, the extension basically packages any needed files for your ad into an mtf file (which is something like a zip file). Once packaged, you send the mtf file to Motif and work with them to traffic the ads to the correct placements.

Another process you might experience is that of trafficking your ads through a company such as Eyeblaster. Eyeblaster has an online interface (or tool) that allows you to log in to complete every step involved in getting your ads live on the Web. Once you have logged in to the tool, the steps are pretty straightforward and not all that different from setting up your standard banners.

1. Enter your media plan.

2. Upload your files and enter the destination URL.

3. Preview your banner.

4. Assign each banner to its flight.

5. Send the Eyeblaster reference to the site.

Enter Your Media Plan

Just as with the standard banners, the first thing you should do when running your ads through Eyeblaster is enter the information about the media plan. Again, this information includes things like the number of impressions purchased, the costs involved, and the placements where the ads will show.

Upload Your Files and Enter the Destination URL

When it comes to uploading your files, Eyeblaster has made it nice and easy with a piece of their interface that will allow you to add a file using a simple form. But what if you're setting up a campaign that is running 30 different banners? Uploading all of those Flash files and backup images could be very tedious and time consuming, so Eyeblaster went ahead and included the ability to upload multiple files at the same time, which helps streamline your day a little.

Preview Your Banner

After your files are uploaded, the Eyeblaster tool has an ad preview feature that allows you to see a fully functional version of your ad. You can either preview it by itself on a blank background or you have the option to see how it looks laying on top of any website of your choice. Once you're happy with it, you can email a link to the preview to yourself, your quality control team, and anyone else who may need to ap-prove the ad before it goes live.

Assign Each Banner to Its Flight

In the Eyeblaster tool, placements are called "flights," and once your ad is approved by all of the appropriate people, you can start assigning them. When you do start assigning your ads to their flights, remember that each individual ad can be as-signed to multiple flights at the same time. In other words, if you had ten flights that were running a 728 × 90 ad, you wouldn't actually need to create ten different 728 × 90 ads unless they were visually different from one another.

Send the Eyeblaster Reference to the Site

Sending the ads to the sites on which they will be running is a little different when you're using Eyeblaster as opposed to setting up a standard banner. With Eyeblaster, you'll use their interface to send an email to the sites (and anyone else you specify) notifying them that their ads are ready for their review. Within the email are any notes you've included as well as instructions for the recipients to view the ads. Once they have looked over the ads, they can then use the Eyeblaster tool to respond by approving or declining them. If they have chosen to decline, they will write their reasons in the response. Based on those reasons, you can make the needed revisions and resubmit the ads until they are correct.

Tracking Rich Media

Tracking rich-media ads is similar to tracking standard ads. In fact, the two are so similar that you can do the tracking for both with the same ad serving company like Atlas or DoubleClick. That also means that all of your tracking can be in one place for a given campaign in which you have both standard and rich-media banners. Generally, this is possible with the use of a 1 × 1 transparent gif file. The gif is loaded from the ad server (Atlas, DoubleClick, etc.) into the rich-media placement. Each time the gif is loaded, it gets counted as an impression of the banner.

On top of all of your tracking being in one central location, the reason it's a good idea to track your rich-media banners through a standard ad server is because the conversion reporting is far less robust with the rich-media companies (if they offer it at all). That said, rich-media companies do report on actions like clicks, impressions, interactions, etc.

Site-served Ads

Site-served ads are simply ads that are hosted by the site on which they are running instead of being hosted by an ad server. The more time that passes, the rarer site-served ads have become for several reasons. While it may seem like less hassle and trouble to go ahead and send your files directly to the site, you end up with far less control and the ability to track the performance of the ad is greatly reduced.

ALERT When a banner ad is site served, you will lose many valuable pieces of control over it, such as the ability to quickly make changes.

Loss of Control

If your banners are site served, you are going to lose a very considerable amount of control over them. For example, you'll be sending the site your actual files instead of the previously mentioned reference tag. This means that you'll need to depend on the person in charge of programming that site to get everything right. By turning over that control, you may find that your 728 × 90 banner was accidentally placed in a 300 × 250 spot ... without being tested. In addition to possibly using the wrong dimensions, the code that shows the default image in the case of a viewer not having the Flash Player installed may not be used. Another large loss is the assurance of knowing the ad was even placed on the site when it should have been. The only real way you have of knowing is to take the time to visit each individual site on which you're running a site-served ad (and you probably have more important things to do with that time).

Slow Changes

If you've ever had to change anything online, you know how nice it is to have direct access to the files you need to alter. But imagine for a minute if you didn't have access to those files. If you have any ads being site served, you'll run into this problem if your banner needs to be changed or replaced. There is a big difference between using an ad server or running site-served ads when it comes to easily making those changes, and that difference is time. Because of the channels you'll most likely have to go through to change a site-served banner, it could possibly take up to a week before the change is actually made. On the other hand, while hosting your banners on an ad server, the same changes could be done in an hour.

Less Tracking

Along with not knowing for sure if your ad has actually been placed when and where it should be, your ability to track how well your ad is performing is reduced. Of course that means less ability to look at costs, clicks, conversions, profitability, and anything else that falls under the tracking umbrella. With less tracking, you'll have a harder time knowing how well that particular banner contributed to the campaign or if you should even spend money in the future to run more ads in that same spot.

Conclusion

To wrap up this chapter, let's take a quick walk back through it. One of the very first steps in any banner project is the media buy, which, as I hope I've shown, involves much more than simply picking up the phone and placing an order. Making sure you're purchasing the correct placements for ads means not only knowing who your target audience is but also what they do, what sites they visit, what they're interested in, and much, much more. Once you have that information, you can better decide where, when, and how often to run your ads. That is, of course, dependent on those times and placements being available.

Also covered in this chapter were the general steps involved in setting up your banners in an ad server tool. Just as a quick recap on those steps, they were to first enter your media plan, then load your banner files and destination URL. The next step is to test your banners. Once tested, you assign each banner to its placement to get the tag and finally you send the tag to the site that is running your ad.

Once your banners are live online, you can track their performance and figure out how much each individual ad (and even detailed aspects of it) is ultimately costing your client. Based on the performance of your banners, you can then optimize the campaign by removing poor-performing ads and increasing the share of voice for ads that are doing better.

Another topic covered in this chapter was that of trafficking and tracking your rich-media ads. While there are differences between these and trafficking/tracking standard banners, the general process is very similar. Once it gets down to the actual tracking, standard banners and rich-media banners are no different at all because you can track them altogether in one location.

Finally, I talked about site-serving ads. While having your ads hosted by the individual sites themselves is becoming an increasingly rare occurrence, there may still be times when you don't have much choice. It's generally a good idea to avoid site-serving ads, but if you find yourself in the situation, keep in mind (and let your client know about) the downsides, such as slow changes, less tracking, and less control over the placement itself.

CHAPTER 9

Designing Microsites

As I mentioned in Chapter 3, there are similarities between designing microsites and designing banners. If you recall, I also mentioned that there are differences between the two as well. This chapter will concentrate on the microsite side of things. These differences can make designing a microsite a very exciting and fun experience due to many factors. Factors such as no file size constraints, more freedom of design, and the ability to dynamically load various types of files at run time all help open up the channels of creativity required to create a microsite that will be viewed and passed from person to person. For a quick overview of what's ahead, here is a list of the sections found in this chapter:

- Less Constraints
- Conception
- Know the Brand (and Learn It if You Don't)
- Navigation
- Designing with Transitions and Animation in Mind

Less Constraints

Before getting into a discussion about the actual designing of microsites, I'd like to talk a little more about some of the differences between microsite design and banner design. More specifically, I'd like to talk about those differences that open up the avenues of creativity by removing the invisible box of constraints. As with just about anything else in life, when the constraints are lifted, more brilliance is possible. On the other hand, sometimes when constraints are removed, more discipline is required.

No File Size Limit

When you transition from designing banner ads into designing microsites, you'll find that one of the most noticeable differences is the lack of file size limits. The reason banner ads have file size constraints is because the banners themselves are not the main focus of the page on which they are displayed. However, when it comes to your microsite, people have navigated to your URL to see it and it alone. In other words, your microsite takes a back seat to no one at its own web address.

With no file size limit, you are much freer to do nearly anything you like as far as images and other aspects of a file that raise the final size of an swf output. Notice that I say *nearly* anything. I say that because even if you are informed that the sky's the limit on file constraints; even if you're told that your only target audience is in office buildings with the highest available Internet connection speeds; and even if you're told that your files will only be seen across an intranet, you should always aim for the lowest possible file size on your final output. This is where increased discipline comes into play and it can be very important to the success of your microsite. Remember to shoot for the moon, but then real it back in a bit until you feel comfortable with the final file size and subsequent load times.

No Timing/Looping Limit

Your microsites obviously aren't going to just sit there and loop an animation over and over again, but you may have some element on your site that does. Perhaps it's a particle effect like sparks, fire, or smoke, and if you ran that same element inside a banner, you'd have to put a stop to it after a given amount of time. On the other hand, you don't have to worry about any of those timing or looping constraints within your site. The main reason I mention this in a chapter about designing is to

let you know that you can feel free to run animations and effects for any given span of time that you feel necessary (even indefinitely if you like). You should, however, keep processor usage and distraction from the content in mind.

Conception

While coming up with a design for a microsite can sometimes be very involved and challenging, the amount of fun that can go into it makes it worthwhile. If you compare designing a microsite to designing a full company website, you'll find that the biggest differences are usually structure and content weight. Since company websites are the online representation of the companies themselves, they usually want those to be nice, clean, corporately structured, and full of business-related content (depending on the client, of course). On the other hand, microsites offer companies a more interactive and immersive escape of sorts to show how fun and free flowing their product or service is when it's in your hands.

Lighten Up, Man

Like I said, microsites are typically a lot more fun than company sites. A comparison might be like saying that if the company website is equivalent to sitting in a meeting in the stuffy boardroom on the fiftieth floor of a corporate glass tower, the microsite is like doing a bungee jump or a base jump from the window of that same boardroom. Both scenarios involve the same company, but the experiences are quite different.

Along with being more entertaining, the microsite is also usually a lot shorter on content than the company website. The simple reason for that is because people visit the company website to get information about the company itself, but people visit the microsite to experience a product. It's all dependent on what users are after. If they are looking for heavy amounts of corporate information, the company site is their target destination. If they are looking for something that gets right to the point of a product while being big on emotion and experience, then they'll be looking for the microsite.

Let the Product Guide You

What your client actually does is obviously very important to the design of a microsite. There are certain industries (and even specific products within an industry) that lend themselves to somewhat of a predefined look and feel. Some will scream for a shiny, extravagant design with lots of bells, whistles, and extra features to amaze, and some will call for more of a simple, elegant, slick design. On a little bit more of a detailed level, the product itself should also influence the colors you choose. For example, if you were designing a site about rocket engines, you might use a combination of reds, oranges, and blues to add to the feel and signify the fire and sky associated with rockets.

Know the Brand (and Learn It if You Don't)

Being familiar with the brand for which you're building a microsite is worth mentioning again (I spoke to this topic in Chapter 3, "Designing Banner Ads," as well). It should significantly sway your thoughts of design for the site just as much as the individual product if not more. But what happens when you get a project to build a microsite for a brand that has never been targeted at you, that you're not familiar with, or that you've simply never heard of? Well, it's time to start studying up.

Find Information

If you're unfamiliar with your client's brand or product, don't hesitate to search around the Internet for it. In this day of free-flowing information, you can usually find what you're looking for extremely fast. First off, visit the client's current website to read about them, view their products, and experience their brand as it exists prior to your redesign. In addition to visiting their website, find out who their competitors are and take a look at how they are presenting themselves.

Another good place to look is to your friends and family. If you are female and the brand is targeted at males, talk to some men who might know something about the product in question. The same can be said for any of the demographics, such as age range. The people you're looking for are those who actually interact with the brand and might be able to tell you their take on it as a consumer. Once you've talked to the correct people, try to put yourself in their shoes and see the brand the way they do.

Finally, look to the world around you. Everywhere you look, something is being advertised and there are brands being shown around every corner. Take a look at billboards as you drive to work, pay attention to advertising on the side of busses you pass, don't be so quick to skip over the ads in a magazine you're reading, and watch the commercials that interrupt your favorite television shows. While you're noticing all of this advertising that surrounds you day in and day out, pay attention to those that are similar to the brand you're currently working with. Most important here is that you don't look at it in terms of copying any designs; rather look to it for inspiration. One last thing to pay attention to—life. Ideas can come out of any strange little happening that you may miss. They can spur from a single sentence that someone says to you in passing. Keep your eyes and ears open and you may catch onto something that fits perfectly with the brand.

Navigation

Navigation is an extremely important element when it comes to designing a micro-site. Not only should the navigation menu be easy to find, but it should also be easy to understand and use. The most typical placement for a site's menu is going down the left side of the page or across the top. If there are subsections under any menu items, they typically drop down under the top navigation or show up beside the left menu when a user places his or her mouse over that item. However, this *is* Flash and Flash affords us the luxury of things like interactive animation; luxuries that aren't available in a regular old HTML site.

What Can't You Do?

Since we are now in the world of Flash, the question changes from, "What else can I do with navigation?" to "What *can't* I do with navigation?" Well, there isn't a whole lot that you can't do, but there are a number of things that you shouldn't do. A quick browsing session of Flash sites on the Internet can usually give you some ideas of both good and bad navigation. Putting the actual look of the menu aside, you should think about aspects like movement, interaction, readability, and the sub-menu (if there is one).

Plain or Pretty

While you're figuring out how you want the navigation to look and move, don't forget to consider the number one factor in the project: your client. The menu design of some sites will have to be plain while others get to be more decorative and pretty. It may go without saying, but if you're working on a microsite for cancer research, you're probably not going to design the same menu as you might for a fun-and-games site for kids. One will be more straightforward and simple, while the other has a crazier, outside-the-box look to it. However, *both* menus should be very easy to understand and navigate. If you find that you have to include any kind of directions telling users how to use the menu, it may be time to rethink the design.

Designing with Transitions and Animation in Mind

A couple of details that some people tend to let slip their minds are transitions and animation. When a page or section of a Flash microsite is designed, you should always think about what happens between the times that users click on a button and when they arrive at the resulting destination. Will the page simply do a "hard cut" type of change as it would with an HTML page, or will there be some movement to get them from point A to point B?

Plan to Move Users

Since we are working with a development tool that will allow us to literally "move" users from one section of a site to another, we should take advantage of that when the situation calls for it. Sometimes the best thing to do *is* the hard cut, but there will be plenty of other times when a nice quick animation will actually strengthen what the design is attempting to portray or just make the site a little more interesting to navigate. If you stop and think about some of the sites where transitions caught your eye, there's an extremely high chance that those animations didn't just happen by accident. Instead, they were very well thought out, planned, and designed in advance of the site actually being built and programmed in Flash.

Just as I stated in Chapter 3, it's a good idea to plan your major animations while you are laying out the design (and even sooner than that when you're only visualizing the design in your head). A very big part of that planning is making sure that you have the assets you need to make the animation happen. Without the correct images (or video), the person that will be animating and programming the site can't create the correct movement. I am reiterating the importance of this again in this

chapter because it does happen that animations are planned without thought to how they will be (or if they even can be) executed with the available assets.

Squash, Stretch, and Anticipation (Animation Details)

While the major movements of the transitions and animations should absolutely be planned in the design phase of the project, you would be okay to wait on the details of those movements. When the design is handed over to the Flash developer, do your best to let go a little while still staying involved. First, explain the major movements that you have designed to the Flash developer. After working with him or her to get the overall mechanics of the animation created, ask him or her to tweak the movement accordingly. In other words, let him or her work out and create the details to making the animation feel as it should rather than just suddenly moving from one point to the next. For example, you may have a ball in your design that you want to get from one side of the screen to the other and the major movement you've decided on is bouncing (as opposed to rolling or being thrown). Let the Flash developer know your thoughts and work with him or her on getting the general bounce animated. Then, walk away and let him or her apply the details such as the general animation rules of squash, stretch, and anticipation. During all of this tweaking remember that there could be a couple of projects where timelines/deadlines may not allow for all of the tweaks you'd like to see. If you find yourself in that situation, try to think of which animations and tweaks are the most important and which ones will be okay with simply moving an object from point A to point B. The bottom line is to trust the Flash developers with the work. After all, it's what they do for a living, right?

Know When to Say When

Knowing when to stop animating is just as important as knowing what to animate and when to animate it. Knowing when to stop animating also means more than one thing: it means not over animating the microsite (unless the brand calls for it), it means animating at the right speeds and intervals, and it means knowing when to stop making changes to the animations.

Overanimation of a microsite can get very annoying to a visitor very quickly. That is unless the overanimation enhances the experience of the brand. As with several other design and animation rules, this one will apply differently to different projects. The main thing is to pay attention to how much animation you have happening within the site that doesn't serve much of a purpose, like getting a user from one

section to the next. Again, you'll have to make a judgment call on this from project to project.

The speed and frequency at which an animation happens is also something that can either keep a user coming back to your site or drive him or her away after the first visit. How many Flash-based sites have you visited where every move you made played an animation before you could get where you wanted to go? And how many sites have you been to where you find yourself waiting longer than you feel you should for those animations to finish? Your visitors have most likely experienced the same thing at other sites as well. That's why it's important to use animations and transitions quickly and only where they help add to the experience of the site.

A final list of all of the *major* animations should be decided on prior to animating and programming the site. Any new animations that are thought of after the site is in full swing of production could possibly set the timeline back depending on the complexity of the new movements. While changes to the site are definitely going to be inevitable in some cases, try your hardest to avoid adding new animations or even changing the existing ones too drastically. Depending on exactly how the site in question is built, retrofitting it for a new animation may even mean having to scrap and rebuild parts that could have taken hours to complete the first time.

Conclusion

Designing for microsites has a few different steps and several of the same steps as designing for banner ads. Going back over some of those steps in this chapter, you'll see that one big difference between the two is the fact that you aren't constrained by final file size or time limits when you're working on a microsite. However, while more and more people are moving from dial-up connections to some form of broadband like DSL or Cable, you should still try to keep your files and your site from getting too bloated. If you make people wait too long to see your microsite, they may give up and leave.

Coming up with a concept for microsites is similar to coming up with a concept for banners, but more detailed and on a larger scale. Your clients want their product (and brand) to be remembered, and your design will help them accomplish that goal. Remember that this isn't your client's corporate website, so depending on the product and where it takes you, keep your concepts from being too stuffy and strict. In other words, try to design for users to have a memorable experience rather than forcing them to read a bunch of legal copy.

Part of being able to create concepts for a new microsite is to know something about the product and the brand. If it's a brand that you're already familiar with, then ideas should start generating in your head right away based on your past experiences with it. On the other hand, it may not be anything that you've ever come in contact with and that means you'll need to do a little research to get a feel for the brand. One way to find your answer is talking to people you know who fall into the target audience of the product.

Menu design is very important on a microsite. It's how users will find their way to new areas of the experience and they should be able to do so very easily. Just like the overall design itself, the layout of the menu is going to be dependent on the client or product involved. For some, you'll need to stick with the classic left or top menu bar while others will call for something more creative and fun. The most important thing to remember in designing the menu is to make it easy and intuitive. Otherwise, you may end up with users that leave too soon simply because they got confused on how to navigate the site.

Finally, think about how your design will live and breathe. You're designing a microsite that will be built in Flash, so go ahead and design some animation and transitions while you're at it. However, remember to actually plan those movements while you work. Make sure you have all of the assets that will be needed in order to create those animations in advance of handing the design over to the Flash developer. Once you do hand it over, work with the developer to get the major motions and mechanics of the animation created. After that, let go and turn over some creative control to let the developer flesh out the small details in the movement. Once everyone is happy with all of the animations, and aside from changes that absolutely must be made, try to keep from making big modifications or additions in terms of the animations themselves. Afterthoughts and retrofitting animation could possibly push a project over its deadline.

CHAPTER 10

Preparing and Building Microsites

As I've mentioned before, a microsite is exactly what it claims to be: a site that is smaller than a regular, full-size site. You could probably also guess that building a microsite is a good deal different than building a banner. For starters, there's going to be a lot more information and interactivity available for your audience on a microsite than on a banner. Despite the differences, there will also be similarities between the two projects. As with building a round of banners, you'll need to plan out how you're going to work on the microsite. You'll also need to make sure you have assets in order and a backup plan for users that have disabled the Flash Player and/or JavaScript. If you've already read Chapter 4, "Preparing and Building Ads," you'll notice the similarities and differences in preparing and building microsites as you read through this chapter, which is broken into the following sections:

- Plan of Attack
- Collecting Assets
- Building to Standards
- HTML/JavaScript
- No-Flash Backup
- Collecting User Data
- Quality Control

Plan of Attack

Having a good plan in place prior to working on any project is priceless. If you get into a project and find out that things weren't planned out quite well enough after spending a good amount of hours on it, you just may find yourself in a very troublesome position. You may find that you have to change so much in the site to accommodate for the lack of planning that you end up reverting back by half of the time already spent.

So where do you start to plan for your build? Talk with the creative person on the project, of course. Before the creative person designed and laid out the site, there was already some planning in place. Planning of what the client wanted to accomplish, a wireframe of the site, possible paths that users might take to navigate the site, etc. That planning played a major role in how the site was designed from a creative standpoint and that creative person has a vision of how it will all tie together.

Inside the Industry

 A site wireframe is a diagrammed skeleton of the site itself. It contains all of the navigation items and how each one ties into or connects with the others. By looking at the wireframe, you can see possible paths of navigation and how many pages deep a given section of the site may go. On some pages you can see processes that may occur and a general outline of the content as well as the importance of a given piece of content. **Figure 10.1** is an example of a single page from a site wireframe.

Page: Video/Audio file administration and moderation

Notes

Legend

Page

Page element

Page functionality

Email

Home Page
1.0

Section One
2.0

Section Two
3.0

Section Three
4.0

Section Four
5.0

Video Encoding

Video Encoding

Is Video/Audio File approved for publication?

No

Yes

Archive

Batch Process
1–2 times per day

Upload to site

Not intended to show design, only to inventory page contents and relationships.

Figure 10.1

Example page from a site wireframe.

ALERT When you're creating and working with information architecture documents such as site maps and wireframes, it is very important to let your clients know that those items are intended to show site organization and content hierarchy/importance, *not* design. On top of verbally informing them of this, you may also consider including it on the documents themselves. Simply place a sentence like "These documents are not intended to show design, only to inventory page contents and relationships" in a place where they will be seen on each page.

While you are talking to the creative person, get as many details as you can and take plenty of notes on his or her answers. Don't be scared to ask about anything no matter how small it may seem because you will often find out that not everything was thought of beforehand. If there are multiple pages in the site, how will you transition between them? Are the rollover states of the buttons and menu items animated or do they just flip from the upstate to the overstate? What if a user clicks that button right there? And that button? Where does this button take the user? You get the idea. The point to this line of questioning is multifaceted: on one side, you need to know how the site will live and breathe; on another side, you need to know how the site will react to certain interactions; and yet on another side, you and the creative person can try to detach yourselves from the project and think like an outside user.

Another thing to do while you are in the planning phase is to think about the code you'll be writing. When you're talking with the creative person about the features and functionality of the site, make mental notes about what code you might need to complete each item. Better yet, write down those mental notes so you don't forget. Also, think about past projects you've worked on. You may find that you worked on another site or even a round of banners that have code you can use in the form of classes or snippets. If you do happen to think of such a project, you'll know that you can already plan on saving a little development time by reusing that code.

Collecting Assets

Before you can actually build a microsite, you'll need to know what it's going to look like, right? Okay, so the creative person on your team has designed the layout of the site and hopefully given that layout to you in at least the form of a Photoshop file (and possibly printouts). That layout is your guide and template for this project and your goal is to mimic it as perfectly close as you can. And that doesn't just mean images either. You'll also need to pay attention to aspects like the typography. There's an art to everything you see in the layout and the text is no exception. Kerning, tracking, leading, ragging—every bit of it is as intentional as the location of the client logo or the menu item names, and you can't forget to build it into the site the same as it appears in the design.

Speaking of typography, another asset to collect is fonts and you'll need to get your hands on any that the creative person used in the layout. If you don't have a place on your servers where you store fonts, ask the creative person to get you the fonts you need to build the site. Since the creative person used the fonts in the design, he or she should be able to get them for you. Be sure to get exactly the right fonts too. Some of the fonts can have different sets even for the bold or italic versions. If you only get the "regular" version of a font and then try to add bold or italics inside Flash, you may end up with a font that appears slightly different than the one you should actually be using, and that could make enough of a difference in the end product that you may not get approval from the creative person.

Any imagery within the design will need to be exported from the layout for use in your site. A lot of times, there can be a mixture of both raster and vector art. Looking back at Chapter 4, you'll remember that raster images are images that are a rectangular grid of pixels with individually defined colors. While raster graphics are generally larger than vector graphics in file size, they will be required for many parts of your work such as photographs of client products. Again referring back to Chapter 4, when cutting raster images from Photoshop you should give yourself about three pixels of cushion between the edge of the object in the image and the edge of the crop area if you can.

Vector graphics are different than raster graphics in that they are not based on a set grid of pixels. Instead, vector graphics use mathematics with primitive shapes like points, lines, and curves. Vector graphics also scale much more gracefully than raster graphics. As a matter of fact, you can scale a vector graphic indefinitely with no loss to the quality of the image it creates. Try that with a raster image and you'll end

up with a poor-quality, pixilated picture that looks more like a piece of blurry mosaic art than the image you started with.

Any time you have a piece of the design that can be built with vector, you should do your best to build it that way. If, however, the creative person on the project has already built it as a vector graphic, you should be able to export it from Photoshop, Illustrator, etc. and bring it directly into Flash. This will ensure you are keeping exactly to the layout as it was originally designed.

Building to Standards

As I covered in Chapter 4, it's a good idea to find a naming convention and stick with it. Whether it's you developing the site on your own or a team that you're a part of, a good naming convention just makes everything that much easier to find and work with. **Table 10.1** contains the same examples I used in the "Building to Standards" section of Chapter 4, but I thought I'd include it again for people, like myself, who tend to flip around in books.

Table 10.1

Naming Convention Examples

MovieClip containing form fields	myFormMc
Input TextField for user's email address	emailInputTxt
Button to submit form	formSubmitBtn
Sound object for background music	myMusicSnd

Separating your site into different files is another good practice to get into. You gain several benefits when you compartmentalize your work in this way. One of those benefits is the option to easily split the project among more than one developer where each person works on a set number of sections in the site. You also gain the benefit of quickly isolating and resolving issues and errors with the site. For example, a bug might be reported to you that only happens in the "About Us" section of a site you've just passed on to quality control. Since each section of your site is broken out to its own file, you're going to have a 99.9% chance that you know exactly which file to open to fix the bug. Additionally, since that file doesn't contain the entire site itself, you won't have to dig through lots of layers and MovieClips on top of MovieClips to hopefully find the code that is the culprit of your problem.

Since we're talking about compartmentalizing your work, let's talk a bit about classes. I've learned over the years that class files are wonderful little helpers that I mentally file among the things that I wish I had understood and utilized much earlier than I did. Flash class files are files with the .as extension and they contain the code to complete a given task whether that task is animation, drawing, interactivity, or any number of other little jobs that could be written in ActionScript. While writing classes with ActionScript 2.0 is more forgiving in its rules, the release of Action-Script 3.0 has changed that leniency. However, by changing that leniency, it has also changed the strength, speed, and quality of the code itself. For detailed information on both ActionScript 2.0 and 3.0, visit the ActionScript Technology Center on the Adobe website at http://www.adobe.com/devnet/actionscript/ (**Figure 10.2**).

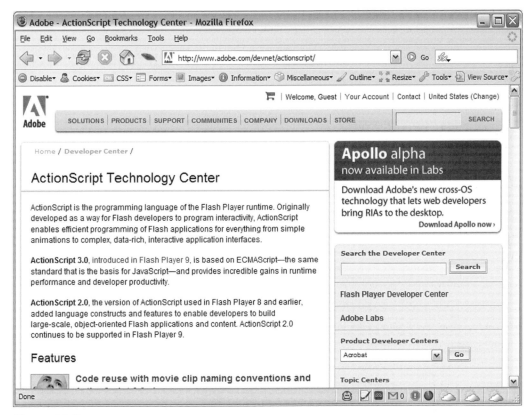

Figure 10.2
The ActionScript Technology Center on the Adobe website.

HTML/JavaScript

Referring back to the "HTML/JavaScript" section of Chapter 4, you'll find information on Geoff Stearns' SWFObject and Bobby van der Sluis' Unobtrusive Flash Object (UFO). Neither of these is only for embedding banners, and in fact, either of them can (and should) be used to embed any Flash movie at all including microsites. The methods of using them are the same as they are for the banners. The main difference is the HTML you will end up placing in the containing div and we'll talk more about that in the next section. If you haven't read it already, turn back to Chapter 4 and read about SWFObject and UFO.

No-Flash Backup

I can't imagine why some users choose to disable the Flash Player in their browsers. I'm not sure, but maybe I can't imagine that because I'm a Flash developer. At any rate, it happens and we need to be prepared for it. There are several options to choose from when it comes to a no-Flash backup, so let's talk about some of them and you decide which is best for your project.

One option is to present users with an image or some text that lets them know that they need Flash to view your site. While you may choose to take this route, there are some downsides that go along with it. If you limit your site to Flash only, you limit the reach of your client's information. Your client is trying to sell their product and they are relying on you to help them do that. If you have any control over it, you should avoid this option and save it as a last resort.

Another option is to have a landing page that gives the user an option of a Flash site or a non-Flash site. This option at least lets the Flash-disabled person get to the content of the site. But who likes the old "choose your own adventure" landing page anymore, right? So what if we take advantage of SWFObject or UFO? If the user's Flash Player is disabled they'll get to see the HTML you placed inside that div we keep talking about. Well now, you've just saved your audience from an extra click and took care of it for them while also making sure they were able to get to the information they were trying to find in the first place. That's awful thoughtful of you and you deserve a pat on the back. So what about the fact that you've only built one page worth of information within that div? Build a menu into that page for access to other pages. In other words, build it as if you were not building a Flash site at all.

With the site behind the site, you are allowing full access to all of the information that you are trying to get to the user. Also, by using the same information in the no-Flash site that you use in the Flash site, your information can be found by search engines and that's obviously another plus. In order to handle the links that will be indexed by the search engines, you'll want to include some form of deep linking into your Flash site. Let's jump in to another scenario real quick: Pretend for a moment that a user is searching for a product that your client sells. He or she presses the search button and a link to the microsite you've built is within the results. This link could appear in many ways depending on which language you've chosen to write your no-Flash site. One example might be PHP where the link looks something like this: http://www.yoursite.com/pages.php?p=prod. The important part of that URL is the variable "p" on the end. We'll take the value of that variable, pass it in to the Flash site, and have the Flash site respond accordingly. In our scenario, the value of p is "prod" and we know that we want to see the products page.

Author's Tip

While I use PHP as the example language in my no-Flash site scenario, keep in mind that you can use your language of choice as long as you pass the correct variable in to the Flash site. I remember a particular project I worked on that used Ruby on Rails for the backend. The deep linking worked in such a way that the URL might read "http://www.yoursite.com/123" and the Flash movie would receive the "123" from the end and know where to go within the site.

I won't go any further into the no-Flash site itself because that's another book on another language all together. But let's go ahead and talk about deep linking.

Deep Linking

Deep linking in a Flash site is not as hard as you might first think it is. In short, the Flash movie is given a value for a variable and it goes to a particular place within itself as if the user had navigated to that place. As with most things, there is more than one way to accomplish this deep linking. **Example 10.1** should give you an idea as to how you might like to handle the issue yourself.

Example 10.1

```
switch(_level0.p){

    case "about" :

        [code to handle moving to the About Us section];

        break;

    case "prod" :

        [code to handle moving to the Products section];

        break;

    default :

        [code to handle errors or unknown values];

        [the best thing to do here is take the user to the home page];

        break;

}
```

In this example, we're using a switch statement to determine where the user is trying to go. The value for the variable "p" has been passed in to Flash at _level0 and that's where we look to find out exactly what that value is. If any of the cases in the switch statement are true, we'll need to write code to move to the intended section of the microsite. One way to do this is to call the same function that would be called if the user clicked on the menu item for that particular section.

Another option for deep linking is SWFAddress by Asual. SWFAddress works with Geoff Stearns' SWFObject to not only provide you with deep linking, but enable use of the Back, Forward, and Refresh buttons in your browser. It does this by utilizing the ExternalInterface functionality introduced in Flash Player 8 and, at the time of this writing, supports the following browsers: Mozilla Firefox 1+, Mozilla 1.8+, Camino 1+, Netscape 8+, Internet Explorer 6+, Safari 1.3+, and Opera 9.02+. To download SWFAddress and read much more information about it, visit http://www.asual.com/swfaddress/.

Collecting User Data

Microsites are a prime location to collect information about your users. They are also a great place to give those users an opportunity to sign up for information about your client. Maybe your client has a monthly newsletter that they offer from their main site, but they want potential customers to have access to it from the microsite as well. Or maybe your client wants to know if users have been to their physical storefronts and how they would rate their experience. In any case, you'll be collecting information from the users, and the forms you build will be determined by the end goal of what that information is going to be used for.

Going back to Chapter 5, "Forms and Data in Ads," remember that I talked about the amount of file size that is taken up by Flash components such as the comboBox. Do you also remember how I went on to suggest building your own custom components to save that file size? Well, while file size is still important in your microsites, it's not quite as imperative that you stay under a given amount. If you're in any kind of situation where you might be running tight on your deadline and you still need to build out a form, you might stick with the Flash components. If you need them to match the color scheme of the site, you can still skin them. However, if you have the time to create your own components or if they already exist, you can make the choice of which component to use in your forms: Flash's components or yours.

Once you have the forms built, you'll need to process and store the information being given to you. To do this from within Flash, you'll need an outside processing page. The processing page can be the same as one you might use for a non-Flash site. As a matter of fact, you could even build a single processing page for your Flash site and your no-Flash backup site. The only thing you'll need to make sure you know is the name/value pairs for the fields in the form. As with the no-Flash backup site, your processing page can be in any one of many choices of programming languages such as PHP, .NET, Ruby on Rails, etc. Once you pass the user's information to the processing page, it will be most likely stored in a database for later use. I'll get into some of those uses in just a bit, but first let's take a look at **Example 10.2** and how to pass that information to the processing page using the sendAndLoad method of the LoadVars class. For the example, we'll assume your form has a "Submit" button and TextFields labeled "First Name," "Last Name," "Address," "Phone Number," and "Email Address," as in **Figure 10.3**.

Figure 10.3

An example of a simple form in Flash.

Example 10.2

```
mySubmitBtn.onRelease = function(){

    processForm();

}

var myResultLV:LoadVars = new LoadVars();

myResultLV.onLoad = function(){

    if(success){

        [code to handle successfully processing user information];

    }else{

        [code to handle processing failure];

    }

}

function processForm(){

    var mySendLV:LoadVars = new LoadVars();

    mySendLV.firstName = firstNameTxt.text;

    mySendLV.lastName = lastNameTxt.text;
```

```
   mySendLV.address = addressTxt.text;

   mySendLV.phone = phoneTxt.text;

   mySendLV.email = emailTxt.text

   mySendLV.sendAndLoad("http://www.mysite.com/processingpage.
php",myResultLV,"POST");

}
```

Here's a rundown of what's going on in **Example 10.2**. The first thing you see in the code is the onRelease function we've assigned to the "Submit" button. When the user fills out the form and clicks on the "Submit" button, the processForm function is called. When called, this function creates a new instance of the LoadVars class and gives it a name of "mySendLV." After that, we go through each item in the form and gather the information that the user has typed in. At this point each line represents one name/value pair being passed to the processing page. These lines break down like this: "mySendLV" is of course the name of the LoadVars object we've just created; "firstName" is the name of the variable that is expected by the processing page for the textField labeled "First Name"; next is the value that will be passed with the firstName variable—"firstNameTxt" is the name we've given the textField and the ".text" property gives us the actual text the user typed in as their first name.

Now that all of the name/value pairs have been assigned to our mySendLV object, it's time to call the sendAndLoad method. The sendAndLoad method accepts three parameters as follows: a URL in the form of a string that will accept the variables you are passing (this is the URL of the processing page), a target object that will accept pass or fail information back from the processing page, and an optional HTTP method in the form of a string. The HTTP method can be either "GET" or "POST" and the default value is "POST." Once the sendAndLoad method has run and all of your variables have been sent out of Flash to the processing page, Flash will be waiting for an answer in return. This is where the onLoad method of myResultLV is called. If the processing page receives all of the information and processes it successfully, a value of "true" is handed back to Flash. However, if there are any problems in processing the data or if the page times out due to network problems, Flash will be given a value of "false." The true or false value is handled in our statement that starts with "if(success)" and appropriate code should be written to handle either scenario.

When using the sendAndLoad method of the LoadVars class, *always* include code for the possibility of a failed attempt to process information. Since computers (and thereby the Internet) are not perfect, unforeseen problems such as users losing their Internet connection or a power outage at the location of the server can occur and should be handled accordingly in your programming.

Capturing information about visitors can be used by your client to offer periodic emails such as updates, newsletters, or limited-time sale offers. Since the Federal Trade Commission (FTC) made the CAN-SPAM Act law effective in January 2004, there are a set of rules that must be followed. These rules are very important for you to know, because if they are broken, there may be legal consequences such as sizeable fines. Some of the overall rules to follow are: Don't be misleading about who has sent the email, and don't be deceptive in the subject line and give users the ability to "opt-out" of your emails.

When allowing users to sign up to receive any kind of emails from your client, you should be fully aware of the CAN-SPAM Act. If you are not familiar with this law, please take the time to learn about it on the FTC website at http://www.ftc.gov/bcp/conline/pubs/buspubs/canspam.htm.

The opt-out feature gives a user the choice to stop receiving emails from your client, and there must be backend code in place to handle these requests for a certain amount of time after you send the email. One thing you don't want to do is make your client's customers unhappy with them, and forcing unsolicited emails to their inboxes would most likely do just that.

Quality Control

You didn't think you were going to get out of this chapter without someone testing your work and trying to break it, did you? If so, think again. Everything you build should be tested by someone other than yourself and preferably by someone whose actual job description involves testing and quality control. You should send your banners through a quality control process and you should definitely send your microsites through one as well. While some microsites can be very small and live up to their namesake, some of them can be very deceivingly wide and involved. Generally, common sense tells us that the wider and more involved something is, the more potential it has to be problematic for us. You could carry that thought over to your microsites and say that the more pages, sections, and functionalities it has, the more chances there are that you'll come across some errors and bugs.

Since your microsite is most likely larger than your banners, it will require more time for the quality control person to test it. There are pages to click through, scenarios to enact, and generally much more for them to try to make it break. So I ask you this: Should they (a) wait until you are completely finished before they start testing, or (b) test while you are working on it? The best answer here is (b). For the best results on that answer, you'll need to keep in close contact with the quality control person the entire time you're working on the site. The general idea is that you do several builds in secession of one another. Your first build might consist of as little as the navigation menu. Have quality control make sure they can't break the navigation and let them know it's working by placing a dynamic TextField on the stage to tell them what section they just clicked on. From there, you add more and more to the site until you have it entirely built out. The advantage here is that quality control can inform you of bugs before they become a part of a larger problem. Now, to avoid the fact that they can't really test something that you keep changing while you're working, you'll need to set up two environments: the development environment and the staging environment.

Author's Tip

When working with gradual builds of a site for quality control, be sure to let them know of any issues you are already aware of and working on. Also let them know of parts of the site that are in progress and will probably break. This will keep quality control from spending time on nonbugs and it will also keep you from having to sift them out.

Development Environment

The development (dev) environment is where you'll do most of your own testing and work on your microsites. The environment for each site will differ according to the site itself and the dev server should be set up exactly how the live server will be. If the final live site will be using Linux, Ruby on Rails, and a MySQL database, that's exactly what should be set up on dev. Since this is the first place you'll be able to tie your Flash work in with the backend, this area should be thought of as your development team's own private sandbox. Anyone looking at the site on this server should most likely expect bugs and glitches right up until the end of the project.

While accessing data that reside on the dev server is completely possible from your local computer, you should also be sure to test your Flash movies from the server as well. Since the development environment is set up to mimic the live site, it's an excellent source for discovery and problem solving. You may find the occasional issues that arise only after you move your files to a server, and you'll be able to solve those problems before the site goes live.

Staging Environment

The staging environment should also be set up to mimic the live site. Since the backend languages, databases, server software, and anything else that may be specific to the site are all the same as the dev server, you can simply move your files over once they are ready to be tested by quality control and viewed for internal approval. You can think of the staging environment like a rehearsal of sorts where your site is practicing to perform for the world.

Conclusion

As you can see from this chapter, there are a few similarities between building a banner and building a microsite. However, there are also many differences like menus, pages, deep linking, etc. A big part of either project is planning. Without a good plan, your site can very easily start to spin out of control and be hard to get back on track. Once you have a plan in place, you can start collecting assets you'll need to build the site (don't forget about the fonts your creative person used in the layout). Something else I talked about in this chapter was standards; standards by means of accessibility and standards by means of naming conventions used for your files, objects in Flash, code, etc. Having your files and code set up in such a way that it is completely understandable and reusable is a great thing and making

sure your site is accessible to users with disabilities is very important. After the standards, I went into the topic of the HTML page that houses your Flash files and "the site behind the site" that allows users without Flash to still access the information they are trying to reach. Additionally, I talked briefly about deep linking into your Flash movie and gave both a quick and rough example of how to do so, and a little information on SWFAddress by Asual. Beyond those topics was discussion on collecting user data and then into quality control where I talked a bit about the different environments you should use while building a microsite. In Chapter 11, I'll be giving information about driving traffic (visitors) to your newly created microsite.

CHAPTER 11

Driving Traffic to Your Microsite

The specific purpose of any given microsite may be as individual and unique as the site itself. The site's intention may be to educate and inform its visitors about a product or to simply entertain them with games and videos while exposing them to your client's brand. However, there is always an underlying objective of any microsite created within the advertising domain: brand/product awareness and interaction. When users come to your client's microsite, they should be able to later recall whose site it was when they think of it. If they do remember (and they remember for the right reasons), the site was a success. But before they can remember your client's microsite, they need to be told it exists, and they need some sort of vehicle to drive them there. The topic of this chapter deals with the step that takes place prior to the users' interaction with, or even knowledge of, the site.

There are several ways to get your client's potential customers to visit their site. Some of those ways cost a little money and some of them are literally as free as talking to a friend. In this chapter, I'll cover several options to drive traffic to your microsite and those options will be spread across the following sections:

- Paid Search
- Banner Ads
- To the Microsite from the Main Site
- Word of Mouth (a.k.a. Viral Marketing)
- User Interactions and Referrals

Paid Search

One of the most valuable ways to drive users to a Flash microsite is by way of a paid search. In a nutshell, you're actually purchasing words and terms in a search engine such as Google or Yahoo. When people do a search for those words, your microsite is displayed in the results. While your site may also find its way into the results based on unpaid (or natural) search terms, this takes time. And since many microsites usually have a limited life span, time is something that may be against you here.

Another advantage that paid search has over natural search is guaranteed placement. By purchasing search terms, you are ensuring your client a spot in the search results that they may not get by means of natural placement. As for how high in the results your client's microsite is placed, each search engine determines its ranking differently. While some search engines actually base the placement on who paid more for a given search term, others have formulas they use to determine the order of the results. One example is that a search engine may take into account how much was paid for the search term, but they also look at the click-through rate for each placement. By figuring in how many people were clicking on a placement after searching for a particular term, the results are more accurate and relevant to the term itself. That extra bit of sorting can make all the difference of where your client's site ends up on the list of results.

Author's Tip

When you are choosing which search terms to purchase, be sure to keep the list relevant to the industry, client, and site. If your client is in the automobile industry, it wouldn't make much sense to purchase a term like "waterslide" or "baseball." While those examples are very clear, there are terms that are less obvious but just as irrelevant. On top of being bad practice and a potential waste of advertising dollars, some search engines will check the relevancy of your terms to make sure they are in line with the advertised site.

Small Costs, Big Results

With costs starting as low as $0.10 per click on the larger search engines, paid search consistently has the lowest cost per acquisition of any outbound marketing you can do for a microsite outside of viral marketing, which I'll cover later in this chapter. While you can find some cases of the cost reaching up to $100 per click in certain industries, most terms will fall within the lower range of $0.10 to a couple of dollars.

When you talk about the actual price of a search term, there are a few factors that come into play. For example, if you're looking at buying a very broad term that is more likely to be searched more often by more people, you'll have to pay more money. On the other hand, a very specific search term is going to cost less money. Let's say you purchased the term "code." That term could apply to an extremely wide range of results, and the reason for the higher cost in this case is because your microsite will be included in the results of everything from computer code to morse code to state code (law). However, a more specific term like "ActionScript" is going to be searched by a smaller group of people and, therefore, your site will be included in fewer results. You may be wondering why it costs more for the broad term when you're going to end up in less relevant results. The reason for the higher rate is the popularity of the term itself and how many other companies have also purchased it. While it would sometimes be smarter to spend less money to reach a more targeted search audience, there are times when the broad term will be worth the extra dollars. For instance, if within one month the targeted term yields 30 clicks that result in 5 conversions (the user purchased, signed up for email, etc.) and the broad term yields 300 clicks resulting in 50 conversions, it was probably worth spending the extra money.

Targeting Your Search Terms

When you purchase your search terms, you'll have other options to choose from to further define your target audience. Some of the options will make the target more refined and narrow and some others will widen the target to reach even more people. How you choose between them will change from project to project and client to client.

Matching

When people do searches, they are less likely to search for a single word than they are for a phrase. For that reason, you will want to look at some of the matching options for your terms. One of those options is called *broad matching* and it basically watches for your word to be used in any search that is performed. If you have purchased the word "car," then broad matching will return your site in the results of searching for everything from "car dealer" to "car wash" to "new car." The upside to broad matching is that you get exposure to thousands of search phrases, but you only had to set up one term. The downside is that your site may end up in irrelevant results. However, remember that more results can equal more clicks, which can equal more conversions, which means more return on investment.

Another matching option is *phrase matching*. With phrase matching, you have actually purchased a phrase as opposed to a single word. An example of this might be that you have bought the phrase "car dealer." Phrase matching will make sure that your microsite is returned in the results when people search for that particular phrase, but not variations of it. In other words, your site will show up in a search for "car dealer," but not in a search for "dealer car."

Yet another form of matching is *exact matching*, and, just as you might suspect, your microsite is only included in the results if a user searches for the exact term that you've purchased. Both phrase matching and exact matching will put your site in more targeted and relevant search results.

Another way to further target specific searches is to create a negative keyword list. This list is used in conjunction with the broad matching to weed out any searches that you know you don't want to be included in. Sticking with the search term "car," let's say your client is a car dealership and they don't want their site to show up in a search for "car wash." Simply add the word "wash" to the negative keyword list and the search engine will make sure that the site is omitted from those results.

Text Ads

Text ads (also known as sponsored links) are the text-based advertisements you see (usually on the right side of the page) when your search results are returned to you. The search engine will determine which text ads to display based on a number of factors, including the amount paid for the advertisement and the relevance to the term that was searched. While the amount you can actually say in any given text ad may change a little from search engine to search engine, the format is generally the

same across the board. Typically, you'll be allowed to include a headline, a couple of lines of copy, and a URL for the advertised site. Because of the limited amount of text allowed in these ads, it's important to have good copy written that gets right to the point while still enticing the user to click on your ad instead of the others around it.

One thing to look for when purchasing text ads is the process the search engine uses in getting the ad running for the first time. While some of them allow your ad to show up immediately after you make the purchase, some others will require you to run your ad through their approval processes prior to it being launched.

Contextual Advertising

Some search engines offer another extremely valuable option that you can sign up for: contextual advertising. At the time of purchasing your search terms, you can also spend a little extra marketing money to have your microsite show up in ads that are running on other sites. Blogs are a great place to find contextual advertising happening, and if you're familiar with Google AdSense, then you've seen an example of contextual advertising in action. The way it works is that the search engine has a system running that reads the content of the site on which the ad is being shown. If that system finds terms that match those that you've purchased, a link to your site will be included in the rotation of ads on that particular site. Contextual advertising is so valuable because it's a winning situation for everyone involved. Every time a user clicks on one of these ads, the site that is running the ads gets revenue, the search provider generates revenue, and your client's microsite gets another visitor and possibly a new customer. On top of that, the chances that a visitor will be interested in your client's brand is fairly high due to the search for relevant terms on the site he or she is already reading.

Banner Ads

Using banners to attract visitors involves more than simply creating a link in an ad and hoping people accidentally click on it. You definitely shouldn't trick them into clicking your ad by presenting them with a fake close button, a fake form to fill out, or anything else along those lines. Tricking your users into visiting your site will only turn them against your client. Instead, your viewers should be enticed or intrigued enough by your banner that they want to visit the site at their own will.

Design Matters

The design of your ads will have a huge impact on whether or not people want to interact with it and visit your site. If they find the ad "attractive," human nature makes them much more likely to be tempted to click on it to see if the destination is just as nice. In addition, they will be quicker to click on an ad that clearly lets them know that they are going to be taken to a place they are interested in.

In addition to designing your banners in a visually pleasing manor, consistency will help attract users to the ads and subsequently to the site itself. The consistency of the banners should be thought of on a few different levels of design. Not only should you pay attention to making sure the banners all look alike, but they should have similar animations as well. By doing this you ensure that no matter what size banner users see from this campaign and no matter where they see it, they'll recognize it. If a user previously clicked on one of the banners from the campaign and liked the site, he or she will probably click on another one that looks and acts the same. Keep in mind that the consistency should not stop with the banners themselves, but should also tie the banners to the site. This consistency from banner to site will help ensure a more smooth transition from the site a user is currently visiting into yours.

Keep Your Promise

When a user clicks on your banner ad, he or she is usually expecting something in particular at the site he or she is being taken to. That something is whatever you have told users that they should expect when they first viewed the banner. Delivering on your promise is not only good business, but it's something that will drive traffic back to your site after the initial visit. If users click on a banner because they are expecting to fill out a form for travel reservations, then that's what they should get. However, if they get to the site and can't find the form, they may become frustrated and go elsewhere to book their travel plans. Once that happens, they'll only remember that they had difficulty on your client's site and they may not return at all.

To the Microsite from the Main Site

Another form of driving traffic to a microsite is by way of the main website. Since your client probably owns their own main website, then driving traffic from there to a new microsite is going to be extremely low cost when compared to a banner campaign. The fact that they won't have to pay for the actual placements on their own site is one thing that helps keep the cost down. In addition to the lower cost,

you can rest assured that the people viewing the site (and the advertisement) are all but automatically your target audience. Since they are visiting your client's main website, you know that they are already aware of, and interested in, the brand. They can be considered the largest built-in audience of the new microsite, and all they need now is a little push in the right direction.

Highlight and Promote

The push users need can come in several different forms and the one that's best is dependent on the website and even the brand itself. One approach would be that the website has a section on the home page that is reserved for featured products or services. This may be an area where a client typically advertises a sale or another upcoming event. If your client has taken the time and spent the money to have a microsite built for a particular product, chances are pretty high that they won't have any problem at all using that promotional area to advertise and drive traffic to that microsite. There may be other areas within the main site that can be utilized for making visitors aware of the new microsite, but the goal is the same throughout: Highlight and promote the new product or service for which the microsite was built.

Send Them Back

Where the main site is a great source of traffic for the microsite, the same can be said in reverse. There are some clients that are naturally very good about keeping users flowing in both directions and then there are those that you'll need to explain this to. While a microsite is focused on a particular product or service that your client has to offer, it's smart to try to influence users to also visit their main website to find more. Once they visit the main website, they may find products or services that your client has to offer that they were

Author's Tip

I made a brief mention earlier in this chapter about the often short life span of microsites, and while it would be nice to leave them up for an extended period of time, it doesn't always work out that way. This means at some point there's going to be a virtual hole where the microsite used to live on the Internet. If users have visited the site before and found it to be useful, they may try to come back only to find it has gone missing. Rather than leaving them wondering what happened, it's a good idea to redirect them to your client's main website. To leave even less room for confusion, it's a better idea to redirect them right to the product's specific page. For example, if you were to visit a microsite for a certain model car and that microsite no longer existed, the best scenario would take you to the page about that car within the auto manufacturer's main website.

previously unaware of. And who knows, they may even be interested in buying those other items. Another advantage to driving users to both sites from within both sites is link popularity. For every link and every click from one site to the other, that destination site's link popularity grows, which, in turn, raises that site in search results. With that said, I should point out that it's a bad practice to overload your sites with links to each other just for the sake of raising their popularity.

Word of Mouth (a.k.a. Viral Marketing)

If the site is designed and built right, users will walk away remembering not only the information they learned or the fun game they played, but they'll be able to tell their friends and coworkers whose microsite they were visiting and the URL to get to that site. Believe it or not, this is actually a form of advertising that goes by different names like "word of mouth" or "viral marketing," and they say it's one of the best forms of advertising available. For one thing, outside of the initial expense to get it going, it's free of cost. The other great aspect is that it seems to be in human nature to listen to and trust people we know much more than we listen to or trust typical advertising. If a friend tells you about a website they visited, chances are you're going to give it a visit, because if your friend liked it, it must have been good and you're guessing you'll like it as well.

One of the great things about microsites is that they are so perfectly built to accommodate viral marketing. If you think about how many times you've suggested a site to a friend or how many times you've been told about a site, you'll start to see that those sites are microsites more often than they are full corporate/company websites. When you have a site that is centered around one specific idea, product, or service, you're able to put more focus and energy into that one item. With that energy, your creations can dig further into the realm of entertainment and that's when you start to hit on the things that people talk about and pass around to each other.

Inside the Industry

 "Viral isn't about how you get someone to your microsite; it's about what happens after someone leaves your microsite."

—John Keehler, Strategist, Click Here, Inc.

Generating a Buzz

Before people start talking about your site, those first potential visitors will need to know it exists, right? After all, if nobody ever sees it then nobody will be able to talk about it. This somewhat wraps back around to using the other forms of driving traffic to your site previously mentioned in this chapter, because those other methods can be used to generate the initial buzz. Then, once people have started talking about the site and passing the URL around to their friends, you can phase those methods out and let the site advertise itself.

Internal Kick-off

A great first step that most companies, clients, agencies, freelance developers, etc. can (and should) do in their attempts to generate buzz about a new microsite is to kick-off the site internally. If you work for an advertising agency, send a notification out to everyone letting them know to check out the new site that your company has just launched for their client. Additionally, you may make a suggestion that your client does the same within their offices. When your client's employees start visiting the microsite, they'll most likely pass it on to their friends and family. Speaking of friends and family, let yours know about the microsite as well. After all, you should be proud that you've been a part of the huge effort that has taken place to make it happen.

Seed the Link

Another way to kick-start word of mouth are blogs. I think it's pretty safe to say that there are a large amount of people who maintain a blog of some sort. Whether they maintain it on their own website or they use one of the many available blogging networks, they are out there and you can utilize them. One way to do this is to find bloggers who are already writing about the brand you are promoting and make them aware of the new microsite.

ALERT Blog spamming (also known as comment spamming) is a very bad practice and it should be avoided at all costs. To avoid blog spamming, simply avoid talking about or posting a link to the microsite on blogs that are irrelevant to the subject matter of the microsite itself. Just remember that if you are going to plug your work in the comments of someone else's blog, either have the blogger's permission to do so or make very sure it fits within the flow of conversation.

There are several ways to find the people or interest groups that are writing about the brand and one of those ways is Technorati (http://www.technorati.com). Technorati allows you to search blog posts from all over the world for a certain term such as your client's company name. Once your results are returned to you, you have a couple of sorting options at your disposal such as authority and language. The authority option uses link popularity along with other factors to determine which blogs historically have the most (or least) authority on the subject of your search. Choosing to include those with less authority will yield a larger number of results, while choosing to show only those with a lot of authority will do just the opposite and lower the number of results shown. This feature may come in handy when you're looking for a person who manages a blog that has many readers and that has posts talking about your client's brand. After finding those individuals, you can proceed to contact them via email to find out if they are interested in writing about your client's new microsite.

ALERT When contacting a blog owner about potentially writing a piece about, or including a link to, your client's new microsite, always be up front and honest about the fact that you work for the advertising agency that created the site (if you created the site on your own and don't work for an agency, you should still inform them as to who you are). Not only is it better business to be honest about such things, but the blog owner will appreciate that honesty and will be more likely to want to help you out. If you decide against informing the blog owner about who you are, you run a high risk of him or her figuring it out later down the line. If that happens, not only will he or she probably remove the story/link, but you can bet he or she will never trust you again after that point. Additionally, it could end up completely reversing the blog owner's thinking about your client.

In addition to contacting other blog owners, you can also write to your own blog to help promote the new microsite. For example, I maintain a blog in which I talk about Flash-related topics. Each time we (Click Here, Inc.) launch a new site that is built with Flash, I write about it on my blog. While my intention is simply to share our work with the online community, there have been times when people have

read my blog, visited a site I wrote about, and subsequently wrote about the site on their own blog. From that point, this scenario can very easily turn into the classic "I shared it with two friends, they shared it with two friends, those friends each shared it with two friends, and so on." With that, you can see how it can spread quickly without much effort on anyone's part. As a matter of fact, it's that viruslike spreading that gives it the name "viral marketing."

Targeting Specific Blogs

Another way to advertise your microsite on blogs is by actually targeting them individually. The difference between using a contextual network and using a blog advertising specialist such as Blogads (http://www.blogads.com) is that you can choose which blogs your ads will appear on. You can start out by sorting through a list of highly visible and influential blogs and then you can narrow your target down as far as you want. For example, you might want to target blogs that are only read by car enthusiasts. Or maybe you want to target Flash developers. Or you could even narrow it down further by targeting Flash developers who are car enthusiasts and live in Dallas. Targeting specific blogs in this way can give you visitors who are interested in topics and products that somehow relate to your client's microsite.

User Interactions and Referrals

I think it's safe to say that you can learn a lot about what people like by physically watching what they do, where they go, and even who they interact with. The same is true for those people when they visit a microsite. The only difference is that you are looking at a virtual trail of actions they left behind. While tracking the sections a user has visited in a Flash site requires a little help from another language outside of Flash (JavasSript, php, etc.), the benefits can be very rewarding in terms of knowing what steps you need to take next in your efforts to bring even more visitors to the site.

What Do Users Like?

You can build your own custom tracking scripts or you can do it through one of several companies like WebSideStory (http://www.websidestory.com) who actually specialize in this field. Using either your scripts or the products these companies have to offer, you can get various reports on items like which areas of the site were visited more. Once you know which particular areas of the microsite interest users the most, you can apply that information to the next banner campaign by highlighting those sections in the creative.

Where Do Users Come From?

Another highly valuable piece of information is to know where your visitors actually come from. A lot of Web hosting companies will provide you with site statistics that give you a list of referrers for your site. Those referrers have a link somewhere on their website that directs *their* visitors to *your* microsite. If your hosting company does not provide site stats or if you (or your company) are hosting the microsite yourself, you may need to look into other ways of getting your referrer reports. There are many options out there ranging from expensive solutions that need to be installed on your server to free solutions like Google Analytics. And just as there is a range of cost for the different solutions, there is also a range of features and details with each solution (which should not actually be judged by the cost).

Regardless of which direction you use to get your list of referrers, that list can help you enhance and fine tune your next (and even current) campaign. By reviewing the list, you can find new referrers as soon as they appear. As a kind gesture, and to open a new relationship with a potential future referrer of your work, it's not a bad idea to send certain new referrers an email thanking them for linking to your microsite. Of course this depends on the kind of site it is, what they had to say about the site, and a few other factors that you'll have to judge for yourself. Additionally, if you find that one of two sites are sending a much larger number of visitors than any of the other referrers, you may want to go ahead and plan on contacting them in the future to see if they would like to promote other projects.

Conclusion

To wrap this chapter up, remember that part of the effort that should be put into a microsite project is getting people to visit it. There are many ways to get people to come to your new site. Some of those ways cost money all the way through the project and eventually in the end, while others cost a little bit up front but resolve to no cost in the end. On top of being virtually free, word-of-mouth advertising can last just as long as people are still talking about it. There are even times when the talk may die down for several months only to have someone bring it back up to their friends at a later date (which could stir the viral effect back into motion).

Don't forget that search engines can be your very best friend when you want to drive people to a microsite. By utilizing their paid search terms, you can guarantee your client a spot in the list of results returned on a search of a given word. Additionally, some search engines also tie in with blogs to offer an additional point of contact

with potential customers. In the end, the benefits of using paid search far outweigh the cost involved with doing so.

Another avenue clients (and sometimes even agencies or developers) forget about is that of the client's main website. There are not many reasons I can think of that would prevent you from linking from the main website to the microsite and vice versa. The visitors are already there, they are already familiar with the brand, and they obviously like it enough to be at one of the two sites in the first place. Why not take advantage of that built-in audience and offer them a way to get to the other site to find more entertainment or information about the brand?

Don't rule out getting other people involved in your viral marketing. Send emails around notifying friends, family, and coworkers about the launch of the site. If you maintain a blog, write about it to let the world know of your company's wonderful work. Contact other blog owners who are already interested in your client's brand, and, after telling them your intentions and who you are, most people will be more than happy (and even thrilled) to be a part of the advertising effort. Some of those blog owners are even signed up to blog advertising networks on which you can purchase space to run your ads. By utilizing a blog advertising network, you can run your ads on blogs that you have targeted based on as specific of a criteria as you see fit.

Finally, keep an eye on what your users are doing while they are visiting your microsite. If you keep reports on areas of higher interest, you can better tailor your next campaign to fit what your visitors want to see. In addition to paying attention to what they are doing while they are on your site, you should know where they were prior to getting there. With that piece of information, you can do things like run ads on sites that have sent a high number of visitors to your microsite or contact the sites directly the next time you launch a similar project.

CHAPTER 12

Advertising Examples

In this chapter I'm going to show some examples of actual client work that I have been a part of. These examples are not intended to be case studies, but rather a way to illustrate some of the possibilities that exist when it comes to using Flash for online advertising. I've broken this chapter into the following sections:

- Rich-media Banners
- A Simply Perfect Microsite

Rich-media Banners

As you may have guessed by the title of this section, the following examples were designed and created to utilize some of the technologies that were covered in Chapter 7 and are made available by rich-media companies.

Simply Perfect Dynamic Debate Ads

Client: Patrón Spirits
Target website: http://www.simplyperfect.com

Figure 12.1
The three main frames of a Simply Perfect Dynamic Debate ad.

While the banners in **Figure 12.1** may look like standard Flash banners with no special technology in place, there are things happening behind the scenes that require the ability to load external content. More specifically, they load a feed in the form of an xml file from the website that they promote. The ads were placed on several different websites and the content of each ad could be easily altered to reflect the most current up-to-date information that also tied in with the content of the website itself. For example, if the ad was placed on a financial website, the content could be changed to a topic dealing with something like stocks and bonds. If the ad was running on a sports-related website, the content could be changed to talk about football, baseball, hockey, soccer, or any other sports topic.

For each size of these ads, a single fla file was created that contained a variable that held the name of the website on which the banner would be shown. If the media plan for this campaign called for six 160 × 600 banners to run on six different sites, the single 160 × 600 fla was published six times with a different value given for the variable in each one. The second piece to the puzzle was an xml file created specifically for the 160 × 600 banners. The xml file contained information pairing up the value of the variable with a topic ID number. In **Table 12.1** I've given fictitious examples of how these associated values would pair up. Once each banner had its assigned topic ID number, that number was then passed to the Simply Perfect website, which answered by returning the content for the banner to display. In these particular banners, that content was two sides of a debate and the percentage of people who had voted or discussed each side.

Table 12.1
Example of Websites and Associated Topic ID Numbers

Website	Topic ID Number
Sports site	99
Entertainment site	98
Music site	428
Nightlife site	616
Business site	81

After the banners were trafficked, the only thing that needed to be changed to keep the content fresh was the values in the xml file. As you can imagine, that simplicity not only cut down the production cost of new iterations of these banners, but also made it incredibly easy and fast to keep the banners up-to-date with hot topics of discussion.

Pork on Tour

Client: National Pork Board
Target website: http://www.theotherwhitemeat.com

The idea behind the Pork World Tour banners (**Figure 12.2**) was to bring a fun change to the dinner table. The overall National Pork Board campaign at the time was titled "Don't Be Blah"; and what better way to avoid being "blah" than to breathe life into a pork chop and turn him into a guitar-wielding reggae/country/jazz/blues/rock-n-roll star?

The ads were designed and built as music videos in which our pork star sang about different recipe ideas for the audience. The songs themselves were recorded in studio and one of our art directors even went the extra mile to sing and play guitar on a couple of the tracks. Once the songs were recorded, edited, and finalized, it was time to start the animations. Each of the animations was built as a "traditional" timeline animation, and care was taken to ensure the movement went in-line with the song itself. Upon completing an animation, it was exported out as an flv (Flash video) file with the audio included. Another file was then created that essentially contained only the "stage" on which the star of the show would perform.

The Pork World Tour banners are a good example of using timeline animation with original audio to create an animated video banner. And since the videos were also set up in the "Fun Stuff" section of the National Pork Board's main website, they are also a good example of engaging users in something fun that they can pass along to their friends for a smile (which can very easily turn into viral marketing).

Figure 12.2

Shots from Pork World Tour video banners.

A Simply Perfect Microsite

Client: Patrón Spirits
Website: http://www.simplyperfect.com

The microsite http://www.simplyperfect.com was very fun to work on and is driven by user-generated content. The general concept of the campaign was that while some areas of perfection are debatable, the perfection Patrón Spirits is not. The main page of the site (**Figure 12.3**) displays a virtual world of debates laid out across the screen. To browse through the different debates, a user would simply move his or her mouse around the screen and the debates would react accordingly. If a visitor was having trouble finding a particular discussion, he or she could resort to the search functionality to see if any debates contained a word he or she was looking for. Likewise, the same visitor could sort the debates by the category under which he or she was originally submitted.

Debate Your Topic

One of the great things about the http://www.simplyperfect.com microsite is the fact that visitors (and administrators) can create new topics of discussion as those topics become hot areas of current debate. For example, a fan of a certain football team may use the form in **Figure 12.4** to submit a new debate about his favorite team versus their biggest rival a week before the two teams are scheduled to play against each other. And since the range of categories is fairly wide, almost any visitor can usually find a debate in which he or she would like to voice his or her opinion.

Once a debate is submitted and approved by the site administrator, it is open for discussion. While some debates attract a large amount of users and others attract less, all are capable of accepting user input in the form of writing and/or uploading audio or video files of themselves making their point on the topic at hand. **Figure 12.5** shows a debate in which many people have weighed in on both sides and a video is playing at the top of the discussion area.

Microsite Television

The Simply Perfect campaign was spread across multiple forms of media from online to billboards to magazines to television. Since Flash affords us the ability to include video with such great quality, the television commercials were converted and placed in the http://www.simplyperfect.com microsite for users to watch and enjoy (**Figure 12.6**).

Figure 12.3

The main page on http://www.simplyperfect.com.

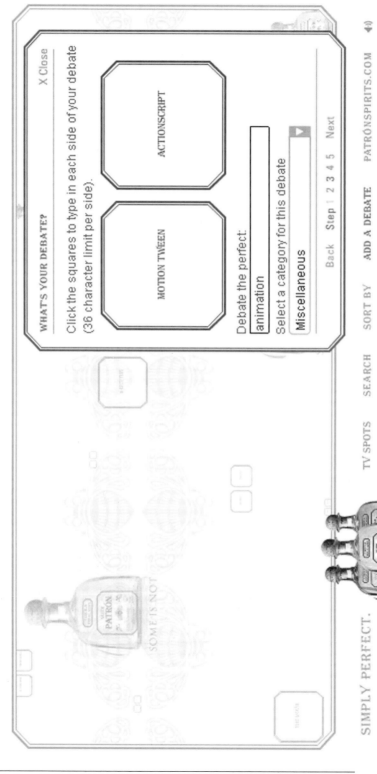

Figure 12.4
The new debate submission form.

Figure 12.5

An active debate within http://www.simplyperfect.com.

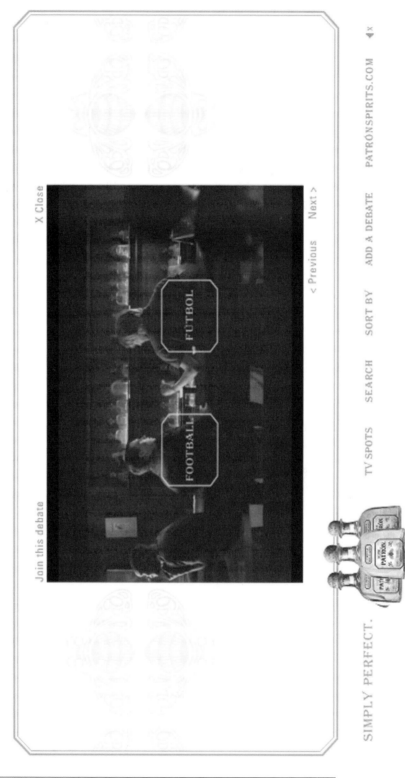

Figure 12.6

The Simply Perfect television commercials within the microsite.

Conclusion

As I mentioned at the beginning of this chapter, the above examples illustrate possible directions that can be taken with Flash advertising. While these are only a few examples, there are many, many more out there that you have most likely come in contact with at one point or another during your time online. It's always a good idea to keep track of microsites that catch your attention in one way or another and to remember banners that grab your eye as well. By creating your own list of examples, you can refer back to them during those times when you need a little kick of inspiration to draw from. While it goes without saying, I would like to add that your list of examples should be used only for inspiration of new ideas and not for actually copying others' thoughts and designs.

CHAPTER 13

Snippets and Classes

Some developers prefer to contain all of their code in classes or external .as files, while some others are more comfortable having their code on the timeline, and still others find that there are times for both depending on the project at hand. In this chapter you'll find helpful, reusable code and classes. The code for each piece will be followed by an explanation about what's happening within it. These snippets and classes can also be found on the website at http://www.flashadbook.com/code/. There are only two sections in this chapter, and you might have guessed that they are:

- Snippets
- Classes

Snippets

Snippets can be very useful when you see that there are tasks or functions that you create and use over and over again. Rather than rewriting the code every time, it's a good idea to save pieces of it that can be moved from project to project. Following are a couple of snippets of code that I've found useful in helping me add a little speed to the process of building either banners or microsites.

Full-stage Button

The full-stage button snippet is one that I use quite frequently when I'm working on banner ads that require only linking to a single location. Since I found myself constantly creating invisible buttons that covered the entire stage, I figured I'd write up this quick little helper to cut that monotonous step out of my production.

The Code

```
var myBtn:MovieClip = this.createEmptyMovieClip("myBtn",this.getNextHighestDepth());

myBtn.beginFill(0x000000,0);

myBtn.moveTo(0,0);

myBtn.lineTo(Stage.width,0);

myBtn.lineTo(Stage.width,Stage.height);

myBtn.lineTo(0,Stage.height);

myBtn.lineTo(0,0);

myBtn.endFill();

myBtn.onRelease = function(){

    getURL(_level0.clickTag,"_blank");

}
```

The Explanation

The first line of code in the full-stage button snippet simply creates a new empty MovieClip instance (I've given mine the name "myBtn," but you can give it any name you like). Since the default x and y locations of a newly created MovieClip are both 0, we don't actually need to set them:

```
var myBtn:MovieClip = this.createEmptyMovieClip("myBtn",this.getNextHighestDepth());
```

The second line uses the beginFill method of the MovieClip to indicate that it's about to start drawing a shape that needs to be filled with the color and alpha values indicated in the method's parameters, respectively:

```
myBtn.beginFill(0x000000,0);
```

Once the beginFill method has been called, lines 3–8 draw the invisible shape by using the width and height properties of the Stage Object, which is exactly what you might think it is: the "stage" (or virtual canvas) on which your work is displayed:

```
myBtn.moveTo(0,0);

myBtn.lineTo(Stage.width,0);

myBtn.lineTo(Stage.width,Stage.height);

myBtn.lineTo(0,Stage.height);

myBtn.lineTo(0,0);

myBtn.endFill();
```

Last, but not least, an onRelease handler is added to our MovieClip and tells it what action to take in the event that a user clicks (and subsequently releases his or her mouse button over) our invisible button:

```
myBtn.onRelease = function(){
    getURL(_level0.clickTag,"_blank");
}
```

Simple Preload Text

Preloaders have been built and coded many times and in many different ways. As a matter of fact, they're used enough that there are preloader components that can be used in your work. However, it's rare that you'll want to use the same exact preloader from client to client and from project to project. Since I noticed that being the case in my work, I put the following snippet together to use as a starting point and sometimes even as the entire preloader. Since putting this small piece of code together, I've used it in many different modified variations for many different projects. The description of this snippet is very simple: It creates a TextField and displays how much of the Flash piece has loaded. Once it is fully loaded, the TextField is removed from the screen and the Flash movie carries on to its next step.

The Code

```
stop();

this.createTextField("loadText",this.getNextHighestDepth(), 100, 100, 0, 0);

loadText.autoSize = true;

this.onEnterFrame = function(){

    var loaded:Number = this.getBytesLoaded();

    var total:Number = this.getBytesTotal();

    var percent:Number = loaded/total;

    loadText.text = "Loading: " + Math.round(percent*100)+"%"

    if(percent == 1){

        delete this.onEnterFrame;

        loadText.removeTextField();

        this.play(); //Replace this.play() with code telling your movie what to do
next

    }

}
```

The Explanation

The first thing to do is stop the movie from playing any further by simply placing a stop command on the first line. Next, a textField is created on line 2:

```
this.createTextField("loadText",this.getNextHighestDepth(), 100, 100, 0, 0);
```

The parameters used to create a textField are as follows: createTextField(instanceName:String, depth:Number, x:Number, y:Number, width:Number, height:Number). As you can see, we've given our textField an instanceName of "loadText" and a depth using the getNextHighestDepth() method, which does exactly what it says. Next, we set both the x and y to 100. This number should obviously be changed depending on the size of your stage and the design of your work. Finally, we come to the width and height parameters, which are both given a value of 0. This may not make sense on the surface and some might wonder why you would even include the numbers if you're only passing 0. Well, the answer is pretty simple: Flash won't create the textField without the parameters, so the 0 is okay to pass because of the next line in the code, line 3:

```
loadText.autoSize = true;
```

The autoSize property of a textField does a couple of things based on the value you give to it. The acceptable values for this property are "none" (default value), "left," "right," and "center." However, you can also assign a value of true or false to achieve your desired outcome. If you set the value to false, it's the same as setting it to "none" or not assigning anything at all. If you set the value to true, it's the same as setting it to "left." By assigning a value to the autoSize property of our loadText textField, we're telling it to expand as much as it needs to in order to accommodate the text we're asking it to display. The direction it expands is determined by the value we assign to autoSize. A value of true or "left" will tell the textField to expand to the left, "right" will tell it to expand to the right, and "center" will tell it to expand in both directions at the same time. Getting back to the code, the fact that the textField will expand as much as it needs to is the reason it was okay to give it a width of 0 when it was initially created. Next is the function to update the text with the loaded percentage of the Flash piece; this takes place on lines 4–14:

```
this.onEnterFrame = function(){
    var loaded:Number = this.getBytesLoaded();
    var total:Number = this.getBytesTotal();
    var percent:Number = loaded/total;
    loadText.text = "Loading: " + Math.round(percent*100)+"%"
    if(percent == 1){
        delete this.onEnterFrame;
        loadText.removeTextField();
        this.play(); //Replace this.play() with code telling your movie what to do
next
    }
}
```

The function to update the percentage is an onEnterFrame function, which means that the code within is executed at the same frame rate as the movie (or at least as close to it as possible). Within the function, we have to do some quick math to get the percentage before we can display it to a user. In order to do this math, we first need to know how many bytes the file size is and how many of those bytes have loaded. Flash makes this easy by providing the getBytesLoaded and getBytesTotal methods that we assign to variables called "loaded" and "total," respectively. Once we have those numbers, we can do a little simple division (loaded/total) to get a

decimal number, which we assign to a variable named "percent." Now we can actually inform a user as to how much of our movie has loaded for him or her. To convert the percentage from a decimal number to a whole number, pass it through the Math.round() method while also multiplying it by 100. Also, wrap some text around it and assign it to the loadText textField:

```
loadText.text = "Loading: " + Math.round(percent*100)+"%"
```

Every time this function runs, we need to make sure we tell the movie what to do once it's completely loaded. This happens in the if() statement at the end of the onEnterFrame function. We test to see if our percent variable is equal to 1 (remember the percent variable was originally a decimal number less than 1, but climbing toward 1). When percent does equal 1, we quickly delete the onEnterFrame function (this stops it from executing its script anymore), we remove the loadText textField because we don't need it anymore, and we tell the Flash movie to go ahead and play (or to do anything else we need it to do once it's loaded).

Classes

Classes can be a huge help to your production time, the consistency of your and your team's work, and even your sanity in those late hours before a deadline. When using classes, you can rest assured that once you have them built and functioning as you intend them to, you don't need to worry about reinventing the wheel every time you find yourself repeating a given task. It also helps to know that if it was working correctly before, it will be working correctly now; that helps when it comes time to send your work to quality control. In this section, I've included classes that I've found useful in my time working in the advertising industry.

BorderButton

The BorderButton class is something that grew from the full-stage button snippet
I previously covered. While you may still want to use the snippet in some cases, the
BorderButton class has added features. In addition to creating an invisible button
that covers the stage, this class also gives you the option to include a border of any
color and thickness you need based on the design layout and specs (some sites
require a border to separate banners from their content). As a matter of fact, the
BorderButton class is set up to offer three different choices. One option for using
this class would be a full stage button which also draws a border around your ban-
ner. Another option would be a full-stage button that does *not* draw a border around
your banner. The third option would be to draw a border around your banner without
creating a full-stage clickable area. Each of these options has their uses, and the
project at hand will determine which you would use. An example would be if you
had a banner with specs that called for a border, but you also need to make three
different clickable areas within the banner. In that case, you would go with the third
option of drawing the banner without including the full-stage clickable area.

The Code

```
class BorderButton extends MovieClip{

    public function BorderButton(tag:String,clickable:Boolean,outline:
Boolean,lineColor:Number,lineThickness:Number){

        if(outline == undefined){

            outline = false;

        }

        if(lineColor == undefined){

            lineColor = 0x000000;

        }

        if(lineThickness == undefined){

            lineThickness = 1;

        }

        var bbMc:MovieClip = _level0.createEmptyMovieClip("bbMc",_level0.get
NextHighestDepth());

        if(outline){

            bbMc.lineStyle(lineThickness,lineColor);

        }

        bbMc.beginFill(0x000000,0);

        bbMc.moveTo(lineThickness/2,lineThickness/2);

        bbMc.lineTo(Stage.width-(lineThickness/2),lineThickness/2);

        bbMc.lineTo(Stage.width-(lineThickness/2),Stage.height-(lineThickness/2));

        bbMc.lineTo(lineThickness/2,Stage.height-(lineThickness/2));

        bbMc.lineTo(lineThickness/2,lineThickness/2);

        bbMc.endFill();

        if(clickable){

            bbMc.onRelease = function(){

                getURL(tag,"_blank");

            }

        }

    }

}
```

The Explanation

In line 1, we declare the BorderButton class and have it extend MovieClip:

```
class BorderButton extends MovieClip{}
```

The reason for extending MovieClip is so we can inherit all of the methods we use that come from the MovieClip class itself. Next, on line 2, is the BorderButton constructor statement:

```
    public function BorderButton(tag:String,clickable:Boolean,outline:
Boolean,lineColor:Number,lineThickness:Number){}
```

In the constructor statement, we set up the function that will be called when a new instance of the class is created in Flash. The constructor statement is where both required and optional parameters are declared for the class. **Table 13.1** describes the parameters of the BorderButton class.

Table 13.1

BorderButton Class Parameters

Parameter	Explanation
tag	The URL that users will be taken to when they click on the banner. The tag parameter should be passed in as a string.
clickable	A Boolean value that indicates whether or not the area is clickable. If set to true, the entire banner becomes clickable. If set to false, only the border is drawn.
outline (optional)	A Boolean value that indicates whether or not to draw a border around the banner. This parameter is set to false by default.
lineColor (optional)	A number value that determines the color of the border. The lineColor should be passed in the form of 0×000000. The default value of this parameter is 0 (black).
lineThickness (optional)	The thickness of the border in pixels. The lineThickness should be passed in as a number and is set to 1 by default.

Next, we get inside the constructor statement to check the values passed in through the parameters and respond. The very first thing we do is check the optional parameters to see if values have been passed for them. If not, we assign the default values. This takes place in lines 3–11:

```
if(outline == undefined){

    outline = false;

}

if(lineColor == undefined){

    lineColor = 0x000000;

}

if(lineThickness == undefined){

    lineThickness = 1;

}
```

Next, we create an empty MovieClip in line 12. Then we check back to the outline parameter to determine whether or not we will draw the outline. If we find a value of true, we use the lineColor and lineThickness parameters to set the lineStyle() accordingly:

```
var bbMc:MovieClip = _level0.createEmptyMovieClip("bbMc",_level0.getNextHighest
Depth());

if(outline){

    bbMc.lineStyle(lineThickness,lineColor);

}
```

After that, we begin the transparent fill and draw a rectangle (or square depending on the banner size) to the stage in lines 16–22:

```
bbMc.beginFill(0x000000,0);

bbMc.moveTo(lineThickness/2,lineThickness/2)

bbMc.lineTo(Stage.width-(lineThickness/2),lineThickness/2);

bbMc.lineTo(Stage.width-(lineThickness/2),Stage.height-(lineThickness/2));

bbMc.lineTo(lineThickness/2,Stage.height-(lineThickness/2));

bbMc.lineTo(lineThickness/2,lineThickness/2);

bbMc.endFill();
```

Finally, we check to see if our BorderButton is clickable. If it is, we set up the onRelease function to go to the intended URL:

```
if(clickable){

    bbMc.onRelease = function(){

        getURL(tag,"_blank");

    }

}
```

Sample Use

To use the BorderButton class from within Flash, use one of the following:

```
//A BorderButton that is clickable and has an outline

var fullBtn:BorderButton = new BorderButton("http://www.flashadbook.com", true,
true, 0xff0000, 3);

//A BorderButton that only draws an outline on the banner

var fullBtn:BorderButton = new BorderButton("http://www.flashadbook.com", false,
true, 0xff0000, 3);

//A BorderButton that is clickable and does not draw an outline on the banner

var fullBtn:BorderButton = new BorderButton("http://www.flashadbook.com", true);
```

SimpleMenu

The following SimpleMenu class is a single-dimension (no dropdowns) menu that has limited styling properties that can be set by the developer. One of the styles that is changeable is the font used for both the upstate (when the mouse is not over the button) and the overstate. For example, you may want to show your menu using Arial font with no underlines until a user rolls his or her mouse over a button. The other modifiable style in the SimpleMenu class is the rectangle that is drawn behind the text of each button. You can control the opacity of the rectangle with the backgroundOpacity parameter and have it semi-see-through (or set that value to 0 and get rid of the rectangle altogether). Additionally, you can control the color of both the upstate and the overstate of the rectangle. Once the SimpleMenu class is used to create a menu in your project, you can assign any function to any button within that menu by using the assignRelease method.

The Code

```
class SimpleMenu extends MovieClip{

    var menuMc:MovieClip;

    public function SimpleMenu(parentMc:MovieClip,menuArr:Array,dir:
String,spacing:Number,upState:TextFormat,overState:TextFormat,backgroundOpacity:
Number,upBackground:Number,overBackground:Number){

        //check to see how many SimpleMenus have been created and increment that
number by one

        if(!parentMc.menuMc0){

            parentMc.menuNumb = 0;

        }else{

            parentMc.menuNumb++;

        }

        //create empty MovieClip to house the menu items

        menuMc = parentMc.createEmptyMovieClip("menuMc"+parentMc.menuNumb,parentMc
.getNextHighestDepth());

        //loop through menuArr and create menu items for each item in the array

        for(var m:Number = 0; m<menuArr.length; m++){

            //create empty MovieClip to act as menu item button

            var itemMc:MovieClip = menuMc.createEmptyMovieClip("itemMc"+m,menuMc.g
etNextHighestDepth());

            //check the direction to render the menu items. if no direction is
passed in, let the user know what to use.

            if(dir == "vertical"){

                var tempY:Number = menuMc["itemMc"+(m-1)]._y + menuMc["itemMc"+
(m-1)]._height;

                itemMc._y = tempY + spacing;

            }else if(dir == "horizontal"){

                var tempX:Number = menuMc["itemMc"+(m-1)]._x + menuMc["itemMc"+
(m-1)]._width;

                itemMc._x = tempX + spacing;

            }else{
```

```
            trace('Please use either "horizontal" or "vertical" for the
SimpleMenu direction param.');

        }

        //check optional params and assign values as needed

        if(!spacing){

            spacing = 0;

        }

        if(!upState){

            itemMc.outFormat = new TextFormat();

            itemMc.outFormat.color = 0x000000;

            itemMc.outFormat.underline = false;

        }else{

            itemMc.outFormat = upState;

        }

        if(!overState){

            itemMc.overFormat = new TextFormat();

            itemMc.overFormat.color = 0x000000;

            itemMc.overFormat.underline = true;

        }else{

            itemMc.overFormat = overState;

        }

        if(!backgroundOpacity){

            backgroundOpacity = 0;

        }

        if(!upBackground){

            upBackground = 0xFFFFFF;

        }

        if(!overBackground){

            overBackground = 0xFFFFFF;
```

```
        }

    if(backgroundOpacity == 0){

        upBackground = overBackground = 0xFFFFFF;

    }

    //create a TextField to display the text

    var itemName:TextField = itemMc.createTextField("itemName", itemMc.get
NextHighestDepth()+1, 0, 0, 1, 1);

    itemName.autoSize = true;

    itemName.antiAliasType = "advanced";

    itemName.selectable = false;

    itemName.text = menuArr[m];

    itemName.setTextFormat(itemMc.outFormat);

    //set rollOver and rollOut functions for the MenuItem

    itemMc.onRollOver = function(){

        if(this._parent.chosenMenuItem != this){

            this.itemName.setTextFormat(this.overFormat);

            redrawBlock(overBackground,this);

            this.useHandCursor = true;

        }else{

            this.useHandCursor = false;

        }

    }

    itemMc.onRollOut = function(){

        if(this._parent.chosenMenuItem != this){

            this.itemName.setTextFormat(this.outFormat);

            redrawBlock(upBackground,this);

            this.useHandCursor = true;

        }else{

            this.useHandCursor = false;

        }
```

```
            }

        itemMc.onRelease = function(){

            if(this._parent.chosenMenuItem != this){

                this._parent.chosenMenuItem.itemName.setTextFormat(this.
outFormat);

                redrawBlock(upBackground,this._parent.chosenMenuItem);

                this._parent.chosenMenuItem = this;

                if(this.releaseFunc){

                    this.releaseFunc();

                }

            }else{

                this.useHandCursor = false;

            }

        }

        redrawBlock(upBackground,itemMc);

    }

    //draw block for item background

    function redrawBlock(fillColor:Number,targetItem:MovieClip):Void{

        targetItem.clear();

        targetItem.beginFill(fillColor,backgroundOpacity);

        targetItem.lineTo(targetItem._width,0);

        targetItem.lineTo(targetItem._width,targetItem._height);

        targetItem.lineTo(0,targetItem._height);

        targetItem.lineTo(0,0);

        targetItem.endFill();

    }

}

//set the x and y values of the menu

public function setPosition(menuX:Number,menuY:Number):Void{

    menuMc._x = menuX;
```

```
        menuMc._y = menuY;

    }
    //get the x value of the menu
    public function get x():Number{

        return menuMc._x;

    }
    //get the y value of the menu
    public function get y():Number{

        return menuMc._y;

    }
    //get the width of the menu
    public function get width():Number{

        return menuMc._width;

    }
    //get the height of the menu
    public function get height():Number{

        return menuMc._height;

    }
    //assign an onRelease function to a menu item
    public function assignRelease(releaseFunction:Function,itemPosition:Number):
Void{

        menuMc["itemMc"+itemPosition].releaseFunc = releaseFunction;

    }
}
```

The Explanation

As usual, line 1 is the SimpleMenu class declaration:

```
class SimpleMenu extends MovieClip{}
```

Next, on line 2, we declare a variable named "menuMc" and give it a type of "MovieClip":

```
var menuMc:MovieClip;
```

The reason for declaring this variable outside of the SimpleMenu constructor statement (which fills lines 3–107) is so it will be available to the other methods of the class, such as setPosition or assignRelease. Next, we move in to the constructor that contains both required and optional parameters, which are explained in **Table 13.2**:

```
    public function SimpleMenu(parentMc:MovieClip,menuArr:Array,dir:
String,spacing:Number,upState:TextFormat,overState:TextFormat,backgroundOpacity:
Number,upBackground:Number,overBackground:Number){}
```

Table 13.2

SimpleMenu Class Parameters

Parameter	Explanation
parentMc	The MovieClip in which the SimpleMenu will be created.
menuArr	An array of strings that will be used as the names displayed on each menu item.
dir	The direction in which to draw the menu items. Acceptable values are "vertical" and "horizontal."
spacing (optional)	The number of pixels placed between each menu item. If no value is given, the default value of 0 is used.
upState (optional)	A TextFormat object that determines how the text looks in the menu items when the mouse is not over them. If no value is given, Arial font is used and is colored black.
overState (optional)	A TextFormat object that determines how the text looks in the menu items when the mouse is over them. If no value is given, Arial font is used, colored black, and underlined.
backgroundOpacity (optional)	The opacity of the colored background rectangle. If no value is given, the default value of 0 is used.
upBackground (optional)	The color to use for the background rectangle in the menu items when the mouse is not over them. If no value is given, the default value of white (0×FFFFFF) is used.
overBackground (optional)	The color to use for the background rectangle in the menu items when the mouse is over them. If no value is given, the default value of white (0×FFFFFF) is used.

The first thing that happens within the constructor is that we check to see if any other SimpleMenus have been created inside the same parent MovieClip that our new SimpleMenu will live. We do this on line 5 by checking to see if the MovieClip "menuMc0" exists. If it doesn't, we create a variable in the parent MovieClip called menuNumb and give it a value of 0 (this variable will be used in the next step of the process). However, if menuMc0 does exist, then the variable menuNumb has already been created and we increment it by 1:

```
if(!parentMc.menuMc0){

    parentMc.menuNumb = 0;

}else{

    parentMc.menuNumb++;

}
```

The next step, on line 11, is to utilize our previously declared variable, menuMc, to create an empty MovieClip that will be our actual menu (note the use of the menuNumb variable in the instance name of the SimpleMenu):

```
menuMc = parentMc.createEmptyMovieClip("menuMc"+parentMc.menuNumb,parentMc.getNext
HighestDepth());
```

After the empty menuMc MovieClip has been created, it's time to start creating the buttons that will make up the menu. This is where the substance of the class is as it uses lines 13–96 to loop through the array that was passed in as the menuArr parameter. With each item in the array, a new button is created and given the appropriate style. The initial step (line 15) that is taken in this loop is to create the actual MovieClip that will be used as the menu item button:

```
var itemMc:MovieClip = menuMc.createEmptyMovieClip("itemMc"+m,menuMc.getNext
HighestDepth());
```

Next, we need to check in which direction the menu items will draw themselves to the stage. This is done by checking the "dir" parameter in lines 17–25:

```
if(dir == "vertical"){

    var tempY:Number = menuMc["itemMc"+(m-1)]._y + menuMc["itemMc"+(m-1)]._height;

    itemMc._y = tempY + spacing;

}else if(dir == "horizontal"){

    var tempX:Number = menuMc["itemMc"+(m-1)]._x + menuMc["itemMc"+(m-1)]._width;

    itemMc._x = tempX + spacing;

}else{

    trace('Please use either "horizontal" or "vertical" for the SimpleMenu
direction param.');

}
```

If an invalid value (or no value) is passed in to the "dir" parameter, we trace a message to the user letting them know they need to use either "vertical" or "horizontal."

Once the direction is determined, lines 27–55 check the optional parameters to see if a default value needs to be assigned to any of them. As noted in **Table 13.2**, the optional parameters are spacing, upState, overState, backgroundOpacity, upBackground, and overBackground:

```
if(!spacing){

    spacing = 0;

}

if(!upState){

    itemMc.outFormat = new TextFormat();

    itemMc.outFormat.color = 0x000000;

    itemMc.outFormat.underline = false;

}else{

    itemMc.outFormat = upState;

}

if(!overState){

    itemMc.overFormat = new TextFormat();
```

```
    itemMc.overFormat.color = 0x000000;

    itemMc.overFormat.underline = true;

}else{

    itemMc.overFormat = overState;

}

if(!backgroundOpacity){

    backgroundOpacity = 0;

}

if(!upBackground){

    upBackground = 0xFFFFFF;

}

if(!overBackground){

    overBackground = 0xFFFFFF;

}

if(backgroundOpacity == 0){

    upBackground = overBackground = 0xFFFFFF;

}
```

Next, on line 57, we create a TextField inside the menu item MovieClip, and give it a name of "itemName":

```
var itemName:TextField = itemMc.createTextField("itemName",
itemMc.getNextHighestDepth()+1, 0, 0, 1, 1);
```

Note the depth at which we create the itemName TextField (itemMc.getNext HighestDepth()+1). The "+1" is because we want to make sure the TextField is placed above the colored rectangle that will be drawn in the MovieClip at a later step. After the TextField is created, we'll set a few properties on lines 58–60 to make sure it behaves as intended:

```
itemName.autoSize = true;

itemName.antiAliasType = "advanced";

itemName.selectable = false;
```

First is the autoSize property that is given a value of true to make sure the text in our menu items is not cut off. Next, the antiAliasType is set to "advanced" to make the font more readable. The antiAliasType is available in Flash Player 8 and above, therefore, this line should be omitted if you are developing for Flash Player 7 or below. After the antiAliasType is set, the selectable property is set to false because we want users to click on the menu items, not select their text. Finally, on lines 61 and 62, we assign the text from the appropriate position in the menuArr array to the TextField and then set the text format:

```
itemName.text = menuArr[m];

itemName.setTextFormat(itemMc.outFormat);
```

The next to last step, which takes place in lines 63–94, in creating each menu item is to assign onRollOver, onRollOut, and onRelease functions:

```
itemMc.onRollOver = function(){

    if(this._parent.chosenMenuItem != this){

        this.itemName.setTextFormat(this.overFormat);

        redrawBlock(overBackground,this);

        this.useHandCursor = true;

    }else{

        this.useHandCursor = false;

    }

}

itemMc.onRollOut = function(){

    if(this._parent.chosenMenuItem != this){

        this.itemName.setTextFormat(this.outFormat);

        redrawBlock(upBackground,this);

        this.useHandCursor = true;

    }else{

        this.useHandCursor = false;

    }

}

itemMc.onRelease = function(){
```

```
        if(this._parent.chosenMenuItem != this){

            this._parent.chosenMenuItem.itemName.setTextFormat(this.outFormat);

            redrawBlock(upBackground,this._parent.chosenMenuItem);

            this._parent.chosenMenuItem = this;

            if(this.releaseFunc){

                this.releaseFunc();

            }

        }else{

            this.useHandCursor = false;

        }

    }
```

With each of these actions, the menu item checks its parent MovieClip (the menuMc MovieClip) for the value of a variable named "chosenMenuItem." If the value of that variable is the menu item itself, then none of the mouse actions receive a response and the hand cursor is not shown. However, if the chosenMenuItem variable does *not* contain a value that matches the menu item, the format of the itemName TextField is altered and the colored block is redrawn to the new color by using the redrawBlock function (which will be covered next). The onRelease function contains a couple of lines of code that do two things: They give the chosenMenuItem variable a value equal to the menu item that was clicked, and they call the releaseFunc function if one exists (the releaseFunc function will be covered at the end of this section).

The final step in the creation of each menu item is to draw the colored rectangle behind the TextField. This is done by calling the redrawBlock function (lines 97–106), which takes two parameters: The fillColor parameter is the color that will be used to draw the rectangle and the targetItem parameter is the menu item in which it will be drawn. The fillColor will initially be given the value of the upBackground parameter that was passed in through the original creation of the SimpleMenu. Each time the mouse rolls over (or out of) a menu item, that menu item calls the redrawBlock function and passes it the upBackground or overBackground value accordingly. When the function is called, it uses the "clear" method to erase the previously drawn rectangle, resets the beginFill values, and then draws the rectangle back in place with the corresponding color and opacity. Here's the redrawBlock function:

```
function redrawBlock(fillColor:Number,targetItem:MovieClip):Void{

    targetItem.clear();

    targetItem.beginFill(fillColor,backgroundOpacity);

    targetItem.lineTo(targetItem._width,0);

    targetItem.lineTo(targetItem._width,targetItem._height);

    targetItem.lineTo(0,targetItem._height);

    targetItem.lineTo(0,0);

    targetItem.endFill();

}
```

Lines 108–128 contain a few methods to get or set properties of the SimpleMenu as a whole. The setPosition method can be used to move the entire menu anywhere on the stage by passing in the correct x and y values:

```
public function setPosition(menuX:Number,menuY:Number):Void{

    menuMc._x = menuX;

    menuMc._y = menuY;

}
```

The get x, get y, get width, and get height methods return number values for the SimpleMenu's _x, _y, _width, and _height properties, respectively. These methods may be used to place other MovieClips, Buttons, etc. in relation to the SimpleMenu:

```
public function get x():Number{

    return menuMc._x;

}
public function get y():Number{

    return menuMc._y;

}
public function get width():Number{

    return menuMc._width;

}
public function get height():Number{

    return menuMc._height;

}
```

Finally, the last method in the SimpleMenu class is the assignRelease method:

```
public function assignRelease(releaseFunction:Function,itemPosition:Number):Void{

    menuMc["itemMc"+itemPosition].releaseFunc = releaseFunction;

}
```

This method allows you to have each menu item respond in its own way when clicked. For example, one item may take the user to an external website, while another item may load an external swf, and yet another item may simply load an image into a MovieClip on the stage. The assignRelease method takes two parameters: releaseFunction is a function that you have written and itemPosition is the zero-based position of the item within the SimpleMenu instance. For example, you've written a function that loads an external jpg into a MovieClip on the stage while also taking the user to an external website in a new window. You want the very first menu item to call this function, so you write the following code:

```
myMenu.assignRelease(myFunction,0);
```

Now, when you click on the first item in the menu, not only will it set the chosenMenuItem variable mentioned earlier, but it will also call your function.

Sample Use

Here is a full example of using the SimpleMenu class in a Flash file:

```
var parentMc:MovieClip = this;

//create an array of names for the menu items

var menuArr:Array = new Array("Menu Item 1","Menu Item 2","Menu Item 3");

//set the direction of the menu

var dir:String = "vertical";

//set the spacing between the menu items

var spacing:Number = 10;

//create a TextFormat for the upState

var upState:TextFormat = new TextFormat();

upState.font = "Arial";

upState.color = 0x000000;

upState.underline = false;
```

```
//create a TextFormat for the overState

var overState:TextFormat = new TextFormat();

overState.underline = true;

//set the colors and opacity for the background rectangle

var backgroundOpacity:Number = 50;

var upBackground:Number = 0xFFFFFF;

var overBackground:Number = 0xCCCCCC;

//create the SimpleMenu

var myMenu:SimpleMenu = new SimpleMenu(parentMc,menuArr,dir,spacing,upState,
overState,backgroundOpacity,upBackground,overBackground);

//write functions for the menu items

function releaseFunction_0(){

    getURL("http://www.flashadbook.com","_blank");

}

function releaseFunction_1(){

    getURL("http://flash.fincanon.com","_blank");

}

function releaseFunction_2(){

    getURL("http://lab.fincanon.com","_blank");

}

//assign the functions to the menu items

myMenu.assignRelease(releaseFunction_0,0);

myMenu.assignRelease(releaseFunction_1,1);

myMenu.assignRelease(releaseFunction_2,2);

//place the menu at x,y of 10,10

myMenu.setPosition(10,10);
```

SimpleGallery

There will most likely be occasions where your client wants to show off a gallery of either several of their products or multiple photographs of a specific product. The automobile manufacturer example I've used in this book would be a prime candidate for a photo gallery. Since you may find yourself making these galleries on project after project after project, it might be a good idea to have a simple base for one at your disposal. The SimpleGallery class is meant as exactly that. It gives you a simple layout for an image gallery with a simple function to view each thumbnail in its larger form. As I explain the code, note that the viewImage function can be replaced by any kind of a transition function that fits the needs of a particular project. For example, you may want to have a look at some of Robert Penner's easing equations that can be found at http://www.robertpenner.com/easing/.

The Code

```
class SimpleGallery{

    var galleryMc:MovieClip;

    public function SimpleGallery(parentMc:MovieClip,imagePath:String,imageArr:
Array,columns:Number,thumbScale:Number,padding:Number){

        //set a variable to the length value of the array of images

        var numbOfImages:Number = imageArr.length;

        //create MovieClip to house entire gallery

        galleryMc = parentMc.createEmptyMovieClip("galleryMc",parentMc.getNext
HighestDepth());

        //create a listener Object that will set the x and y of each image after
it's loaded

        var thumbListener:Object = new Object();

        thumbListener.onLoadInit = function(targetMc:MovieClip):Void {

            var containerMc:MovieClip = targetMc._parent;

            containerMc._x = (containerMc.imgCol * containerMc._width) +
(containerMc.imgCol * padding);

            containerMc._y = (containerMc.imgRow * containerMc._height) +
(containerMc.imgRow * padding);

        }

        var imgLoader:MovieClipLoader = new MovieClipLoader();
```

```
imgLoader.addListener(thumbListener);

//loop through imageArr array and create MovieClips to hold each image

for(var i:Number = 0; i < numbOfImages; i+=columns){

    for(var c:Number = 0; c < columns; c++){

        if(i+c < numbOfImages){

            var imgContainer:MovieClip = galleryMc.createEmptyMovieClip
("imgContainer"+(i+c),galleryMc.getNextHighestDepth());

            var img:MovieClip = imgContainer.createEmptyMovieClip("img",
imgContainer.getNextHighestDepth());

            imgContainer.imgRow = i/columns;

            imgContainer.imgCol = c;

            imgContainer.imgDepth = imgContainer.getDepth();

            imgLoader.loadClip(imagePath + imageArr[i+c], img);

            imgContainer._xscale = imgContainer._yscale = thumbScale;

            imgContainer.onRelease = function(){

                viewImage(this);

            }

        }else{

            c = columns;

            i = numbOfImages;

        }

    }

}

//function to call when an image is clicked

function viewImage(thumb:MovieClip):Void{

    if(thumb._xscale < 100){

        var halfWidth:Number = thumb._parent._width/2;

        var halfHeight:Number = thumb._parent._height/2;

        thumb._xscale = thumb._yscale = 100;

        thumb._x = halfWidth - thumb._width/2;
```

```
                    thumb._y = halfHeight - thumb._height/2;

                    thumb.swapDepths(thumb._parent.getNextHighestDepth())
              }else{

                    thumb._xscale = thumb._yscale = thumbScale;

                    thumb._x = (thumb.imgCol * thumb._width) + (thumb.imgCol *
padding);

                    thumb._y = (thumb.imgRow * thumb._height) + (thumb.imgRow *
padding);

                    thumb.swapDepths(thumb.imgDepth);

              }

        }

    }

    public function setPosition(galleryX:Number,galleryY:Number):Void{

         galleryMc._x = galleryX;

         galleryMc._y = galleryY;

    }

    public function get x():Number{

         return galleryMc._x;

    }

    public function get y():Number{

         return galleryMc._y;

    }

    public function get width():Number{

         return galleryMc._width;

    }

    public function get height():Number{

         return galleryMc._height;

    }

}
```

The Explanation

The SimpleGallery class starts out by declaring a variable named "galleryMc," which is typed as a MovieClip:

```
var galleryMc:MovieClip;
```

We'll use this variable a few lines later to create a new empty MovieClip that will house the entire gallery. Once the galleryMc variable is in place, we move on to the constructor and its parameters, which are explained in **Table 13.3**:

```
public function SimpleGallery(parentMc:MovieClip,imagePath:String,imageArr:
Array,columns:Number,thumbScale:Number,padding:Number){}
```

Table 13.3

SimpleGallery Class Parameters

Parameter	Explanation
parentMc	The MovieClip in which the SimpleGallery will be created.
imagePath	The path to the images in the file system. The imagePath value is a string that can be either a relative or absolute path.
imageArr	An array of file names that will be used in the SimpleGallery. Each file name in the array should be a string value.
columns	The number of columns (or images across) to display in your SimpleGallery.
thumbScale	The size of the thumbnail images based on a percentage of the full-size images (50 = 50%; 20 = 20%).
padding	The number of pixels to place between each thumbnail image.

Once inside the constructor, the first thing we do is create a variable named "numbOfImages" and give it a value of the length of the imageArr array parameter:

```
var numbOfImages:Number = imageArr.length;
```

Author's Tip

Remember to always assign the length of an array to a number variable if you will be accessing it from any repeating method such as a for() loop or a while() statement. It is less processor intensive for the loop to reference a number variable rather than accessing an array and basically counting its elements every time.

We'll refer back to the numbOfImages variable later when we create the thumbnails of the images. Next, we use the galleryMc variable we declared earlier to create an empty MovieClip within the parentMc:

```
galleryMc = parentMc.createEmptyMovieClip("galleryMc",parentMc.getNextHighest
Depth());
```

After the galleryMc MovieClip is created, we create another variable of type object and give it a name of "thumbListener":

```
var thumbListener:Object = new Object();
```

The thumbListener.onLoadInit function on lines 10–14 will then set the _x and _y values of a given MovieClip (I'll come back to this function at the end of this section).

The next step in the SimpleGallery class is to create a MovieClipLoader as is done on line 15:

```
var imgLoader:MovieClipLoader = new MovieClipLoader();
```

After we've created the MovieClipLoader and given it a variable name of "imgLoader," we'll assign the thumbListener object by using the addListener method:

```
imgLoader.addListener(thumbListener);
```

Now, the thumbListener will essentially "listen to" anything our MovieClipLoader does. And since it's listening, we can tell it what to do any time certain actions take place (such as when an external load has started or finished).

Now that we have a MovieClip set up to hold all of our images and we have a listener object listening for us to load those images, it's time to start loading them into their own individual MovieClips, placing those MovieClips in the correct places, and assigning onRelease functions to them. All of this is done in the nested for() loops on lines 18–36:

```
for(var i:Number = 0; i < numbOfImages; i+=columns){

    for(var c:Number = 0; c < columns; c++){

        if(i+c < numbOfImages){

            var imgContainer:MovieClip = galleryMc.createEmptyMovieClip
("imgContainer"+(i+c),galleryMc.getNextHighestDepth());

            var img:MovieClip = imgContainer.createEmptyMovieClip("img",img
Container.getNextHighestDepth());

            imgContainer.imgRow = i/columns;

            imgContainer.imgCol = c;

            imgContainer.imgDepth = imgContainer.getDepth();

            imgLoader.loadClip(imagePath + imageArr[i+c], img);

            imgContainer._xscale = imgContainer._yscale = thumbScale;

            imgContainer.onRelease = function(){

                viewImage(this);

            }

        }else{

            c = columns;

            i = numbOfImages;

        }

    }

}
```

The nested for() loops can be thought of like this: The outside loop is for each entire row of images while the inside loop is for the individual images in those rows. I'll explain with an example where the columns parameter has been given a value of 3. The first time the outside loop is run, the variable "i" has a value of 0 and we step directly to the inside loop. Since the columns variable has a value of 3, we know this loop will run three times. Here is what happens on lines 20–34: The if() statement on line 20 checks to see that we have not gone over the number of images that are in the imageArr array. If we have not, we step to line 21 where an imgContainer MovieClip is created to house both the image itself as well as a few variables we'll need later. After the imgContainer is created, we create another MovieClip inside it and give this one a name of "img":

```
if(i+c < numbOfImages){

    var imgContainer:MovieClip = galleryMc.createEmptyMovieClip("imgContainer"+
(i+c),galleryMc.getNextHighestDepth());

    var img:MovieClip = imgContainer.createEmptyMovieClip("img",imgContainer.
getNextHighestDepth());
```

Next, on lines 23–25, we assign important variables to the individual images:

```
imgContainer.imgRow = i/columns;

imgContainer.imgCol = c;

imgContainer.imgDepth = imgContainer.getDepth();
```

These variables will be used to determine the _x, _y, and depth of each image as it is placed on the stage and interacted with. The first variable we assign is imgRow. The value of imgRow is set based on two values: the value of the variable "i" in the outer loop and the value of the columns parameter. Since the outer loop is incrementing the variable "i" by the value of the columns parameter, dividing these numbers works out perfectly. If the outer loop is running for the first time and "i" has a value of 0, then 0 ÷ 3 = 0 (remember 3 is the value of columns in this example). The next iteration would be 3 ÷ 3 = 1, then 6 ÷ 3 = 2, and so on. Next is the imgCol variable, which needs much less explanation as it is simply based on the value of

the variable "c" in the inner loop. Since "c" is incremented by 1 each time, its value is easy enough to guess (0, 1, 2, etc.). The next variable, imgDepth, is another easy one to explain because it is simply given the value of the depth at which the imgContainer MovieClip was created. Line 26 is where we actually load our image (whose location we get by concatenating the value of the imagePath value with the name of the file from the imageArr array) into the img MovieClip, and on line 27, we look back to the value of the thumbScale parameter and apply that value to the _xscale and _yscale properties of imgContainer:

```
imgLoader.loadClip(imagePath + imageArr[i+c], img);

imgContainer._xscale = imgContainer._yscale = thumbScale;
```

The last thing that we do to imgContainer in this loop is assign the onRelease function to call our viewImage function (the viewImage function will be covered next):

```
imgContainer.onRelease = function(){

    viewImage(this);

}
```

Once we have looped all the way through the imageArr array and created all of our images, the value of "c" is set to the same value as the columns variable and the value of "i" is set to the value of the numbOfImages variable. This step ensures that we don't continue trying to create images that don't exist in the imageArr array:

```
}else{

    c = columns;

    i = numbOfImages;

}
```

As I mentioned earlier, the contents of the viewImage function can be replaced by any kind of a transition function that fits the needs of a particular project. In this case, I simply chose to take the image from its thumbnail size directly to its full size while centering it to the rest of the gallery both vertically and horizontally. However, if the image is clicked on while it is already at its full size, it shrinks back to its

thumbnail size and goes back to its correct position in the gallery layout. The first step in this process is the if() statement on line 39 that checks the _xscale of the image:

```
function viewImage(thumb:MovieClip):Void{

    if(thumb._xscale < 100){

        var halfWidth:Number = thumb._parent._width/2;

        var halfHeight:Number = thumb._parent._height/2;

        thumb._xscale = thumb._yscale = 100;

        thumb._x = halfWidth - thumb._width/2;

        thumb._y = halfHeight - thumb._height/2;

        thumb.swapDepths(thumb._parent.getNextHighestDepth())

    }
```

If the _xscale is less than 100, the process of enlarging the image is set in motion. On lines 40 and 41, the variables halfWidth and halfHeight are given values of half the width and height of the entire gallery, respectively. This is done by getting the full width and height of the galleryMc MovieClip (thumb._parent) and dividing them both by 2. Next, the _xscale and _yscale of the image are both set to 100. Once full sized, the image is centered to the gallery. To center the image, its _x property is set to the value of halfWidth minus half the width of the full-size image. The same is then done for the height. Lastly, on line 45, the swapDepths() method is called to move the full-size image on top of all of the other thumbnails. When the user clicks on the full-size image, the imgCol, imgRow, and imgDepth properties that we set earlier come into play:

```
}else{

    thumb._xscale = thumb._yscale = thumbScale;

    thumb._x = (thumb.imgCol * thumb._width) + (thumb.imgCol * padding);

    thumb._y = (thumb.imgRow * thumb._height) + (thumb.imgRow * padding);

    thumb.swapDepths(thumb.imgDepth);

}
```

First, on line 47, the image is scaled back down to the original thumbScale value. Lines 48 and 49 check which row and column position the thumbnail came from and set the _x and _y appropriately. And last but not least, the swapDepths() method is called to put the thumbnail back on its original depth.

Now let's get back to that onLoadInit function from lines 10–14:

```
thumbListener.onLoadInit = function(targetMc:MovieClip):Void {

    var containerMc:MovieClip = targetMc._parent;

    containerMc._x = (containerMc.imgCol * containerMc._width) + (containerMc.
imgCol * padding);

    containerMc._y = (containerMc.imgRow * containerMc._height) + (containerMc.
imgRow * padding);

}
```

The main reason I held off on the explanation of this function is because it uses variables that I had not yet talked about in addition to the _width and _height properties of the thumbnail (which had also not been set). The first thing to mention is the targetMc parameter. This parameter was passed with a value of the img MovieClip in each of the imgContainer MovieClips when we called the imgLoader.loadClip() method back on line 26. Using that targetMc parameter, we create a variable of type MovieClip and name it "containerMc." We then give containerMc a value of the parent of the img MovieClip:

```
var containerMc:MovieClip = targetMc._parent;
```

Now we get to the variables that were created much earlier in this section: imgCol, imgRow, and padding. In addition to the values of those variables, we can now obtain the _width and _height properties of the MovieClip (these values were actually 0 prior to the image being loaded). Using these variables with a little addition and multiplication, we can set the _x and _y properties of each thumbnail:

```
containerMc._x = (containerMc.imgCol * containerMc._width) + (containerMc.imgCol *
padding);
```

```
containerMc._y = (containerMc.imgRow * containerMc._height) + (containerMc.imgRow
* padding);
```

Sample Use

Using the SimpleGallery within Flash is pretty straightforward as you can see in the following example:

```
var parentMc:MovieClip = this;

var imagePath:String = "images/"

var imageArr:Array = new Array("galleryImage1.jpg","galleryImage2.
jpg","galleryImage3.jpg","galleryImage4.jpg","galleryImage5.jpg","galleryImage6.
jpg","galleryImage7.jpg","galleryImage8.jpg","galleryImage9.jpg")

var columns:Number = 3;

var thumbScale:Number = 15;

var padding:Number = 5;

var myGallery:SimpleGallery = new SimpleGallery(parentMc,imagePath,imageArr,column
s,thumbScale,padding)

myGallery.setPosition(100,100);
```

Just to recap a couple of the variables you see in this example, imagePath is the path to the location of the images (this path can be either relative or absolute). The imageArr variable is an array of the names of the images that are in the folder referenced by the imagePath variable. The names include the file extension to allow the ability to use other types of images. A quick note on the imageArr variable: If you have the proper code in place via PHP, .NET, Ruby, etc., you could use that code to check the folder and dynamically pass all of the names of the files in to Flash. Using that list, you could then populate your imageArr array. By doing it this way, your gallery would be up to date and have the correct images each time you added a new image to the folder.

Reverse

Reversing a MovieClip in Flash can come in handy in many situations like animated menu buttons or really anything else that may be moving on the stage. I've included the following small Reverse class that I put together simply because I find myself using it to get to previous states of animations in numerous projects. It's pretty small and straightforward, so the explanation on this one is shorter, but let's take a look at the entire piece of code first.

The Code

```
class Reverse{

    public function Reverse(targetClip:MovieClip,targetFrame:Number,speed:Number){

        var rev:Number = setInterval(reverseClip,speed);

        function reverseClip():Void{

            if(targetClip._currentframe > targetFrame){

                targetClip.prevFrame();

            }else{

                targetClip.gotoAndStop(targetFrame);

                clearInterval(rev);

            }

        }

    }

}
```

The Explanation

As I said, this explanation will be short and sweet since there isn't a whole lot to the class itself. So to start, just like any other class we have the constructor on line 2:

```
public function Reverse(targetClip:MovieClip,targetFrame:Number,speed:Number){}
```

The parameters in this class are self-explanatory but I'll go ahead and break them down. The first parameter, targetClip, is the MovieClip that will be reversed. The next parameter, targetFrame, is the frame on which you would like the targetClip to stop reversing, and the last parameter, speed, is the speed by which the clip will be reversed. Moving on to line 3, the setInterval will run the reverseClip function at the given speed:

```
var rev:Number = setInterval(reverseClip,speed);
```

Finally, on lines 4–11 is the actual function that performs the reverse on your MovieClip:

```
function reverseClip():Void{
        if(targetClip._currentframe > targetFrame){
            targetClip.prevFrame();
        }else{
            targetClip.gotoAndStop(targetFrame);
            clearInterval(rev);
        }
    }
```

Simply put, the reverseClip function checks the targetClip's _currentframe property to see if it is greater than the targetFrame. If it is, the targetClip is told to go back one frame. Once the _currentframe property is not greater than the targetFrame, the targetClip is told to go to the targetFrame and stop while the rev setInterval is cleared.

Sample Use

A quick and easy sample use of this class would be if you had a MovieClip on your stage that was named myMc and had a timeline animation inside of it. To get myMc to reverse to the first frame when it has been clicked on, use the following code:

```
myMc.onRelease = function(){
    var rv:Reverse = new Reverse(this,1,30);
}
```

To make myMc reverse to a certain point in its timeline, simply change the target-Frame parameter like so:

```
myMc.onRelease = function(){
    var rv:Reverse = new Reverse(this,18,30);
}
```

Finally, you could place the call to the class at the end of an animation to cause it to rewind after it has been played:

```
var rv:Reverse = new Reverse(this,1,30);
```

There are several ways you can use the Reverse class to control your animations, so play around with it a little until you find the right use for your project.

Conclusion

While I hope you are able to get some use from the code snippets and classes within this chapter, the main goal was to give you some ideas of ways to streamline your workflow. By saving snippets of code, you can easily copy and paste them into your work rather than retyping all of the code every time. It also helps because there are times when you'll remember that you wrote code to perform a specific function, but your brain seems to have gone blank and you can't remember how you did it previously.

Classes are also extremely handy and reusable. Even if you can't use the exact line-for-line code from a class, you can always create a new class by extending or modifying it to suit the needs of a particular project. Keep an eye out for project situations that seem to repeat themselves on at least a semi-regular basis. When you notice those situations, think about writing a class or saving a snippet or two of the code that helped you complete the task at hand. One more suggestion: In addition to reusing your code, be sure to share it with your team. If you're all using the same code, then projects are easier to maintain and troubleshoot.

Index